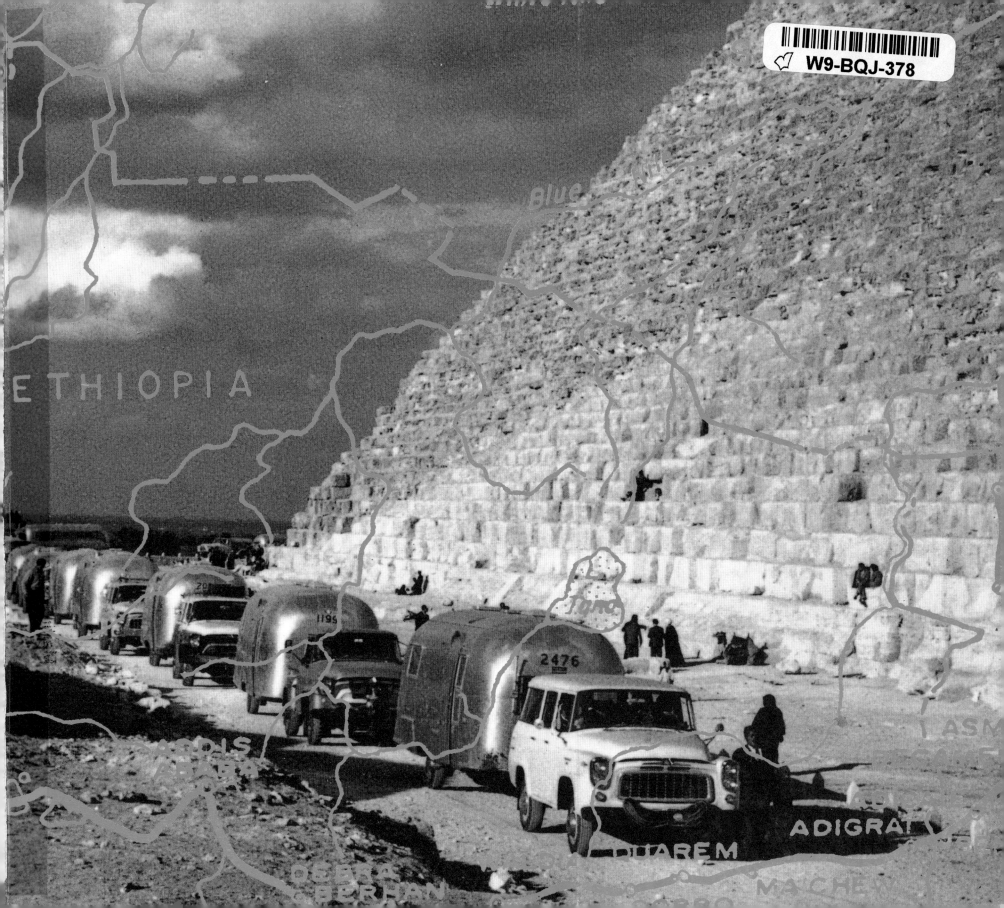

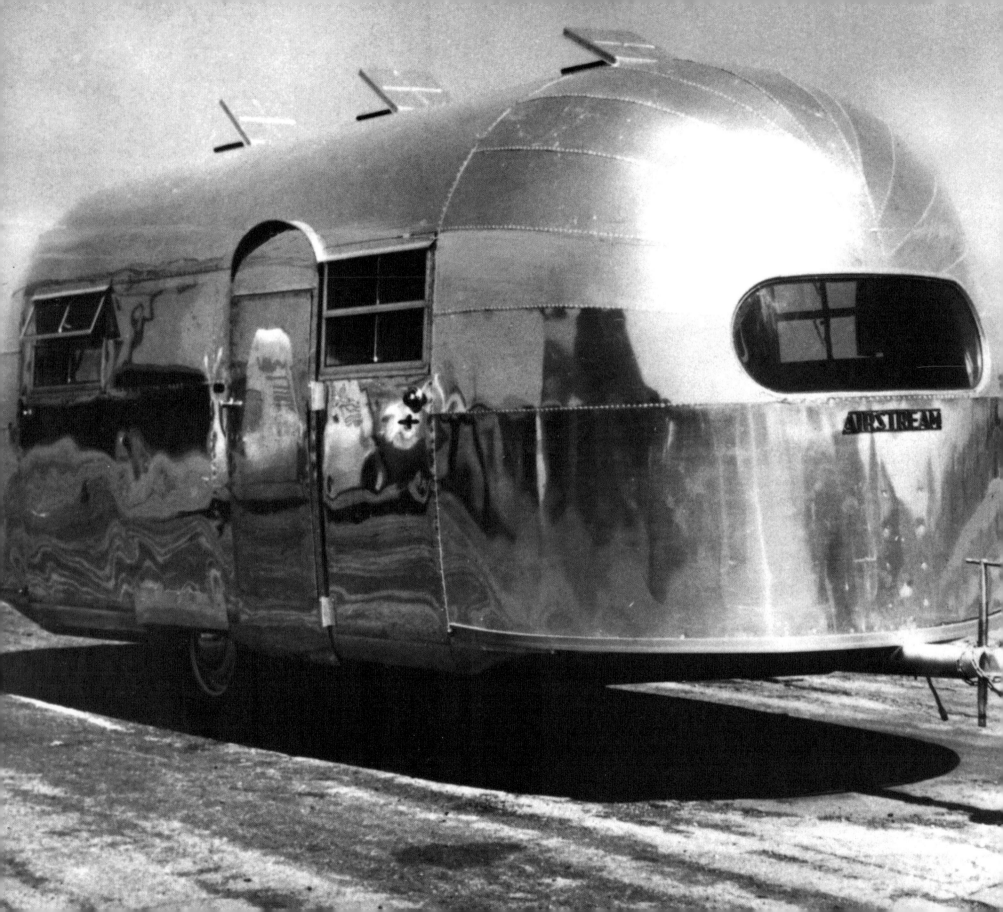

REDUCE RESISTANCE

STIMULATE DESIRE

LIVE WITH UTOPIAN AESTHETIC

HAVE FAITH IN TECHNOLOGY

ESTABLISH AN ORDERLY ESSENTIAL

DESIGN VISUAL EFFICIENCY

DRIVE SLOWLY, APPEAR QUICKLY

Ivan Trance

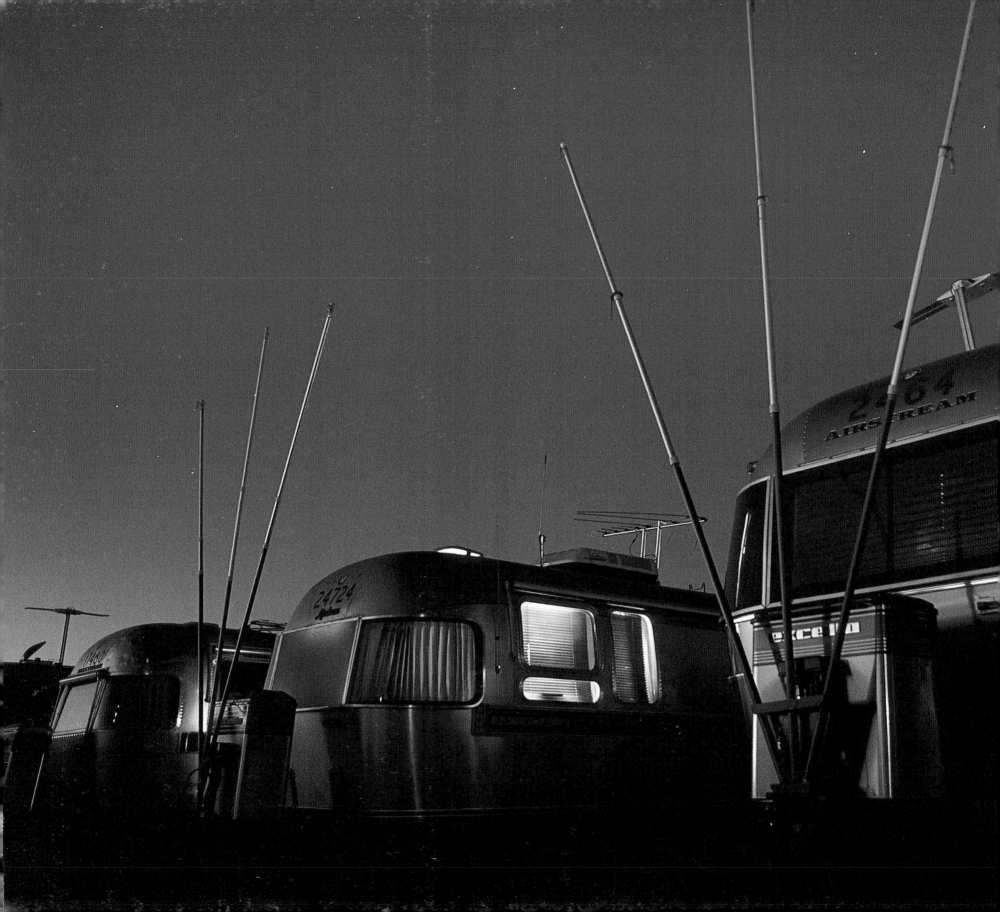

THINGS RARE OR THINGS BEAUTIFUL

HERE ARE WISELY ASSEMBLED

THEY INSTRUCT THE EYE TO

LOOK AT ALL THINGS IN THE WORLD

AS IF NEVER SEEN BEFORE.

Paul Valery, 1937

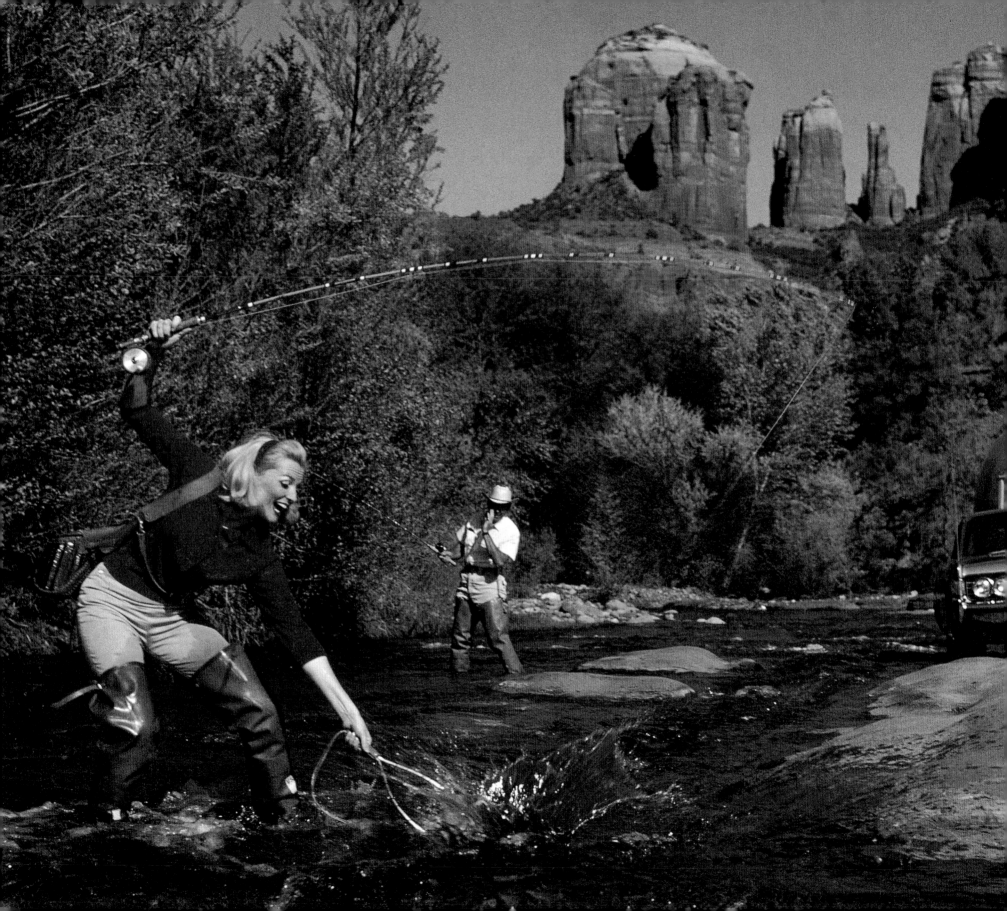

ADVENTURE IS WHERE YOU FIND IT,

ANY PLACE, EVERY PLACE,

EXCEPT AT HOME IN THE ROCKING CHAIR.

Wally Byam

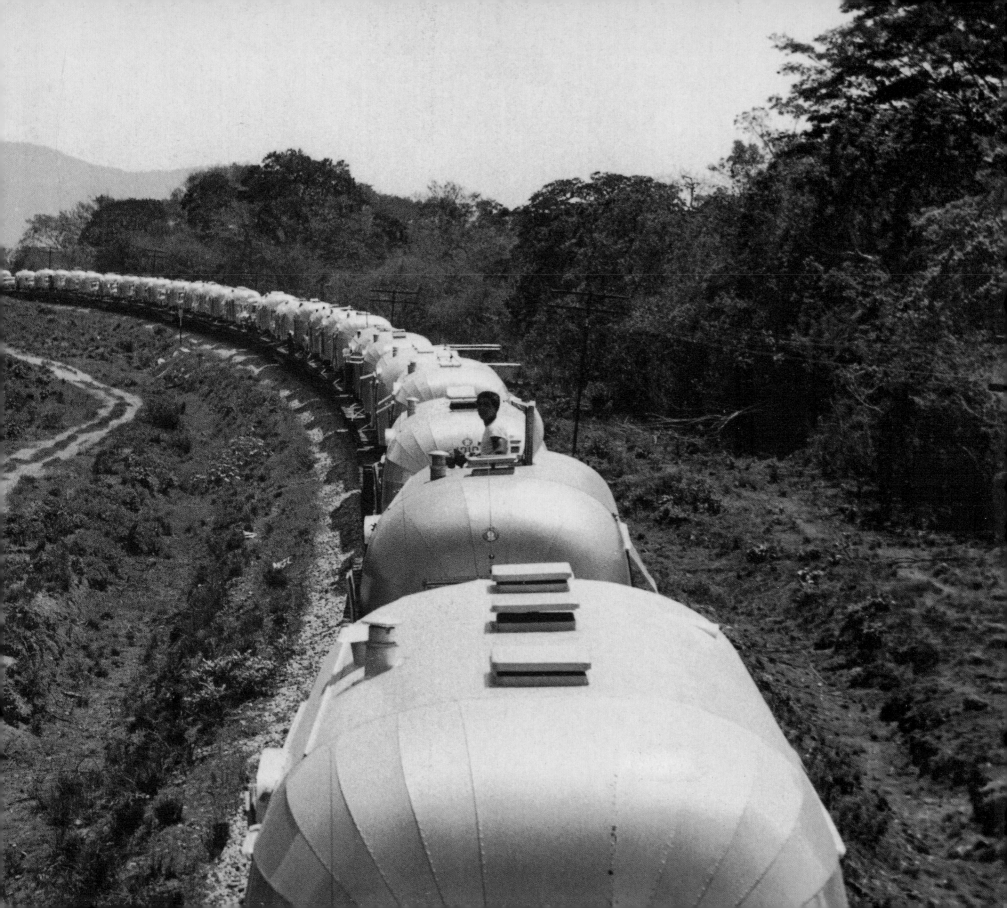

by Bryan Burkhart
and David Hunt

AIRSTREAM

THE HISTORY OF THE LAND YACHT

CHRONICLE BOOKS

SAN FRANCISCO

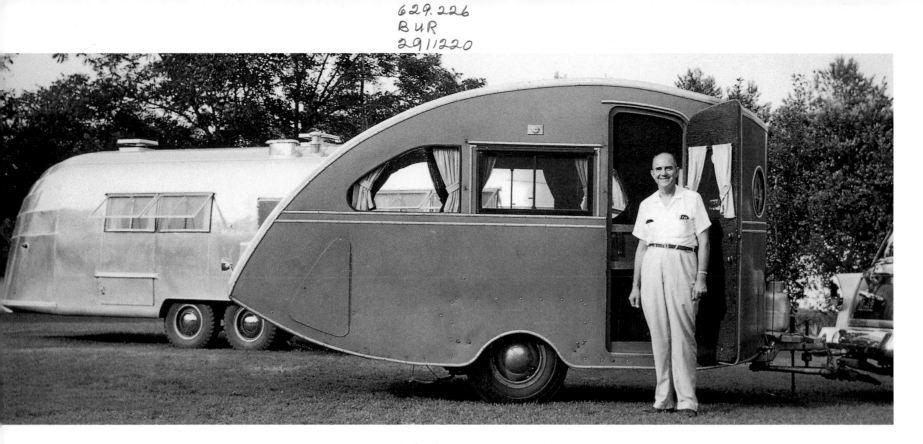

Printed in Hong Kong

Library of Congress Cataloging-in-Publication Data:
Burkhart, Bryan, 1963—
Airstream : the history of the land yacht / Bryan Burkhart
and David Hunt.
 p. cm.
Includes bibliographical references and index.
ISBN 0-8118-2471-3 (pb.)
1. Airstream trailers—History. I. Hunt, David, 1969—
II. Title.
TL297.B77 2000 99-39938
629.226—dc21 CIP

Frontmatter images:
pg 1: Caravan alongside Great Pyramid, 1959.
pg 2–3: Airstream advertisement in the fall, 1964.
pg 4–5: French bicyclist, Latourneau, pulls an Airstream.
pg 6–7: Evening Glow. Photo: Woods Wheatcroft, 1998.
pg 8–9: Airstream advertisement, fishing, 1959.
pg 10: Airstream caravan on a flatbed train, Arriaga, Mexico, 1958.
above: Dr. H.W. Holman built his 1935 Airstream from plans
supplied by the Airstream Company.

Book design by Bryan Burkhart / MODERNHOUSE
Text by David Hunt

Distributed in Canada by Raincoast Books
9050 Shaughnessy Street
Vancouver, B.C. V6P 6E5

1 0 9 8 7 6 5 4 3

Chronicle Books LLC
85 Second Street
San Francisco, CA 94105

www.chroniclebooks.com

THE TIME IS NOW !

ACKNOWLEDGMENTS

Airstream Incorporated

Chrysler Historical Foundation
DaimlerChrysler AG Classic Archives
Detroit Historical Society
The State of Idaho
Museum of Science and Industry
The Newberry Library
Ohio Historical Society
Smithsonian Institution
Vintage Airstream Club
Wally Byam Caravan Club International

Allison Arieff
Bob Aufuldish
John Beaver
Olivier Chételat
Bud Cooper
Melanie Doherty
Carolyn Eicher
Ester Garrison
Shawn Hazen
Mark Jensen
Leo Keoshian
Michael Manwaring
Deke O'Malley
Preston Pearson
John Randolph
Alan Rapp
Pate Rawak
Helen Byam Schwamborn
Gayle A. Steinbeigle
Herb Thornby
Clyde Wagner
Linda Watren
Woods Wheatcroft

To my parents Donald and Patricia Burkhart for having the ability to see beauty,
and to smile and laugh when I pulled an Airstream trailer into the driveway.

To my parents J.B. and Marcia Hunt.

All pictures courtesy of Airstream Incorporated unless otherwise noted.

contents

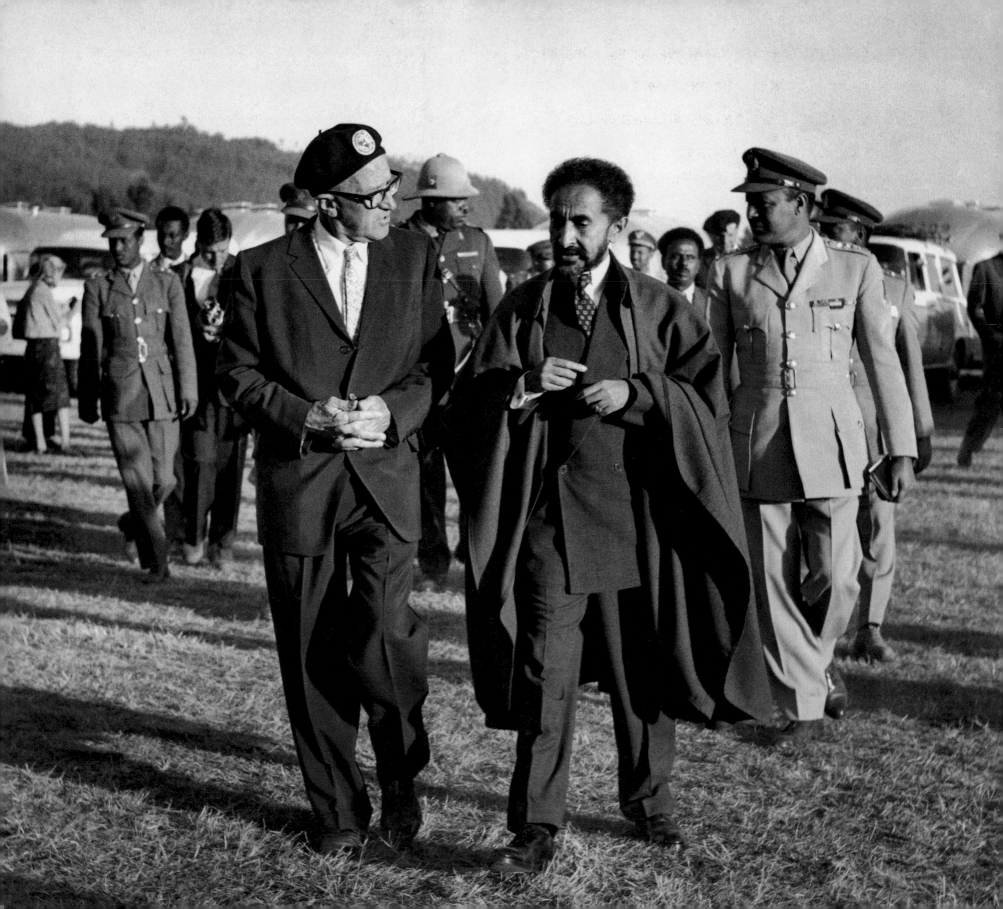

"WHETHER WE LIKE IT OR NOT, ANY FOOL CAN SEE THAT THIS

EARTH IS GRADUALLY BECOMING ONE WORLD.

NOBODY KNOWS WHAT THE FORM OF THE 'ONE' WILL BE,

BUT IT'S GOING TO BE ONE OR NONE."

Wally Byam, 1960

drive slowly, appear quickly

On November 9, 1959, Wally Byam shook hands with the Conquering Lion of the Tribe of Judah, His Imperial Majesty, Elect of God, Haile Selassie I, Emperor of Ethiopia. He simply requested an audience with the mythical king, stepped out of his gold-anodized 1957 Airstream World Traveler, and sauntered past a full-grown lion that was lounging on the palace stairs, gaining entrance to the throne room. The emperor, in full military regalia, his long black cloak flowing in the wind, received him with the warmth and respect accorded any traveling dignitary from the West.

Wally, who had spent the summers of his youth leading the lonely life of a shepherd, driving a small flock of goats to his family's remote pasturage high in the mountains of Oregon, now found himself trekking across the plains of Africa, shepherding those who shared his belief that "Adventure is where you find it—any place, every place, except at home in the rocking chair." Where once, as a teenager, he had lived in a simple two-wheeled, donkey-powered cart covered with a thin tarp, he now found himself in a fully self-contained, aluminum-skinned, gleaming silver bullet fronting a caravan of more than forty vehicles bearing his signature design.

A few years earlier, in 1956, Wally had been escorted by motorcade through the streets of Havana, Cuba, for a similar rendezvous with President Fulgencio Batista, who would

WALLY & HAILE SELASSIE I, 1958
Tour the Airstream caravan as the travelers set themselves
up for an evening in Ethiopia as a guest of the emperor.

THE ORIGINAL
THROW AWAY
✔ LIST FOR TRAILER & CAR

THINGS TO CHECK BEFORE PULLING OUT, THEN THROW PAGE AWAY.
PAD IS THEN READY FOR NEXT TRIP.

CHECK LIST INSIDE

1—Turn electric refrigerator OFF __ __ __ — ☐
2—Light gas refrigerator __ __ __ __ — ☐
3—Secure bath room door __ __ __ __ — ☐
4—Put pin in refrigerator door __ __ __ — ☐
5—Make sure water pump switch is turned to OFF ☐
6—Put TV and radio in safe place __ __ __ — ☐
7—Shut all windows and vents __ __ __ — ☐
8—Put grate clips on stove __ __ __ __ — ☐
9—Set thermostat on furnace to LOW __ __ — ☐
10—Put covers in sink __ __ __ __ __ — ☐
11—Close all curtains __ __ __ __ __ — ☐
12—Check water level at gauge, fill if necessary ☐
13—Empty and flush holding tank __ __ __ — ☐
14—Lock door and set dead bolt __ __ __ — ☐

CHECK LIST OUTSIDE

15—Release water hose, electric cable and secure __ ☐
16—Roll up and secure awning __ __ __ — ☐
17—Fold and secure lawn chairs __ __ __ — ☐
18—Remove jacks from under trailer __ __ __ — ☐
19—Hook trailer to car and connect wiring __ __ — ☐
20—Hook brake wire under deck lid __ __ __ — ☐
21—Lower front window guard __ __ __ — ☐
22—Put rear view mirrors on car fenders __ __ — ☐
23—Lower TV antenna and radio aerial __ __ — ☐
24—Check clearance, brake, tail and back-up lights ☐
25—Raise step at door and secure __ __ __ — ☐
26—Check tire pressure on all tires __ __ __ — ☐
27—Have you remembered your CAMERA? __ __ — ☐
28—After moving out 50 ft., walk back and check
area for goods or tools __ __ __ __ __ — ☐

TO REORDER, WRITE TO:
MEADOWS MODERN
132 W. SUMNER AVE.
LAKE ELSINORE, CALIF.

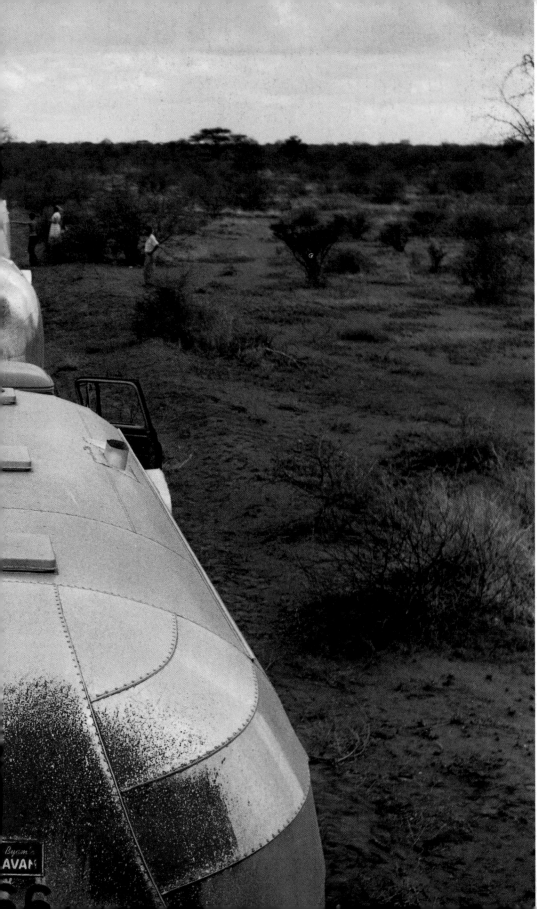

"It was impossible, so it took a little longer to accomplish."

soon have a revolution on his hands. Armed soldiers
lined the roofs as Batista stepped into Wally's shining
zeppelin to admire an aerodynamic example of atomic-age
comfort, aptly named because it rode along the highway
like a stream of air.

Wally was not alone. On his trip through Africa, he set
out as leader of a caravan of forty-one trailers, twenty-nine
of which would complete the trip that, over the course
of seven months, covered more than 13,000 miles of
desert, mountain, forest, and jungle, from Capetown
to Cairo. There were no precedents—no records to be
broken, no prizes to be won. Wally and a few like-minded
souls were fond of saying, "It was impossible, so it took
a little longer to accomplish." This thought—in essence a
kind of pioneering optimism coupled with a love of adven-
ture—is the spirit of trailer travel then as much as now.

Journalists in Johannesburg had predicted dire conse-
quences for the caravan from the start. The travelers
in the twenty-nine trailers that made it past the pyramids
at Giza were surprised to learn that the South African
press had reported that all but three trailers had
been sold along the way for $150 each. Not only had
the group managed to surmount collapsed bridges and
broken axles—at one point rolling 607 miles with no gas
stops, overcoming numerous hospitalizations and one
emergency operation—it would also learn to weather its
biggest obstacle: public opinion.

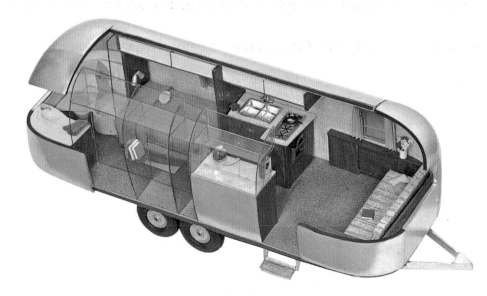

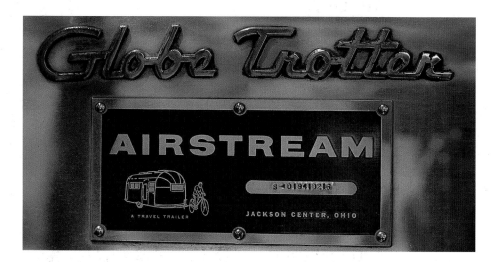

AIRSTREAM TRAILER PLAQUE
(above) Each trailer produced is named and numbered.
This trailer was produced at the Jackson Center, Ohio factory.

AXIOMETRIC DRAWING
(top) This illustration reveals the inside space of a 24-foot
Airstream, 1964.

WALLY BYAM WEARING THE BLUE BERET
(right) The Blue Beret cap was a good way for Airstreamers
to find each other while visiting large open markets and
villages. The *Blue Beret* is now the name of the WBCCI's
magazine on caravanning.

Widely recognized as the father of modern trailer travel, Wally Byam made a career of overcoming public opinion to ensure that his dream of free and comfortable travel made accessible to all would become a reality. He must have smiled to himself when in 1937, at the beginning of the explosive trailer boom, *Fortune* magazine was forced to take notice, commenting on the industry's early innovators:

> "Small men, most of them, mousetrap makers startled by the customers banging at their doors, they have no exalted ideas about converting homeowners to nomadism . . . They want the trailer to be a vehicle, not a permanent address."[1]

If anything Wally was the embodiment of exalted ideas, taking a do-it-yourself backyard enterprise in the late 1920s to what *ID* magazine, a periodical devoted to contemporary industrial design, recognized in 1999 as a company bearing one of the top forty industrial design concepts in North America, whose greatest achievement is, quite naturally, aerodynamic living. An Airstream trailer is so well designed

"We are facing a movement of population beside which even the Crusades will seem like Sunday school picnics."

Gilbert Seldes, 1930

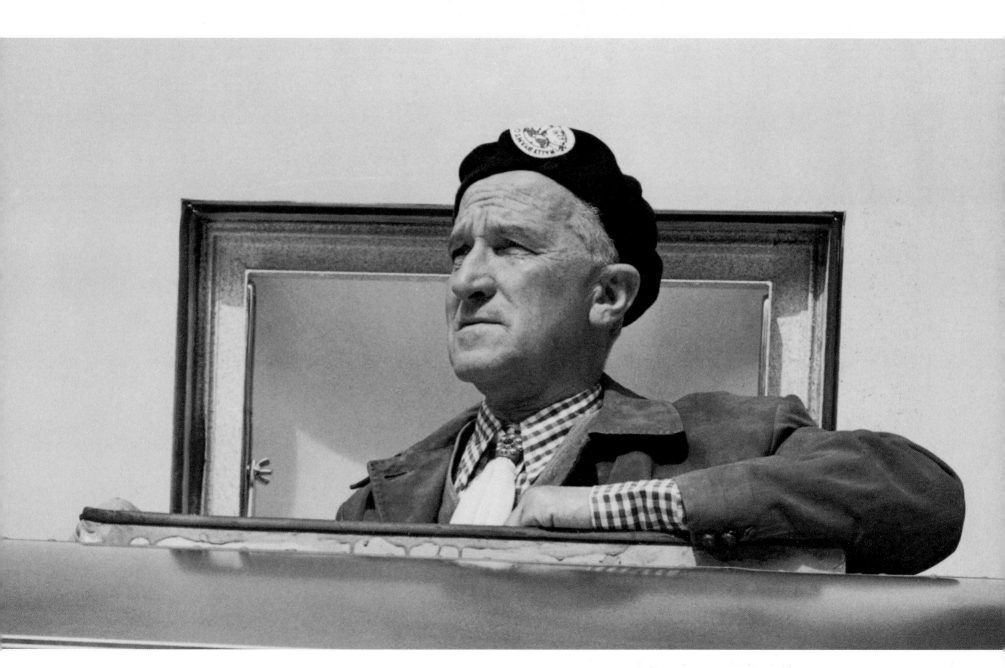

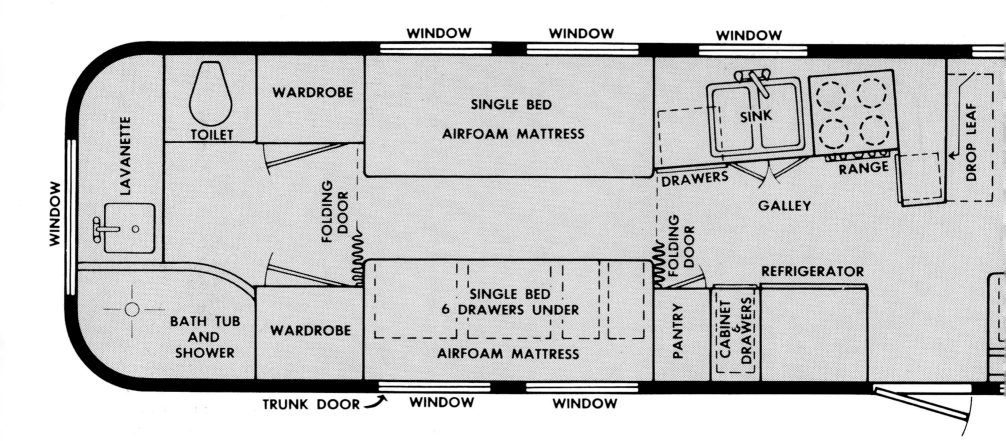

WINDOW WINDOW WINDOW

WINDOW

TOILET

WARDROBE

SINGLE BED
AIRFOAM MATTRESS

SINK

DROP LEAF

LAVANETTE

DRAWERS

RANGE

GALLEY

FOLDING DOOR

FOLDING DOOR

REFRIGERATOR

BATH TUB
AND
SHOWER

WARDROBE

SINGLE BED
6 DRAWERS UNDER

AIRFOAM MATTRESS

PANTRY

CABINET & DRAWERS

TRUNK DOOR

WINDOW WINDOW

AIRSTREAM FLOORPLAN
(above) Diagram shows the layout of a 30-foot Airstream
"Sovereign" twin. This unit was built for travelling not only
in style, but comfort.

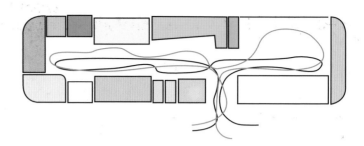

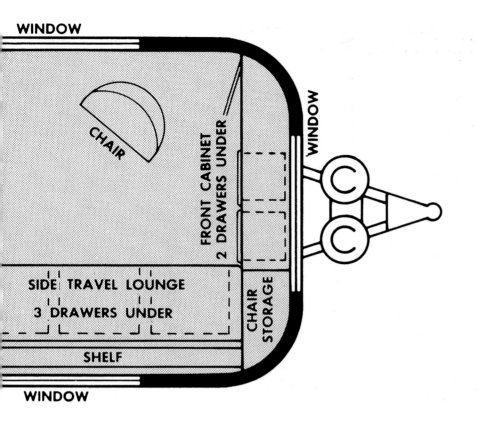

WINDOW

CHAIR

FRONT CABINET
2 DRAWERS UNDER

WINDOW

SIDE TRAVEL LOUNGE

3 DRAWERS UNDER

CHAIR STORAGE

SHELF

WINDOW

that it competes not with other products, but other lifestyles; it is a quantum leap from the trailer's humble beginnings as a glorified trunk or luggage rack propped up on the flatbed of a stripped-down chassis.

While early advertising copywriters traded on the romantic pioneer vision of the covered wagon, the first trailers actually grew out of the necessity for storage, not manifest destiny. As camping equipment spilled off roofs and out of strapped down trunks, the need for a place to stow one's gear drove some tinkerers to build small wagons. Wally describes his own first experiment in the late 1920s, as a "crude, boxy structure which rested none too easily upon a Model A Ford chassis, little more than a bed you could crawl into, a shelf to hold a water bottle, a flashlight, and some camping equipment . . . protected from the elements." Legend has it that he built his own trailer in response to his wife's refusal to go camping without her kitchen. From this point forward, Wally would beta test his own products, seeking ever-higher levels of comfort and convenience based on his own experiences on the road.

Design innovations, however, were secondary in comparison to the massive demographic shifts that were sweeping the nation as a result of the Great Depression. At the height of this economic collapse, the cultural critic Gilbert Seldes remarked, "We are facing a movement of population beside which even the Crusades will seem like Sunday school picnics."[2] Wally Byam set himself up to be

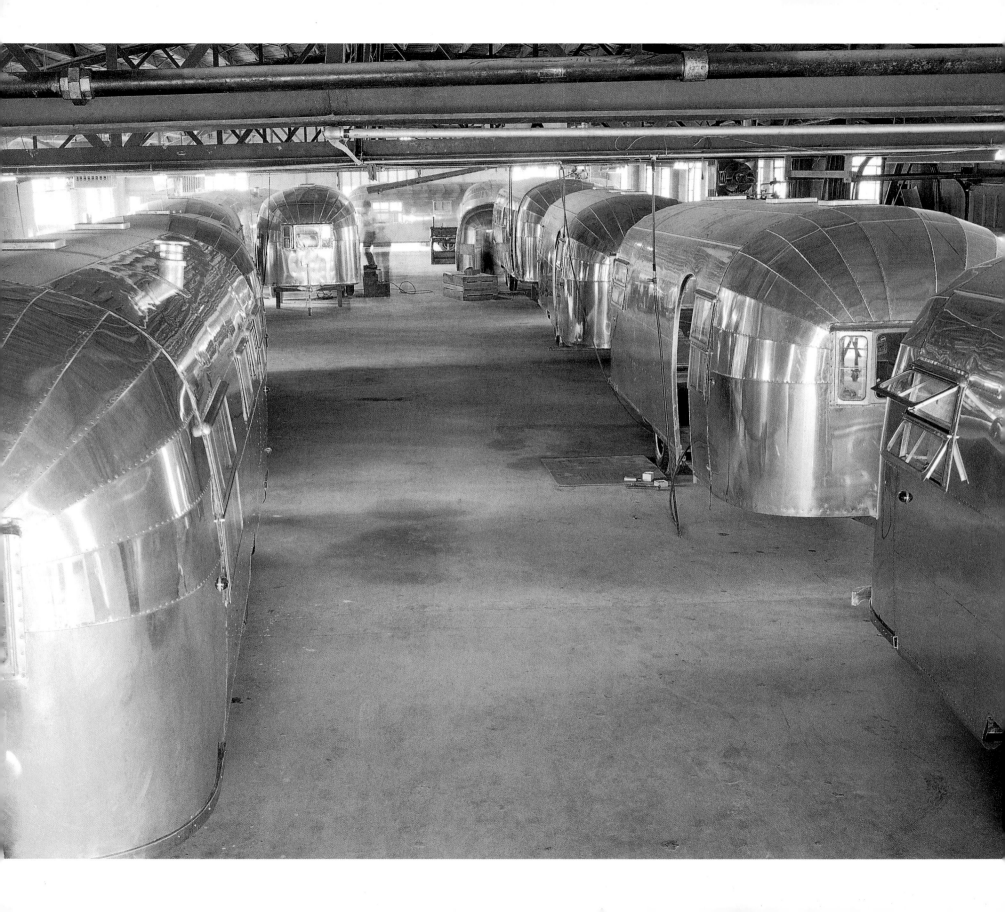

An Airstream trailer is so well designed that it competes not with other products, but other lifestyles.

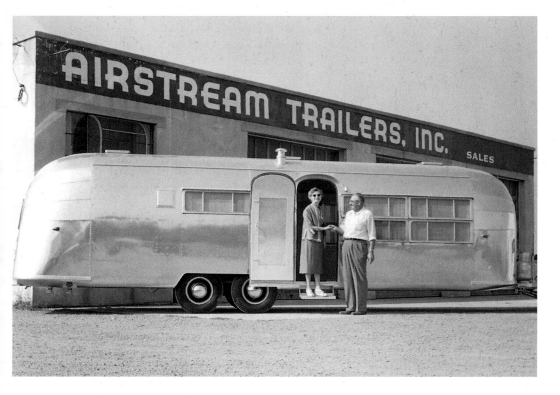

AIRSTREAM FACTORY
(left) Trailer frames hang suspended before being attached to the floor and frame.

OUTSIDE THE FACTORY
(above) Another happy customer. This couple ordered the trailer, specified the interior surfaces, and were able to stop in while the factory workers fabricated the trailer to see the progress.

the leader of this movement. He saw early on that the legions of wheat harvesters, cotton pickers, journeymen mechanics, and factory workers migrating from job to job, like the Joad family of John Steinbeck's *The Grapes of Wrath,* were seeking a simpler, low-cost alternative to the skyrocketing rents of the city. Though Wally saw the potential for sales among these disenfranchised groups, he discouraged "living" in a trailer, championing instead the notion of the travel trailer. By the middle of the jazz age, while many crowded the juke joints and speakeasies hoping to wait out the Depression, Byam foresaw a population eager to take to the road to let out its pent-up war-time tensions.

This dream so captured the public imagination that Sinclair Lewis fictionalized it in his 1929 novel *Dodsworth.* Sam Dodsworth, a visionary in the mold of Henry Ford, is dubbed a crank for raving about the beauty of "streamlines." He dreams of:

> "land yachts, of a very masterwork of caravans: a tiny kitchen with electric stove, electric refrigerator; a tiny toilet with showerbath; a living-room which should become a bedroom by night—a living room with radio, a real writing desk; and on one side of the caravan, or at the back, a folding veranda. He could see his caravanners dining on the veranda."[3]

But if ever there was a volatile industry, trailers were it. Without market research to determine who would buy

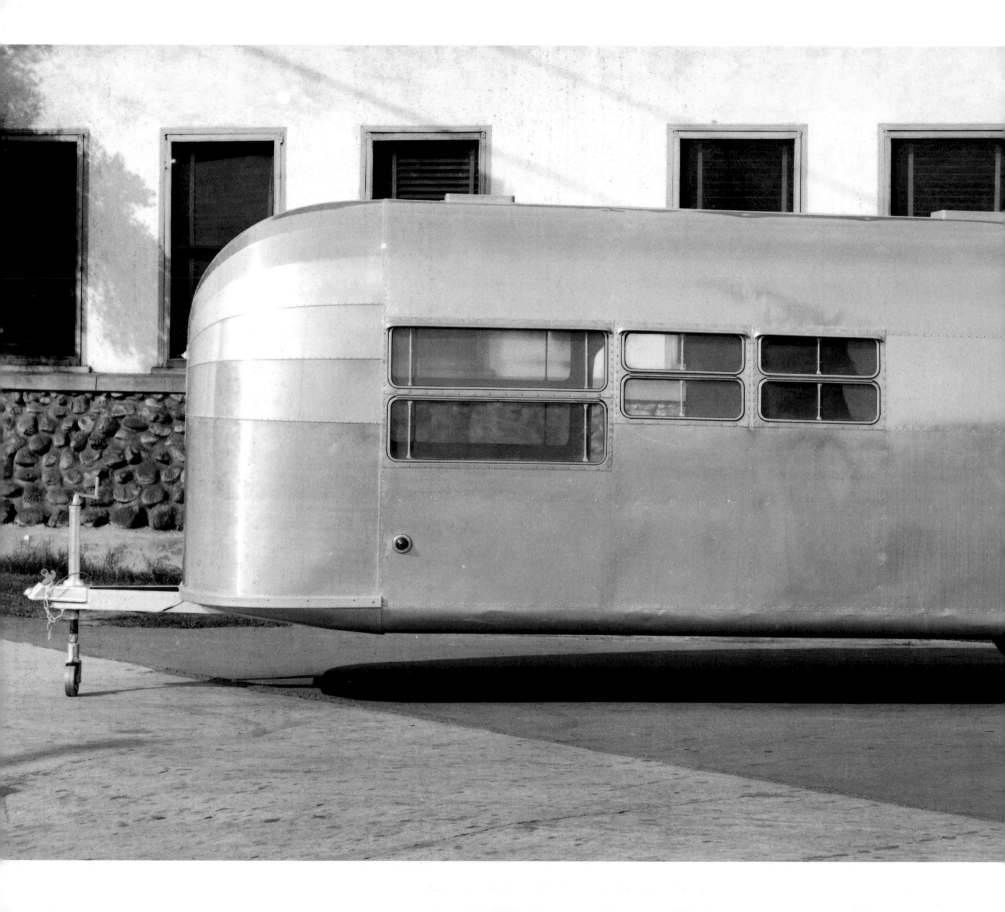

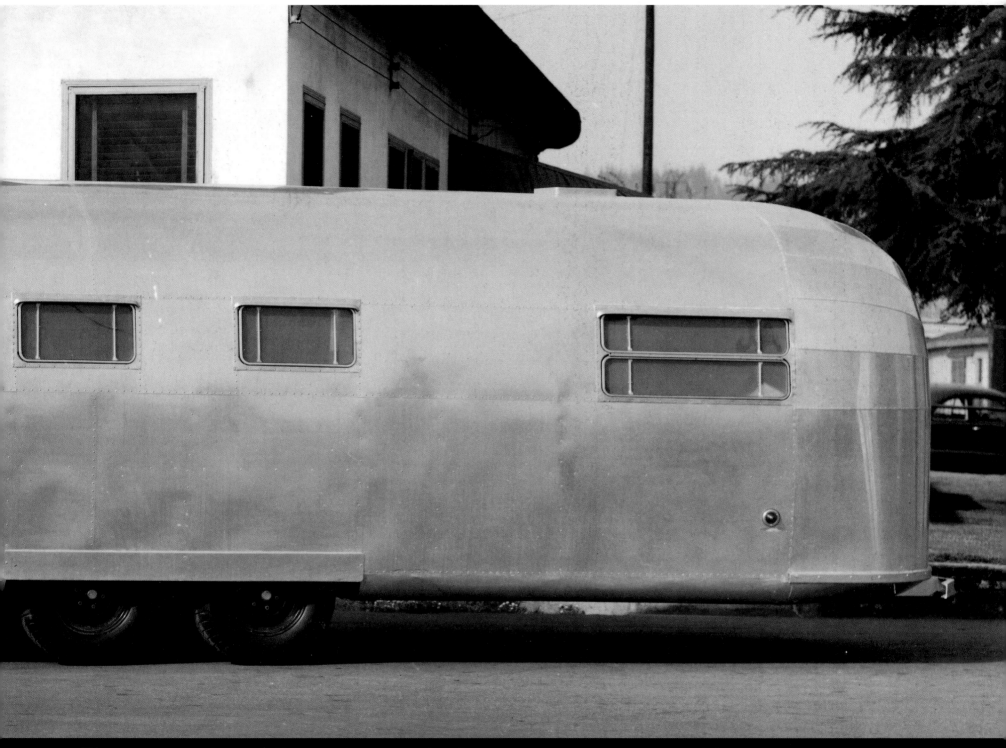

They want the trailer to be a vehicle, not a permanent address.

AIRSTREAM'S AMBASSADOR (above) Despite the 30-foot length, this unit was designed to travel, not stay put.

new

AIRSTREAM **safari**

GIVES YOU EVERYTHING YOU WANT IN A TRAVEL TRAILER

AUTO TRAILER EXCHANGE
8526 S. Figueroa St.
Los Angeles 3, California

BOYER TRAILER SALES
6668 Long Beach Blvd.
N. Long Beach, California

GILLESPIE TRAILER SALES
950 E. Foothill Blvd.
Claremont, Calif.

PULMOBILE TRAILER
SALES
4563 San Fernando Rd.
Glendale, California

SPERRY TRAILER SALES
9921 E. Garvey Blvd.
El Monte, California

SEE AIRSTREAM AT
THESE FINE DEALERS

Yes, everything you ever wanted in a travel-trailer...at a price YOU easily can afford! Unique in its self containment, with its own built in water supply and lighting, the new Airstream SAFARI gives you complete independence on the road. Here at last, and at a popular price, is a travel-trailer that is sumptuously roomy on the inside and gracefully compact on the outside; lightly maneuverable, yet battleship strong. The new SAFARI is a real Airstream from hitch to bumper.

FEATURES! 10 feet Panoram Window • Twin Beds • Convertible Dinette • Complete Galley • Separate Toilet Room • Own Light & Water

AIRSTREAM ADVERTISEMENT
(above) Airstream advertised in several travel-related magazines, including *National Geographic*, which wrote about Airstream caravans in the late '50s and '60s.

PIER TRAILER PARK
(right) The glory of mobile living allowed for some unusual locations to stay. Word spread from traveller to traveller and many would stay in specific locations for months and years.

If ever there was a volatile industry, trailers were it.

them, focus groups to see if they actually worked, or polls to chart their popularity, the trailer industry was a high risk enterprise—the high-tech start-ups of the day, minus the venture capital. In 1932, there were less than forty-eight trailer manufacturers; but by 1936, that number had grown to eight hundred, only to dip back down again to around forty in 1940. They were mostly backyard entrepreneurs eager to capitalize on high-profile predictions made by economic sages like Roger Babson, who had previously warned of the market crash of 1929. In 1935, Babson boldly proclaimed, "200,000 trailers will swarm the roads this spring. Whether they betoken a New Way of Life or a plague of locusts is something that makers, taxpayers, hotelkeepers, and lawmakers are quietly disputing. This much is certain: trailer making is becoming a $50 million industry."[4]

Although engineers and vacationers alike were enthralled by the transatlantic flight of the *Spirit of St. Louis* in 1927, the "Lindbergh boom," with its emphasis on healthy design principles such as low weight and streamlined simplicity, had yet to take effect. A template for "organic design" that merged the harmony of nature with structural dynamics seemed inevitable, but proved to be elusive. As a result, in the late 1930s, *Automotive Daily News* reported 160,000 trailers on the road, only 35,000 of which were factory built.

Detroit's failure to take notice of the growing popularity of the trailer didn't stop the rest of the Midwest from becoming a hive of activity. Elkhart, Indiana, became the epicenter of

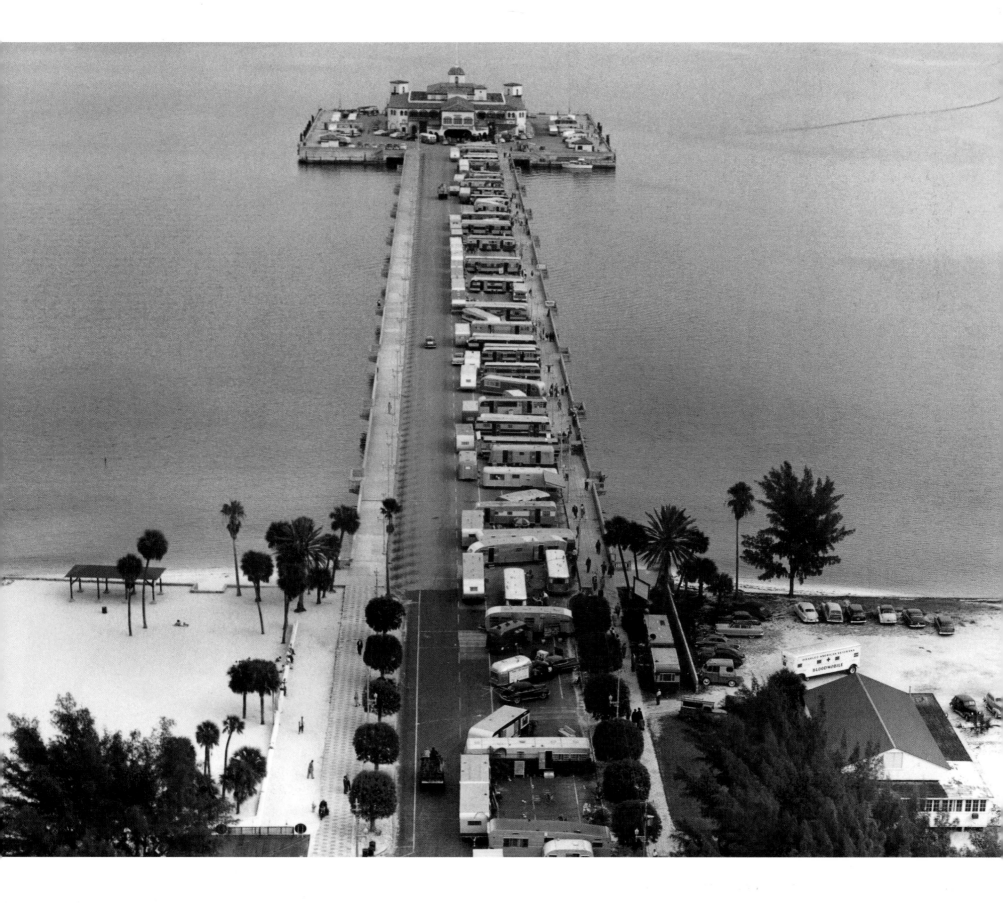

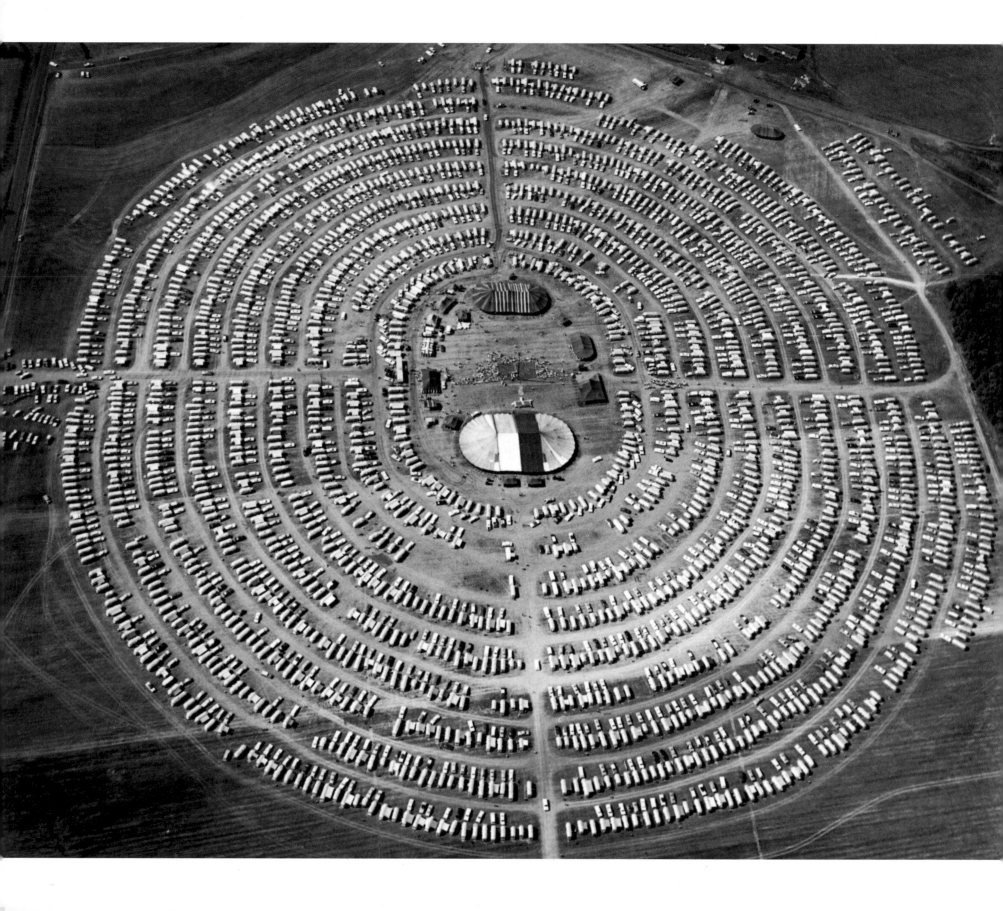

the industry, followed by Wisconsin and Illinois, while in California, production was concentrated in the "island industry" of Los Angeles. From the beginning East Coast trailers differed from their West Coast counterparts in shape, construction, and modes of distribution. Both made it through an extended adolescence to experience the business's second big growth spurt.

By the mid-1930s trailers were being used as mobile showrooms for salesmen to hawk their wares. Kelvinator, General Electric, RCA, and Singer Sewing Machine all converted trailers into portable showrooms, and products as diverse as Victor radios, Kingfisher fishing tackle, and Madam White cosmetics all took advantage of the trailer as readymade display case—packing and unpacking made obsolete. *McCall's* magazine went so far as to spend $12,000 on a thirty-two-seat movie theater that traveled the country as a literal "promotional trailer."

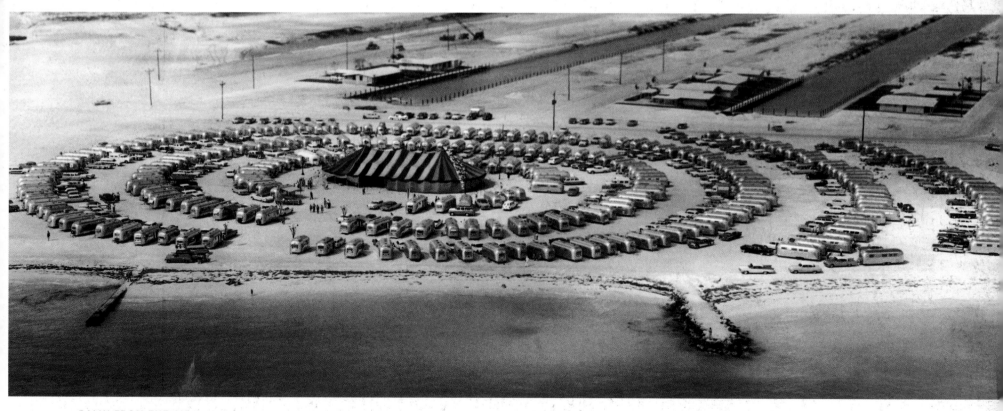

RALLY FROM THE AIR
(left) Airstream rally formation, Auburn, Washington, 1962.
(above) Airstream rally formation, Florida coast, 1960.

"Keep your eyes on the stars, and the stars in your eyes . . .

see if you can find out what's over the next hill, and the next

one after that."

Wally Byam

EUROPEAN CARAVAN
(right) Touring through Italy.
Leaning Tower of Pisa in background.

WALLY BYAM CARAVAN CLUB
(above) Emblem of the club showing
Wally wearing the famous blue beret.

It doesn't take a degree from Wharton to see that the forced savings and shortage of consumer goods required during World War II translated into a huge buying binge on the part of the American people. Trailers were being swept up left and right to solve the housing shortage created by the leap in wartime marriages. Universities began to use them to house the surplus of students returning to campus to study under the G.I. Bill. And as soon as the trailer strayed from its initial use as a vehicle for sportsmen and tourists, a tool for leisure and travel, the floodgates of possibility swung wide open.

At the height of the trailer boom, the U.S. Army Medical Corps purchased fifteen Airstreams for use as rolling hospitals, while state and federal agencies enlisted the trailers for everything from bookmobiles and tuberculosis X-ray units, to housing for forestry patrols and education centers. Even religious organizations saw their potential for use as rolling pulpits to spread their missionary fervor.

The trailers of the 1930s and 1940s possessed the building blocks of self-contained living—electricity, running water, a marine-style toilet, and a stove or range—but none of this is any good while you are cruising down the highway in the tow car. Eventually you have to pull over for the evening. Gas station owners stood waiting for these "gasoline Bedouins," offering their vacant back lots for tired motorists and charging twenty-five cents a day to plug in to electricity and hook up taps for water. These informal

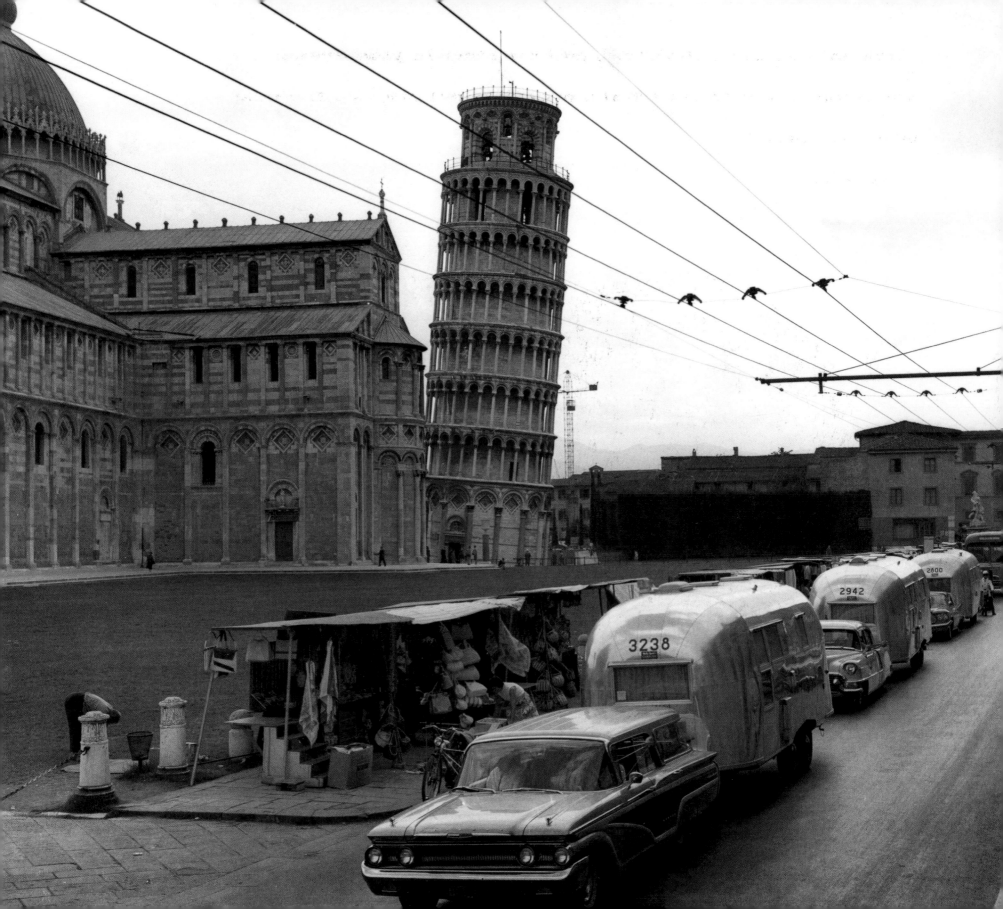

Why the name "Airstream"?

Because it rode along the highway,

"like a stream of air."

spaces became the first trailer parks, and some people never got back on the road, unhitching their tow cars to escape tax collectors and landlords forever.

With all this growth, legislative backlash was inevitable. The American Association of Motor Vehicle Administrators declared in the 1930s that trailers threatened to become "the greatest menace on the road." In 1937, it was estimated that ten thousand laws would come in front of city, state, and federal legislators to regulate trailers—everything from simple safety measures tied to brakes and lights to sanitation conditions in trailer camps, which were already being decried as "crowded rookeries" and "itinerant flophouses."

At $65 a month (the total cost including food and utilities) for the average stay in a trailer camp, and with no threat of property tax in sight, so-called "builders" clamored to put together "trailers" knowing they would never be subjected to the rigors of the open road to test their frames and fixtures. Since a trailer could not be held to the standards of a house, building inspectors were powerless to condemn flimsy wiring, plumbing, and construction. This marked the inauspicious birth of the mobile home in the early 1940s, a "vehicle" primarily designed to move only once or twice after leaving the dealer, yet one whose disreputable image was destined to shadow the trailer wherever it rode.

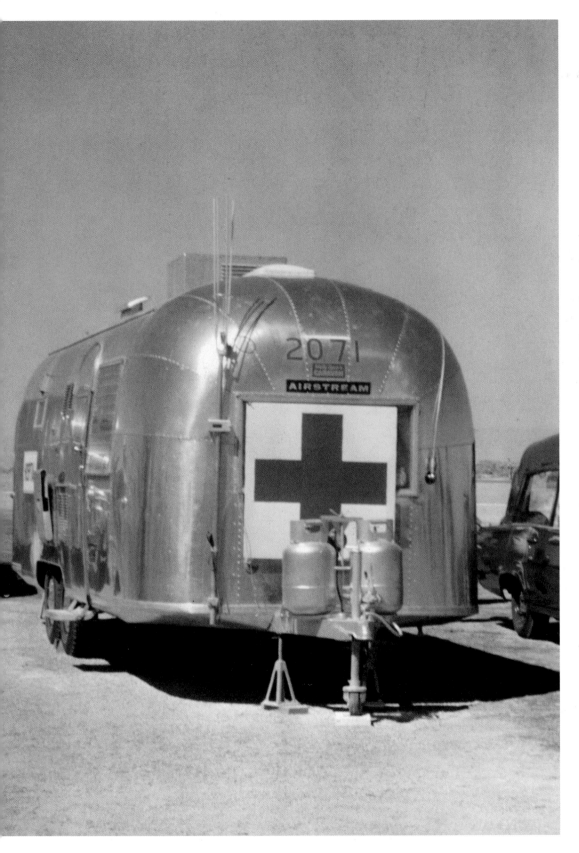

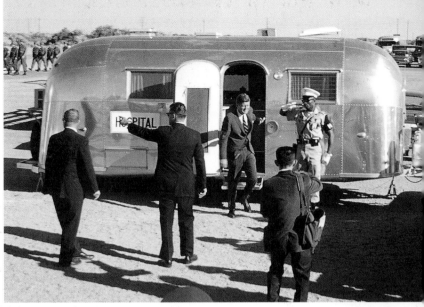

JFK INSPECTING THE HOSPITAL
(top and left) Airstream Inc. worked with the military, creating specialized mobile hospital units and quarantine units to house astronauts returning from space.

CIVIL DEFENSE ATOMIC TEST
(above) This trailer took part in the famous 1955 "Doomtown, U.S.A." Civil Defense Test in Nevada, and was subjected to the explosive force of an A-bomb device detonated at only 1.9 miles away. Total damage was one small body dent and two broken windows.

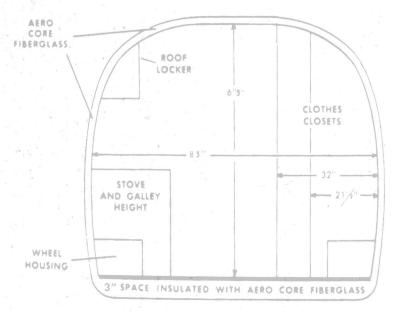

CROSS SECTION

AERO CORE FIBERGLASS

ROOF LOCKER

6'5"

CLOTHES CLOSETS

85"

32"

21½"

STOVE AND GALLEY HEIGHT

WHEEL HOUSING

3" SPACE INSULATED WITH AERO CORE FIBERGLASS

Wally Byam once said, "We are determined to improve our 'public image,' as the boys on Madison Avenue say, so that people change their absurd notion that we are homeless gypsies." The myth of the trailerite as a rootless hobo, or "tin can tourist," was bad enough without the stigma of the mobile home to compound the problem. Airstreamers have been paying for the sins of their ignoble cousin in the media ever since.

As Carol Burch-Brown explains the mobile home distinction in her book *Trailers:* "Their campiness is oddly resistant to nostalgic idealization. Although (house) trailers are ubiquitous in our communities and countryside, they do not appear in our iconography of tastefully worn dwellings and colorful subcultures, except as a sign of otherness."[5] That is to say, their alien and desolate quality remains taboo in popular culture.

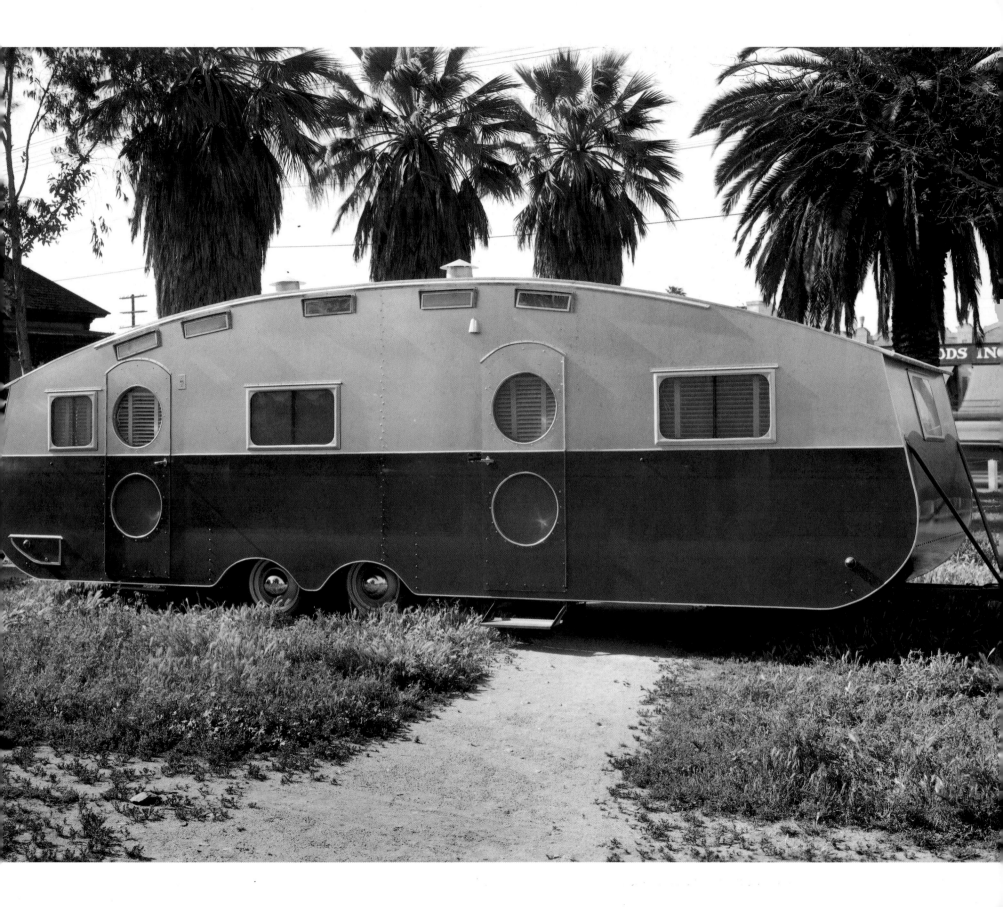

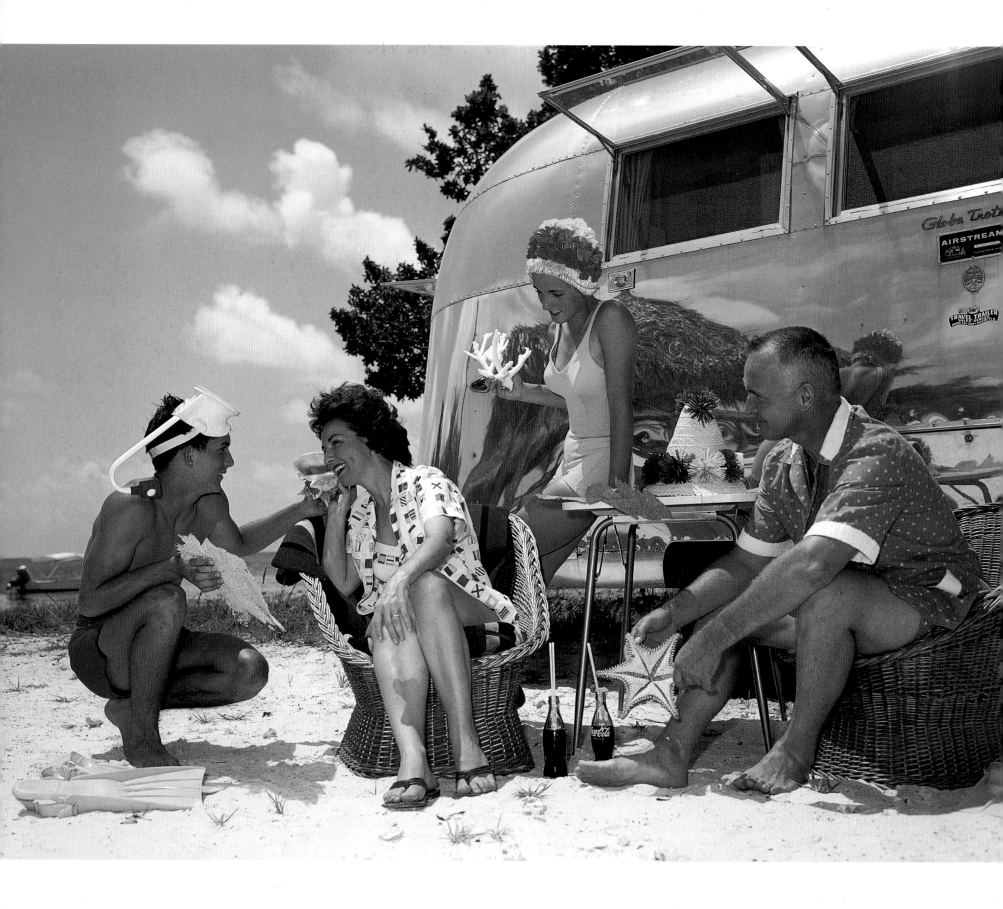

> ## "We are determined to improve our 'public image,' as the boys on Madison Avenue say, so that people change their absurd notion that we are homeless gypsies."
>
> Wally Byam

So what exactly differentiates an Airstream from other trailers? Why is an Airstream considered a family heirloom to be passed down to the grandkids, while you'd be lucky if your Winnebago gets credit on a dealer trade-in? Why is the typical Airstream owner in his vehicle twenty-eight weeks out of the year, while other RV owners spend four? The answer goes back to the Airstream caravans and the sense of community they instill in their members.

In his book, *Trailer Travel Here and Abroad,* Wally Byam noted, "While I organized and led nearly all the expeditions described in these pages, I appreciate better than most that a quarterback does not make a football team, nor one man a caravan."[6] He wasn't just describing the group effort so necessary to accomplish his goal of spreading "person to person" diplomacy to the "four corners of the world" as embodied in the legacy of the Wally Byam Creed, but the feeling of shared pleasure through hard work and self-reliance that shaped, and has continued to shape, the core desire of those that feel, as Wally does, that "it is better to wear out than rust out."

That desire is symbolized in the Wally Byam Caravan Club International (WBCCI), which was founded in 1955 to bring international caravanning to the United States on a local, year-round basis. The club's values are best expressed in the story of the blue beret that each member sports as a proud moniker of inclusion. In 1951, Wally led a caravan of a hundred people to Managua, Nicaragua,

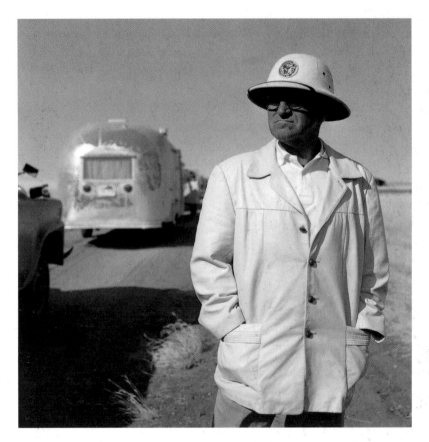

"It is better to wear out than rust out."

Wally Byam

AIRSTREAM IN THE '90S
(far right) The new Airstream models have evolved into highly sophisticated trailers, appealing to independence and freedom with modern conveniences.

ETHIOPIA
(right) Caravanning through Africa, 1963.

and needed a way to identify members of the crew quickly in a large crowd. He decided on the soft, woolen beret he had seen people wear on his trips to Europe—a uniform of sorts, but one that allowed for different ways of wearing it to suit the individual; formal enough for church, yet convenient enough to fit in your back pocket.

Wally never confined his vision to the bottom line. Described by the press as a "man in motion, a mover of people and things," and as a fast-talking Californian who was "jolly and indefatigable," he spent six months out of the year leading caravans everywhere from the exotic ruins of Persia to the jungles of Angkor Wat. And it was all business, so to speak. Since the Airstream motto was "Let's not make any changes—let's make only improvements," Wally was never fixated on next year's model or what the competition was doing. He considered the swamps of Central America to be his studio, laboratory, and testing ground all in one. Imagine Lee Iacocca

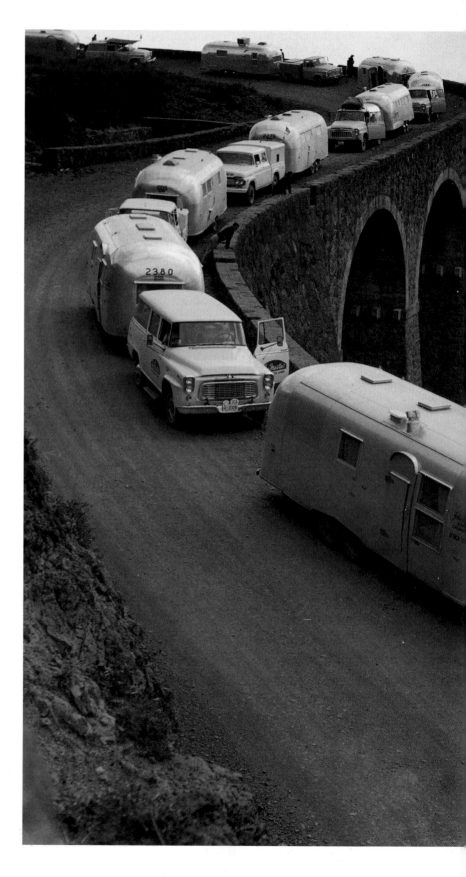

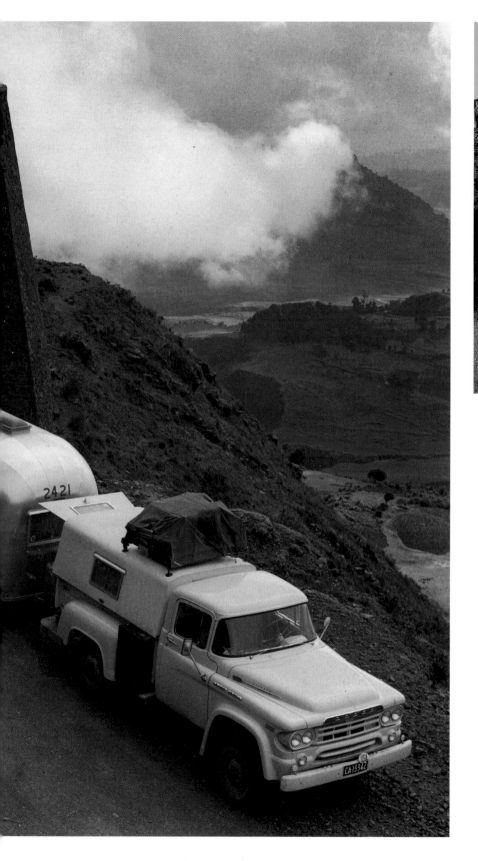

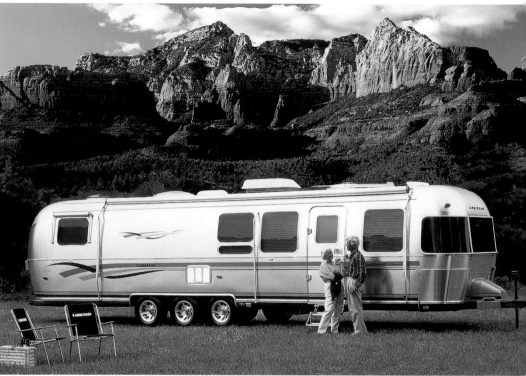

standing by to lend a hand when your Chrysler gets a flat and you'll have some idea of how this worked.

Caravanning may be based on the old covered wagon theory of "safety in numbers," but at its heart it is a deep longing to be free from the cares of the world, beholden only to one's whims. This is a difficult concept to convey in words in an age when the phrase "carpe diem" is just another strategy to sell products. No doubt, Airstreamers may express their brand loyalty in upgrades of newer models, but it's a loyalty that grows out of a commitment to each other, not from an urge to have the latest toy on the block. As Wally wisely counseled, "Keep your eyes on the stars, and the stars in your eyes . . . See if you can find out what's over the next hill, and the next one after that."

Wally clearly mapped out his vision of adventure, not in an annual report or shareholders' meeting, but as oral history expressed in what he called "the four freedoms," which he laid out in *Trailer Travel* (listed on following page).

THE FOUR FREEDOMS

Freedom from arrangements–reservations, schedules, taxis, tips. "You don't have to worry about reservations in the next town or where you are going to sleep that night. You have all your accommodations right there with you. Home is where you stop."

Freedom from the problems of age–"For some, checkers, clubs, gardening, and grandchildren is not enough. Out of this boredom, ailments are born."

Freedom to know–"You meet people on a train or a plane and the next day you separate. When you travel in a trailer, you meet people in their homes and they meet you in theirs."

The first three freedoms add up to the fourth, the **Freedom for fun.** "To relax and lose yourself mentally."

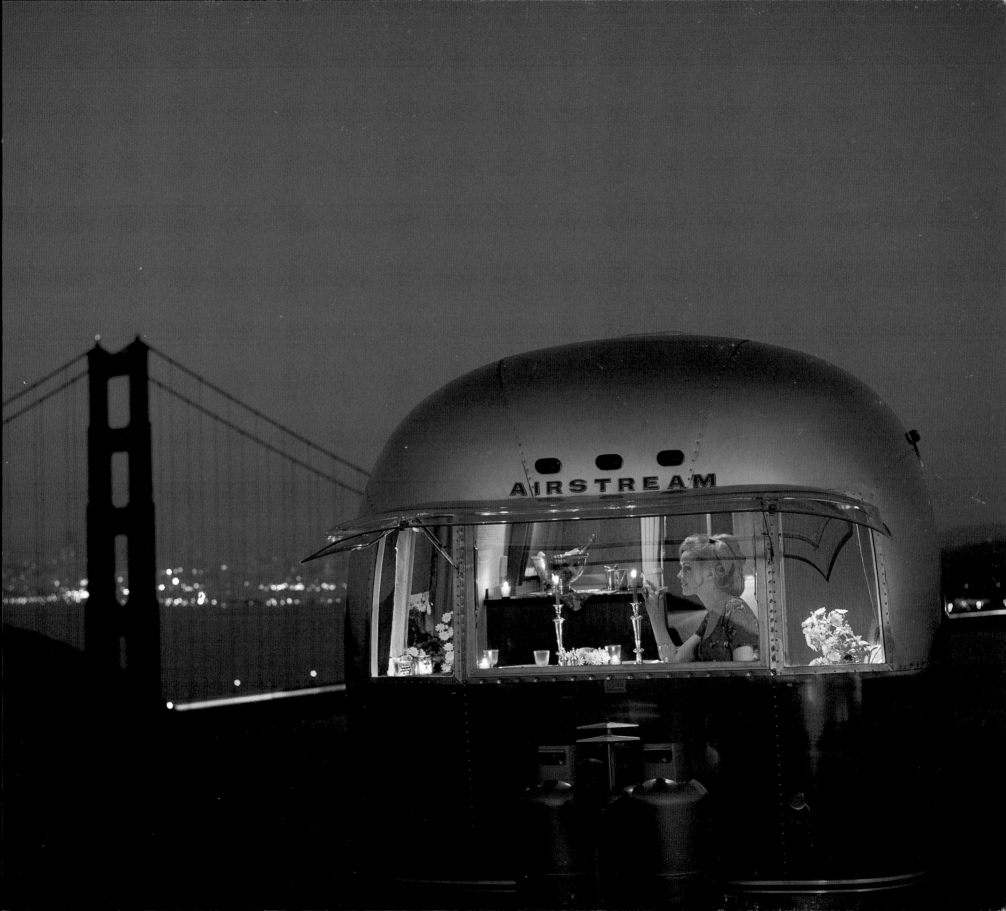

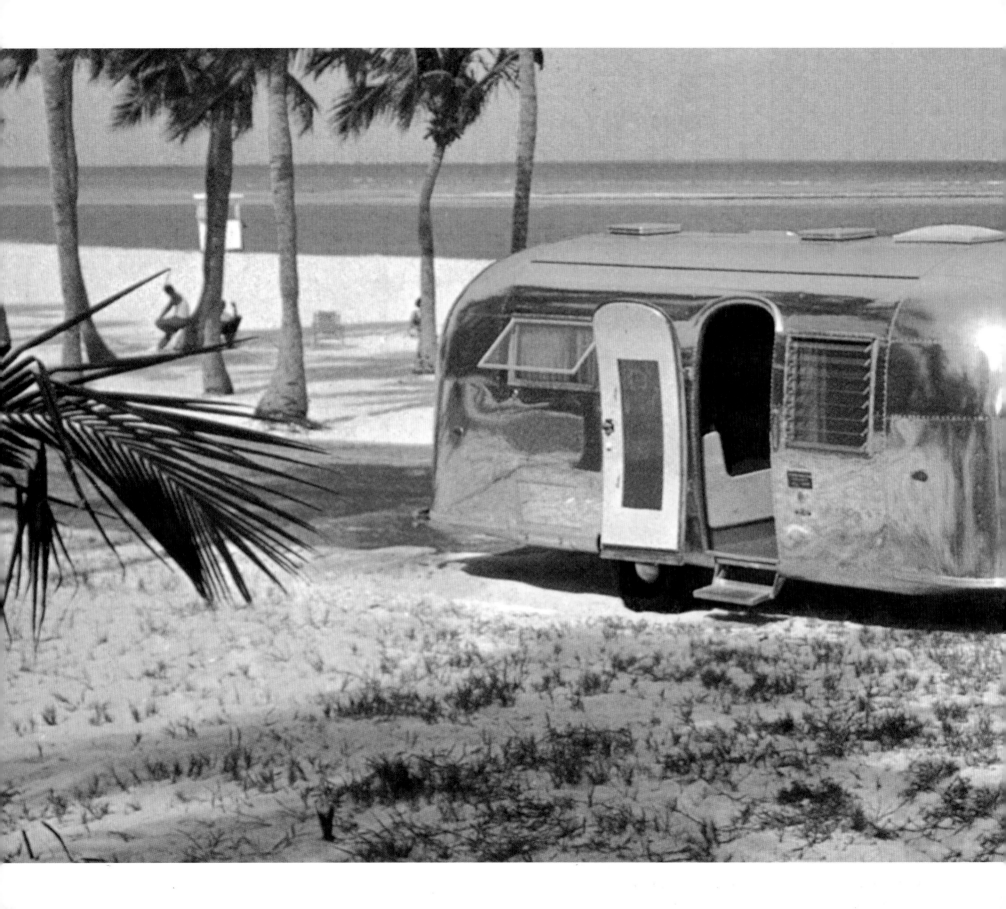

ADVERTISEMENT Image from Airstream brochure. Florida, 1964.

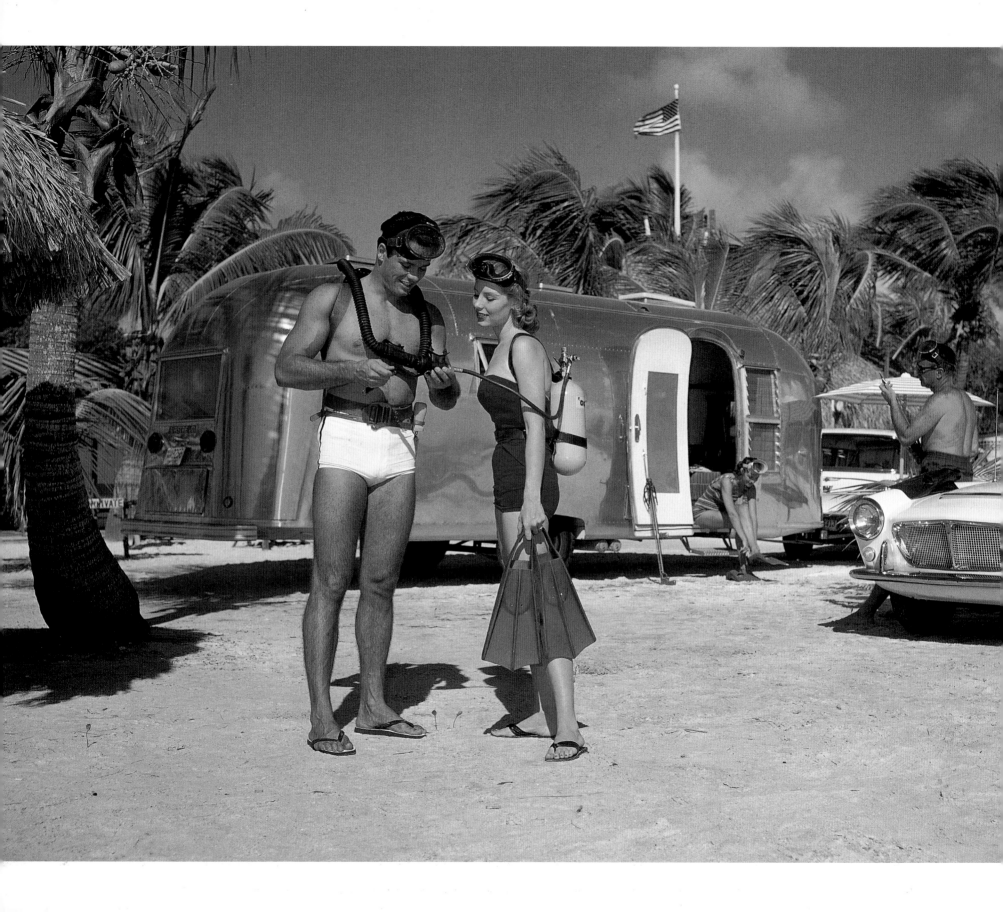

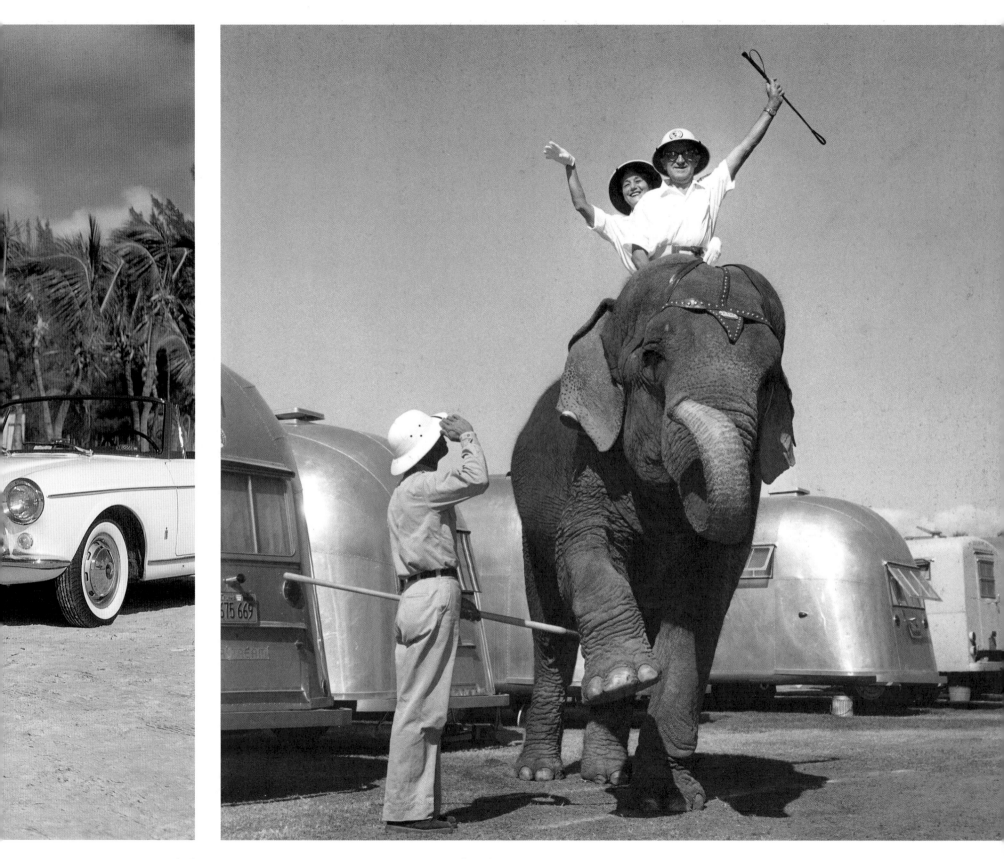

ADVERTISEMENT (left) Another image of leisure advertised in an Airstream brochure. (above) Wally and Stella promoting the African Caravan at a Palm Springs Rally, 1957.

"Let's not make any changes—

let's make only improvements."

Wally Byam

WEARING THE MEXICAN SOMBRERO
(far left) Wally living it up in Oaxaca, Mexico, 1956. The caravan leader conducts group meetings, covers the current schedule, tells travel stories, and shares information about the new surroundings. Wally also learned directly from these caravans how to improve the features and design of the Airstream.

AROUND THE WORLD CARAVAN
(left) Meenakshi Temple, near Madurai, India, 1964.

"TO PLACE THE GREAT WIDE WORLD AT YOUR

DOORSTEP, FOR YOU WHO YEARN TO TRAVEL WITH

ALL THE COMFORTS OF HOME."

Wally Byam, 1962

never leave well enough alone

It's practically axiomatic these days that a product is designed and marketed to appeal to the way it makes us feel, rather than what it actually does. The sensuous curves of a Porsche may turn heads on the freeway, but who actually needs all those horses kicking under the hood on a casual Sunday drive? Flashback to 1920 and the emergence of Machine Deco, a design term coined to distinguish it from French Art Deco and Art Nouveau, the precursor to the streamline aesthetic. In his 1951 autobiography, *Never Leave Well Enough Alone,* the industrial designer Raymond Loewy laid down the radical principles that made everything from his logos for Lucky Strike cigarette packs to toasters, Studebakers, and the signs for Exxon and Shell enduring cultural icons. His rounded radio cabinets and ovoid pencil sharpeners were originally dubbed "clean-lined" for their reduced visual complexity and emphasis on simplicity of operation; but as the first commercial designer to apply the flowing parabolic silhouettes of streamlining to regular household objects and appliances, he was chastised by critics for promoting a kitschy facade that disguised, rather than revealed, the function of the machine. Loewy wittily countered his detractors with the image of Betty Grable, quipping that her "liver and kidneys are no doubt adorable, though I would rather have her with skin than without."[7]

GLENN CURTISS'S EARLY TENT TRAILER
(left) Expanding out like a jewelry box, this camper brought all the comforts of home with it, making a good afternoon a great one (1921). This prototype lead Curtiss into his designs for the Aerocar. Photo: The Curtiss Museum.

1900

LZ1 Zeppelin
First flight of the *LZ1 Zeppelin* airship, which flew for 20 minutes.

Max Planck
Formulates quantum theory.

George Eastman
Invents Kodak Brownie camera.

1901

Frank Hornby
Designs and produces the Meccano construction toy.

Guglielmo Marconi
Transmits telegraphic radio waves across the Atlantic.

1902

Wilhelm Maybach
Produces the first Mercedes cars.

Georges Claude
Invents the industrial process of liquefaction of air.

Vladimir Ilyich Lenin
Publishes *What Is to Be Done?*

1903

J. C. Beidler
Invents the photocopying machine.

Wilbur and Orville Wright
Fly a gasoline-powered airplane, *The Flyer*, over Kitty Hawk.

Wilhelm Einthoven
Perfects the electrocardiograph.

1904

Panama Canal
Construction work begins.

Ultraviolet light
The first ultraviolet lamps hit the market.

Universal Exposition
Opens in St. Louis, Missouri.

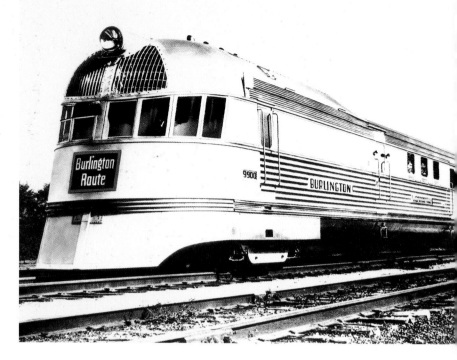

Strange that Loewy's design philosophy was embodied in the acronym MAYA (most advanced, yet acceptable) when everything from his personal style (custom suits and a pencil-thin mustache) to his blueprints for the *Princess Anne* ocean liner inspired by aircraft design, seemed to flout the conventions of the day. Loewy felt that stream-lining "symbolizes simplicity—eliminates cluttering detail and answers a subconscious yearning for the polished orderly essential."[8] He was offering a smooth, frictionless, machine-age future to cure a post-Depression hangover.

In fact, while Wally Byam was shipping off to sea as a cabin boy on a freighter touring the South Pacific (once jumping ship in Tahiti), corporations were commonly enlisting the aid of art school trained designers like Norman Bel Geddes to stimulate consumption. Bel Geddes's influ-ential book *Horizons* finally convinced executives at Chrysler to roll out the teardrop Airflow, later prompting Wally to select it as the tow car on his Airstream Incorporated business card. *Horizons* gloried in the beauty of the low-slung horizontal as a new design idiom, one that gained expression in the 1932 Locomotive Number 1. Based on the simple insight that "speed will increase as weight and wind resistance are reduced," it was the first train whose outer skin was as smooth as possible, eschew-ing protruding handles and keeping all windows flush.

These trains, or "streamliners" as they were called, were moving billboards advertising the merger of science and form to an eager public. In 1934, the Burlington *Zephyr* set a world record by travelling a thousand miles nonstop from Denver to Chicago. Two million people gazed at its bright, shiny, corrugated stainless-steel frame when it came to rest as an exhibit at the Chicago World's Fair. Its horizontal spot welding was a design feature that Wally took note of, later adapting it to his early Airstream rivet patterns. The *Zephyr* offered the total package—a trip in the lap of luxury whose interior design launched the modern furnishing style.

"We declare that the splendor of the world has been enriched by a new beauty: the beauty of speed," announced F. T. Marinetti in *The Futurist Manifesto* in 1909. "A racing automobile with its bonnet adorned with great tubes like serpents with explosive breath . . . a roaring motor car

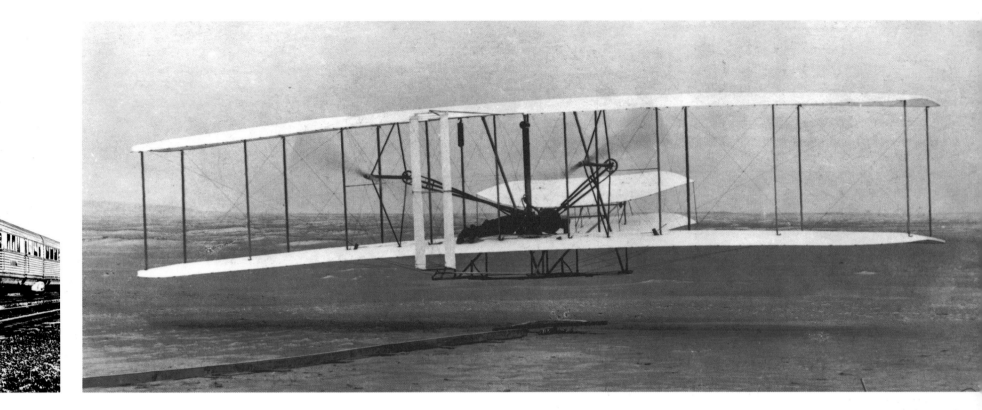

which seems to run on machine gun fire, is more beautiful than the Victory of Samothrace." Marinetti's somewhat overheated proclamation, which equated speed with a sort of sublime violence, jibed with the public's desire for newer and faster modes of just about everything, but it wasn't until later in the 1930s when the streamline style aestheticized speed that the concept become palatable to the average consumer.

Thankfully, designers were able to get the more ornamental extremes of streamlining out of their systems with designs for staplers, cameras, and gas pumps before settling on the reductive, flared forms that were essential in both the operation as well as the character of the planes, trains, and automobiles of the day. For a time, it seemed as if they had lost sight of the sleek and pointed prows that had given the Phoenician ships their aerody-

namic superiority, wallowing instead in a postwar urge for bigness that just looked bloated. The noted designer Egmont Arens lamented in 1936 that streamlining had become "designing for eye resistances, rather than wind resistances." Clearly, streamline would reach its pinnacle only with a return to utilitarian values.

Streamline's ideal formula is a formal compactness that lends static rigidity combined with a low weight and smooth, spherically shaped surfaces rendered in a bright, lightweight metal. This highly nuanced blueprint was more than a cosmetic repackaging of a good thing in the manner of, say, repositioning New Coke for a jaded pub-lic—it was less stumbled upon through corporate brain-storming than arrived at through extensive trial and error in wind tunnels and test flights. Engineers found inspira-tion in the sci-fi prose of Jules Verne used to describe

1905

Neon
The first neon light signs appear.

Motor buses
The first motorized buses debut in the streets of London.

Albert Einstein
Formulates the theory of relativity.

1906

International Exposition
Opens in Milan.

Sir James Dewar
Designs the first Thermos bottle.

1907

Hoover
Markets the electric vacuum cleaner for use in the home.

Louis Lumiere
Invents process for color photography.

August Musger
Invents the slow motion effect for film.

1908

Henry Ford
Designs and develops his Model T, the first mass-produced motor car (assembly line starts in 1913).

General Motors
The GM automobile Corporation is formed.

Adolf Loos
Publishes *Ornament and Crime.*

Peter Behrens
Designs and produces the electric fan, manufactured by AEG.

1909

Robert Edwin Peary
Reaches the North Pole on April 6.

Filippo Tommaso Marinetti
Publishes *The Futurist Manifesto.*

Sigmund Freud
Writes *Introduction to Psychoanalysis.*

Captain Nemo's *Nautilus* in *20,000 Leagues Under the Sea* as much as the wraparound lines of the *Graf Zeppelin* built in 1928 or the *Hindenburg* dirigible, the first streamlined airship that hit the scene in 1919:

> "The fact was that for some time a number of ships had been encountering on the high seas, "an enormous thing," described as a long, spindle shaped object that was sometimes phosphorescent, and infinitely larger and faster than a whale . . . The blackish back that supported me was smooth and shiny, without any overlapping scales. When one tapped it, it made a metallic sound, and however incredible it might seem, it appeared to be made out of riveted plates . . . Here we were, stretched out on the back of a sort of marine craft, which, as far as I could judge, was the shape of an immense fish, made of steel. I examined its surface to find some sort of open-ing, some panel, or a "manhole"—to use a technical expression; but the lines of rivets along the joints in the plates were quite firm, tight fitting, and uniform."[9]

The titles alone of the two most influential world's fairs of the period—Chicago's 1933 "A Century of Progress" and New York's 1939 "The World of Tomorrow"—captured a vision of utopian prosperity as surreal as Fritz Lang's *Metropolis,* and were even less grounded in the truth. Jetsons-like human conveyor belts, Bel Geddes's glass domed Futurama exhibit of a miniature Le Corbusian city, and Epcot-like recreations of European skylines seemed bent on persuading the public that prosperity was a short rocket-ship ride away. One critic noted that it was more

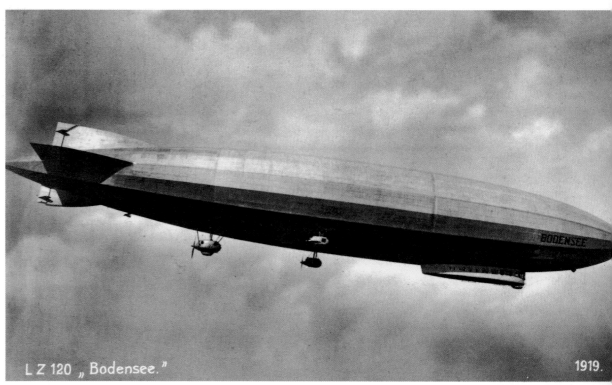

LZ 120 „Bodensee." 1919.

INTERIOR WIRING
(left) This photograph reveals the structural member of the trailer body being wired, before the inside skin is attached. A good example of Airstream's monocoque structure.

LZ-120 ZEPPELIN
(above) Precursor to *Graf Zeppelin* and *Hindenburg,* 1919. Photo: The Smithsonian Institution.

like "looking at Tomorrow and arriving mostly in the middle of Today." Nevertheless, the 1939 World's Fair became a potent and enduring symbol of a space age Shangri-la that Hollywood finds hard to resist even today.

Eager housewives and impressionable young inventors were not the only ones on hand when Westinghouse featured a seven-foot robot named Electro at the 1939 World's Fair that sang, danced, and smoked cigarettes, or when robot dogs, amphibious cars, and picture phones were displayed as the casual accessories of the new nuclear family. If Maybury was to be recast with a techno-spin, with Ward Cleaver commuting to work on newly envisioned elevated expressways and "moveable sidewalks," someone had to step in to provide the backstory to gradually ease a willing public into the twenty-first century, even though it was fifty years away. As always, the Hollywood dream factory was waiting, standing by with a slew of popular-culture

1909 (continued)

Louis Bleriot

Crosses the English Channel in an airplane.

1910

Henri Fabre

Successfully completes the first seaplane flight.

Michelin Tires

The first Michelin road maps of the United States roll off the presses.

Le Corbusier, Mies van der Rohe, and Walter Gropius

All work in Peter Behren's architectural practice.

1911

Radio transmitter

Is placed on top of the Eiffel Tower.

The *Titanic*

Sets sail on her maiden voyage, and sinks.

1912

Futurism

First Futurist exhibition opens in Paris.

Marcel Duchamp

Paints *Nude Descending a Staircase*.

Franz Kafka

Writes, *Metamorphosis*.

1913

Conveyor belt

Henry Ford uses a conveyor belt assembly line for the production of the Model T automobile.

Marcel Duchamp

Creates *Bicycle Wheel*, his first of many readymade sculptures.

Carlo Castagna

Designs the Alfa Romeo 20/30 for Count Mario Ricotti.

Leica Camera

Produces their first camera.

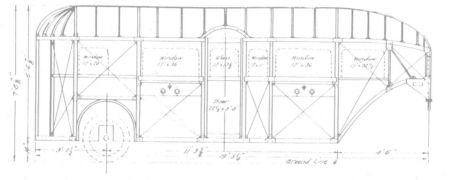

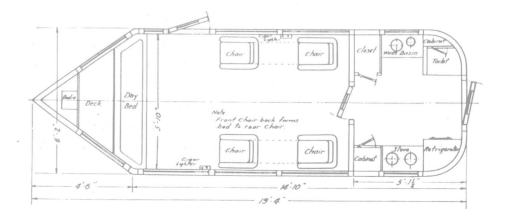

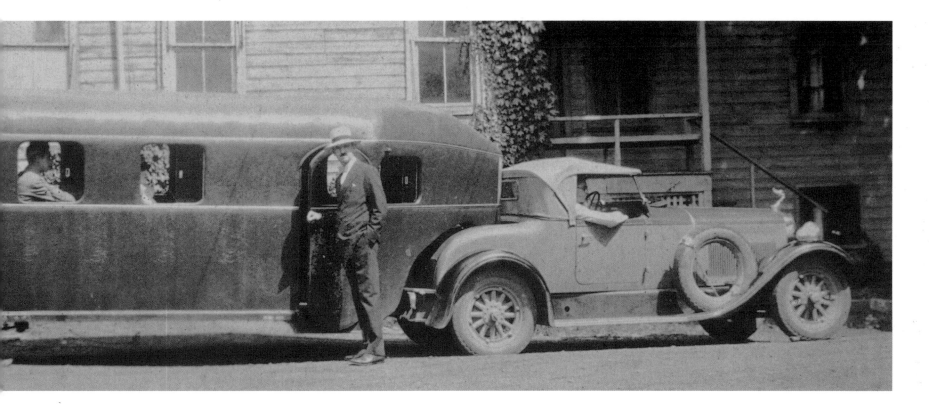

metaphors to be churned out in movies, books, and pulp magazines of the day—doling out slices of the futuristic pie. The widespread panic caused by Orson Welles's radio broadcast of the fictional *War of the Worlds* invasion put Hollywood on notice that the public was primed for filmic fantasias that exploited the fear and anxiety brought on by accelerated industrial growth and the sleek luxury goods that rolled off the expanding networks of assembly lines straight into the homes of a newly minted middle class.

Airstreams fit into this new stereotypical vision of a highly mobile, constantly shifting populace, one giddy and a bit bemused by its newfound wealth, but nevertheless eager to part with some greenbacks to participate in the movement. In films, slapstick and farce, holdovers from the days of vaudeville, seemed a comforting genre to bridge the gap between pragmatic Americans nursing their postwar wounds and the new products that would usher them into

bourgeois respectability. In 1950, Jimmy Stewart, reprising his role as the befuddled everyman who traded his existential doubt for comedic laughs in *It's a Wonderful Life,* starred in *The Jackpot* as a department store clerk who wins $24,000 in prizes on a radio call-in show called "Name That Mystery Husband." The winnings included a palomino horse, assorted jewelry and watches, and the pièce de résistance—a new Prairie Schooner trailer. Buried under an avalanche of gifts, and helpless to restore equilibrium to his previously tranquil, if a bit boring, former life, Stewart ends up pawning the gifts one by one—in the process regaining his dignity and the love of his family.

Four years later, Lucille Ball and Desi Arnaz starred in *The Long, Long Trailer,* and as the title suggests, it was. At forty feet and weighing over three tons, the trailer they purchase at a trade show prompts Desi to comment with exasperation: "I couldn't tell if I was pulling it, or it was

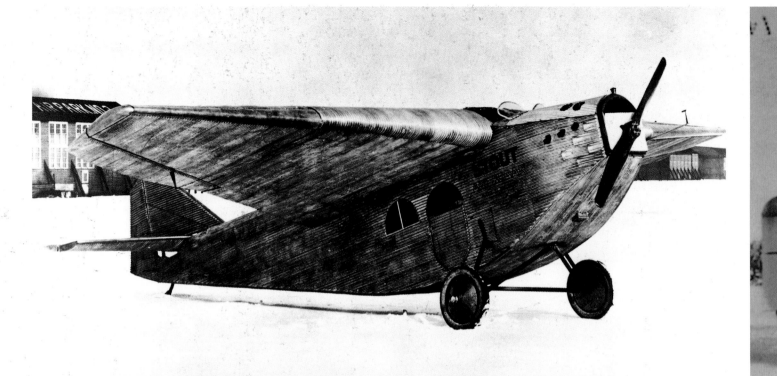

1913 (continued)

Umberto Boccioni
The sculptor fabricates *Unique Forms of Continuity in Space*.

1914

World War I begins.

Traffic lights
The first traffic lights appear in Cleveland, Ohio.

Le Corbusier
Develops his project for the Domino House.

Walter Gropius
Designs sleeping car compartment for Deutsche Reichsbahn.

1915

Duraluminum
Junkers make airframes using Duraluminum, a lighter and stronger aluminum.

World's Fair
San Francisco hosts the first World's Fair.

Alexander Samuelson
Designs the Coca-Cola bottle.

D.W. Griffith
Directs *Birth of a Nation*.

Henry Joy
President of Packard Motor Company builds his own trailer.

1916

Dada
Birth of the Dada movement in Zurich.

Robert Andrews Millikan
Measures the charge of an electron.

1917

Theo van Doesburg
Founds the group and the journal *De Stijl*.

Charlie Chaplin
Appears in the silent film *The Immigrant*.

pulling me." The movie begins on a rainy night in the lodge of the Laramie Trailer Court as Desi recounts through flashback a series of misadventures that includes parallel parking, pulling the hefty trailer up a steep incline, and trying to fry an egg on a tilted stove as the trailer teeters to the side, stuck in the mud.

The two set out on their honeymoon, straight from the chapel to the trailer, and throughout their madcap crosscountry trip—part *Honeymooners,* part *On the Road*—they rediscover their love for each other despite the perils of highway living. *The Long, Long Trailer* is unique in that most of the action takes place inside the proscenium stage of the trailer's compartmentalized rooms or behind the wheel of their giant Buick tow car, the trailer looming like an encroaching semi in the background. When Lucy and Desi sing a duet of the ballad "Trailing and Roaming," they seem to forget their troubles for

a moment, capturing that ideal state of freedom.

While Hollywood and heavy industry were teaming up to serve this fairy tale to an eager public, renegade inventors more in the mold of Thomas Edison and Alexander Graham Bell were toiling in obscurity, biding their time until the lifestyles of the masses caught up with their new vehicles for leisure. Wally Byam had just graduated from Stanford University in 1923 with a degree in law, but set his sights on a career in journalism, first starting off as a cub reporter and then becoming an advertising copywriter for the *Los Angeles Times.* He later started his own publishing venture whose first success was a program guide for commercial radio similar to the *TV Guide* of today.

Wally really caught fire with a how-to guide on home woodworking that ran one of the first articles on how to build a trailer. Meanwhile, in 1920, both *Scientific American* and *Popular Mechanics* ran articles on Glenn Curtiss's

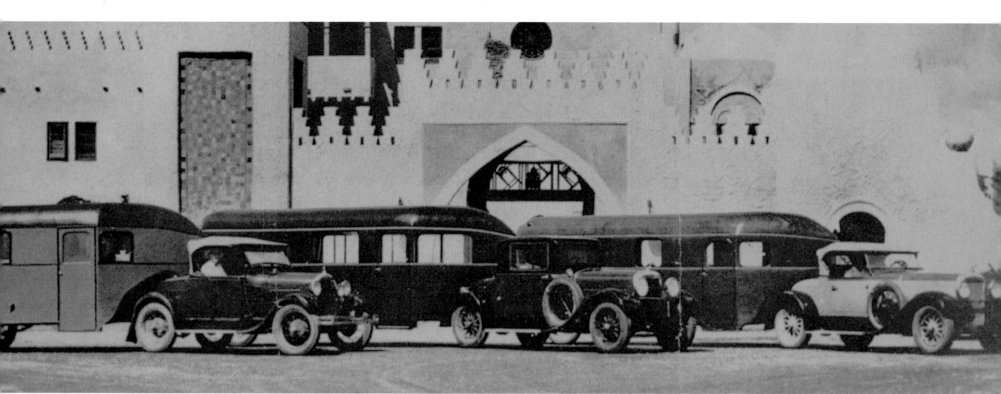

DURALUMINUM AIRCRAFT
(left) Designed by William Stout.
Photo: The Smithsonian Institute.

AEROCAR LINE-UP
(above) The complete fleet of
Aerocars by Glenn Curtiss.
Photo: The Curtiss Museum.

"motor bungalow," which they described as a "compact hotel on wheels." Curtiss is best remembered as the manufacturer of the Jenny airplane, the inventor of the flying boat, and the manufacturer of the motorcycle that bore his name. He was initially inspired to build trailers by the horse-drawn "caravans" or imitations of Gypsy wagons that had been in use by the British from 1880 to 1920, but with his finger on the zeitgeist he constructed his vehicle out of wooden struts and piano wire in the shape of an airplane fuselage to cut down on weight. The roof was covered with fabricoid, a synthetic leather-like material that gave a sturdy rainproof top in stark contrast to the early "pop-up tent trailers" that had been manufactured as early as 1916. The motor bungalow was long at twenty feet, and light because of the wood veneer on its side. It slept six comfortably, although the beds folded out not into the interior, but toward the outside of the vehicle like a tiered Japanese pagoda.

Curtiss continued to tinker with his designs in his experimental aircraft lab in Garden City, Long Island, which featured an elaborate wind tunnel to hone and test a vehicle's aerodynamics. Like most early trailer dabblers, he started as an automobile designer, and his early efforts were bizarre hybrids of egg-shaped bodies designed to reduce drag, and mounted on a Packard chassis for speed and power. His greatest innovation was a vehicle with two separate but interconnected chassis, one for the engine and one for the passengers that cut down on excessive vibrations on the road. This "goose-neck hitch" later became the industry standard, offering better stability and handling, while preventing skidding and side sway. Marketed as the Curtiss Aerocoupler, it featured a pin that dropped into the hub of a wheel mounted in a Goodyear airplane tire just above the rear of the tow car like an oversized phonograph tone-arm needle.

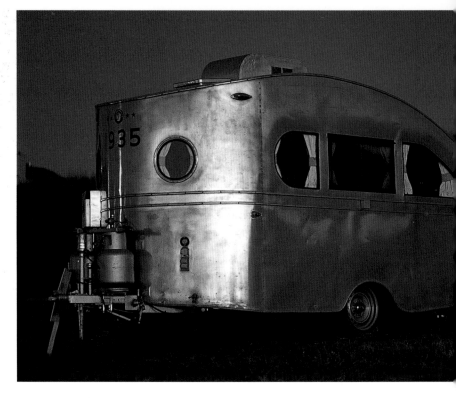

Unfortunately Curtiss, like Loewy, was guilty of a romantic exuberance that at one point led him to change his design from an enclosed box to a collapsible unit that opened like a jewelry box—neither the safest nor most convenient of creatures on the road. Other ill-fated flourishes included an exotic Arabian Nights theme town featuring pseudo-Moorish architecture and proto-Disney street names like Ali Baba, Alladin, and Sinbad. Curtiss was at his best when he addressed the basic principles of weight, strength, and drag. He was aware of the Hungarian-born engineer Paul Jaray's critique of the "teardrop" or "falling drop of water" shape that had been gaining critical momentum because it was "a secret learned by listening to nature," a slogan that stuck in the popular imagination.

Technical literature of the early 1920s like this German review gushed, "The drop is in fact nothing more than a natural streamlined shape, automatically produced by falling particles of liquid. We normal mortals are amazed because it is thick at the front and slender behind. But this proves only that our human instincts about resistance to movement by the air are incorrect. Most cars are pointed at the front and blunt at the rear. This produces greater resistance when in motion, but above all very heavy formation of eddies, which can be seen by the extent to which dust is raised. A good streamlined or teardrop shape means that these eddies disappear almost entirely, so that very little dust is produced, even when driving very rapidly." Jaray

reasoned that a falling drop of water actually hurtles through the air end over end, like a child tumbling down a hill. He felt that if you must look at nature, look at a bird or a fish, whose stabilizing tail or fins act like a rudder or keel.

Curtiss took Jaray's ideas to heart with his Aerocar, which he worked on obsessively between 1919 and 1928. He was able to lower wind resistance (hence, increasing speed) with a V-shaped front and steel sides, clocking an amazing eighty-three miles per hour on a test drive. Strangely enough, if the Aerocar frame became bent out of shape by hitting a rock or dip in the road, it could be tuned like a piano by adjusting the Pratt truss supports under the leatherette skin. This "truss fuselage" design, a holdover from the aircraft industry, seemed rather dated since most airline manufacturers were moving toward a tubular monocoque, or "stressed skin" shell.

The Aerocar saw duty as an ambulance, a hearse, and

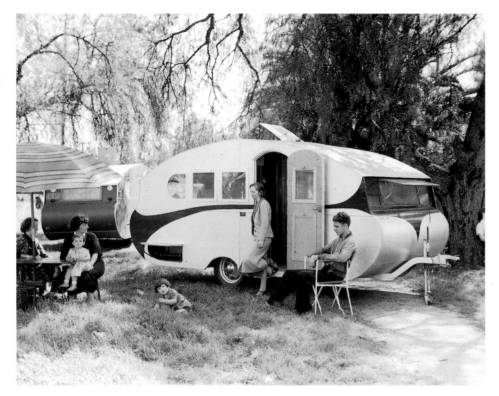

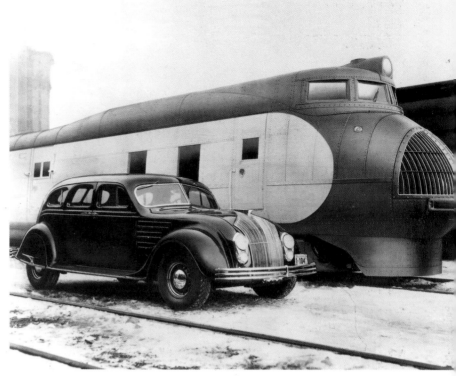

even a garbage truck, but at $2,600 for the basic unit, it was pretty much the Mercedes equivalent of a luxury sedan built exclusively for the wealthy. While design innovations for trailers flatlined, waiting for cues from the aircraft industry, Curtiss was able to focus on the Aerocar interior, developing such amenities as dome lights, shatterproof glass windows, a radio aerial, and a full kitchen complete with sink, finished in ivory lacquer. His spreads were opulent drawing rooms out of a nineteenth-century English novel of manners that seemed to include everything but a passenger in ascot and smoking jacket perusing his book-lined library. If Curtiss was high-end, his trailers were vastly outnumbered by their cheaper counterparts, such as Warner Manufacturing of Wisconsin's "Prairie Schooner," those made by Shattuck Trailer Co. of Minnesota, and Michigan's Auto-Kamp Equipment, which at best featured simple iceboxes, folding tables, and gas stoves.

Much like the Japanese auto industry's cheaper and more efficient improvements in the 1970s and 1980s of the car designs that came out of Detroit, Arthur Sherman was able to add his voice to a growing conversation with his "Covered Wagon," which he created in 1929. For $395 you could cruise in relatively high style in a plywood box with plush interiors. Sherman initially purchased a wheeled box from one of the increasing number of manufacturers who claimed that you could pitch it in five minutes. When five minutes turned into hours of endless frustration, Sherman built his own model, first exhibiting it at the Detroit Auto Show of 1930, where it drew a huge crowd and immediate orders for more.

He quickly became the leading manufacturer, boasting a full product line: the seventeen-foot Master Model ($645), the nineteen-foot Deluxe ($865), and the twenty-three-foot Custom Coach ($1,260). By 1937, his annual plan was to

build 20,000 trailers for a projected $10 million in profits. Silver Dome of Detroit, Palace Travel of Flint, and Schult Trailers of Elkhart all engaged in price wars with Sherman as aggressively as auto manufacturers do today.

Sherman's experience with a faulty do-it-yourself product purchased from a faceless manufacturer unfortunately typified the norm in the 1930s. Keep in mind that Ralph Nader-type consumer advocates had yet to patrol the hundreds of products rolling off assembly lines, and *Consumer Reports* and industry regulations were not yet in fashion. Wally Byam ran into the same problem when he printed one of the hundreds of articles submitted to him on how to build a trailer. The many complaints he received via reader mail spurred him to design and build his own trailer, the plans for which appeared in an article he sold to *Popular Mechanics* on how to build your own trailer for $100.

A mom-and-pop operation from the start, Wally Byam built his early trailers in his backyard. These were exclusively made-to-order custom versions, and the buyer would often come on over to lend a hand, adding a personal touch. Even today, customers are always welcome in the Airstream factory to see "how things are coming along."

Where Curtiss had set the future industry standards of a permanently fixed roof and walls, streamlined styling, and a side entrance, Wally contributed added headroom by dropping the floor between the axles so one could stand upright. Wally always kept in mind that since a trailer was a rolling house, it should need a minimum amount of setup time when you eventually stopped on the road. Like other manufacturers he gradually progressed from plywood to masonite to metal in order to add stability and to give the trailer a sense of a prefabricated shelter on wheels, not some portable, telescoping gadget that unfolded like a fishing pole. Though he was aware of W. B. Stout's two-ton

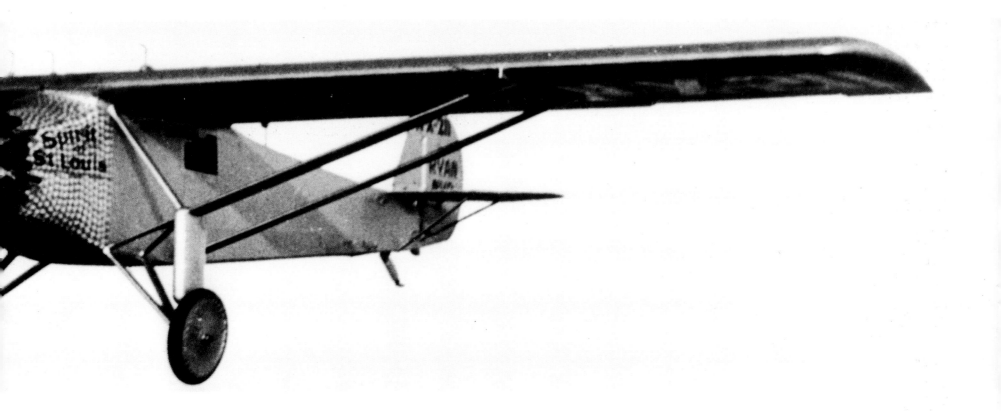

folding metal house, complete with venetian blinds, that retailed for $2,600, he must have scoffed at its impracticality for the average trial-and-error recreational builder.

Furthermore, as the number of trailer camps providing water, electricity, and other services continued to grow, it made sense to equip your trailer with appliances that could take advantage of these fixed utilities—not just a box to carry your camping equipment to a remote wilderness in the woods. Travel had become less a matter of "roughing it" than a relaxing leisure option for the whole family. Miami's Biscayne Boulevard trailer park sported a post office, bar, liquor store, slot machines, and a bus to take the kids to school—a combination of Las Vegas revelry and heartland suburbs. Rumors did abound, however, of rolling bordellos bouncing between the Sarasota, Brandenburg, and St. Petersburg, Florida, camps.

In 1940, the head of the F.B.I., J. Edgar Hoover, always good for a paranoid rant on the ubiquity of crime and vice in American life, issued the warning, "Today there is a new home of crime in America, a new home of disease, bribery, corruption, crookedness, rape, white slavery, thievery, and murder. Hence the terse order that goes out daily to law-enforcement agencies when criminals are on the loose: 'KEEP CLOSE WATCH ON TOURIST CAMPS!' The facts are simple. A majority of the 35,000 tourist camps throughout the United States threaten the peace and welfare of the communities upon which these camps have fastened themselves and all of us who form the motoring public. Many of them are not hide-outs or meeting places, but actual bases of operations from which gangs of desperadoes prey upon the surrounding territory."

Although the trailer boom seems to have grown out of a hobbyist's desire to take miniature models and plans from the fantasy stage to a burgeoning leisure-based reality on

1924

Plexiglas
Invented by Barker and Skinner.

André Breton
Writes the *Surrealist Manifesto*.

Louis de Broglie
Publishes study concerning
wave theory of matter.

Constantin Brancusi
Creates *The Beginning
of the World*.

1925

Marcel Breuer
Designs the Wassily Chair,
made from tubular steel.

Exposition
Exposition Internationale des
Arts Décoratifs et Industriels
Modernes, Paris.

Sergei Eisenstein
Directs *The Battleship
Potemkin*.

F. Scott Fitzgerald
Completes the classic
The Great Gatsby.

Adolf Hitler
Publishes *Mein Kampf*.

1926

Ernst May
Oversees the construction
of 15,000 houses in the
suburbs of Frankfurt with fully
fitted interiors.

Alexander Calder
First experiments with
wire sculptures.

Fritz Lang
Directs the film *Metropolis*.

1927

William Hawley Bowlus
Supervises the construction of
the *Spirit of Saint Louis*.

Charles Lindbergh
Flies the *Spirit of St. Louis*
from New York to Paris.

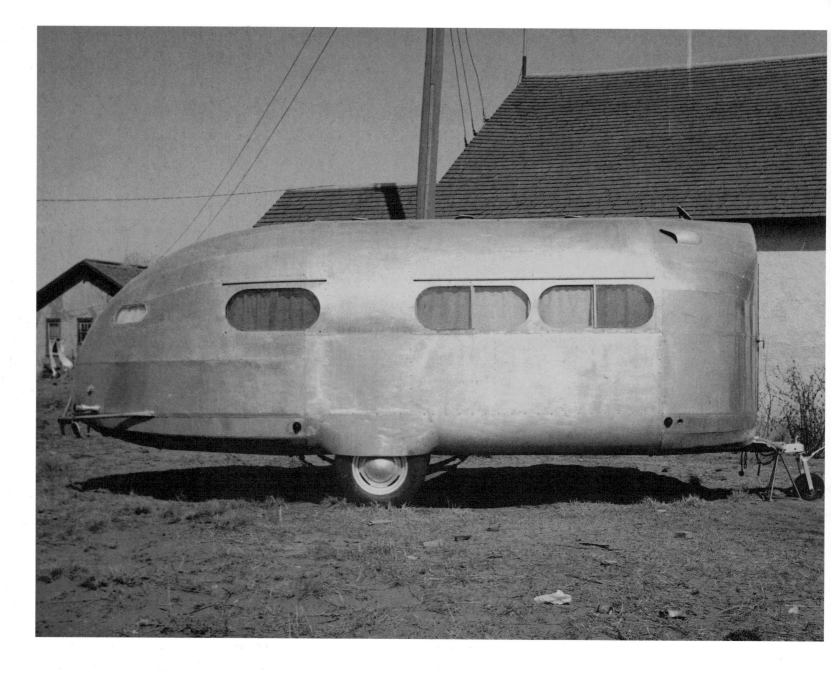

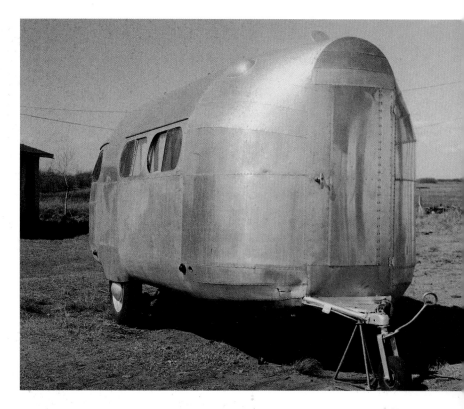

BOWLUS PROFILE
(left) Designed by William Hawley Bowlus. The predecessor to the Airstream. The Bowlus trailer was smaller in heft, compact, and beautifully crafted.

BOWLUS LOGO
(middle) From an original Bowlus brochure. Courtesy of Leo Keoshian.

BOWLUS DOOR
(right) The doorway of the Bowlus trailer was located in the front, above the hitch.

the newly improved highways coast to coast, it was actually spawned by good old American competition. The Wright brothers had made headlines in 1903 with their flight at Kitty Hawk, yet by 1914, on the eve of the first World War, the United States was still without a competitive plane of its own. Even the famed pilot Eddie Rickenbacker flew his sorties in a French-made aircraft. As a point of nationalist pride, the wealthy hotel owner Raymond Orteig offered a $25,000 prize for the first plane to make a New York to Paris transatlantic flight, hoping to win back aerial supremacy. Enter William Hawley Bowlus, the single most important designer in determining the final shape of what would become the classic Airstream Clipper.

After stints in the U.S. air service in 1917, flight training in Venice, California, and two years as an aircraft mechanic in England and France, Bowlus became a pilot for the first regularly scheduled commercial airline in the United States, a short Los Angeles to San Diego commuter route. He was later hired as the plant manager of Ryan Aircraft in San Diego, where he supervised construction of the *Spirit of St. Louis,* which Lindbergh would soon pilot to international glory, winning the 3,610-mile transatlantic journey in 33 hours, 30 minutes.

Bowlus's dreams were never constrained by mere contests and records. In 1929, he had already flown a sailplane or glider of his own creation to a new "soaring" record, breaking the Wright brothers mark of 14 minutes, 28 seconds that had stood for eighteen years. All told, by 1932 he had designed and constructed his Albatross sailplane, setting world records for distance and altitude in it. Fame was nothing new for him, and his design renown in the aeronautical industry would remain legendary if that alone were his only contribution. But

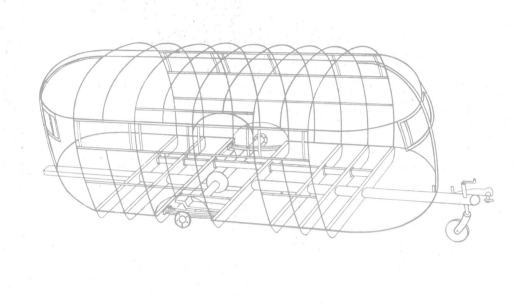

during his soaring experiments out in the hot Southern California desert, he saw the need for a mobile shelter and became intrigued by the possibilities of land travel. Besides, at the height of the Great Depression from 1933 to 1936, trailers were the only business that showed any signs of growth.

Like the first trailers of his contemporaries, Bowlus's resembled a large ostrich egg with a wooden frame bowed and curved into a streamline shape through heat steaming. He stretched a heavy canvas "sock" over the frame in a preview of "monocoque" design—a single unified body that was distinct from the "platform" trailers of the day—a design that no one could copy since no one else had the technology. Unlike the basic plywood garage-built units constructed from lumberyard scraps and the equipment found in an average tool shed, Bowlus relied on the latest aviation breakthroughs, a sophisticated

manufacturing and testing plant, and the generous backing of textiles mogul William Du Pont.

Bowlus set his mind to solving the problem of creating a strong, rigid trailer light enough to be towed at high speeds by a midsized car. By introducing Duraluminum, a lightweight alloy as strong as steel but just one third the weight, he had aluminum's advantages of no shrinking, peeling, rusting, sagging, or squeaking, with a reduced weight that put far less stress on the clutch, brakes, and rear end of the car. In fact, in the 1930s, when it was still legal to ride in the back of a trailer while it was being towed, it was not uncommon to see Ruth Bowlus cooking dinner while hurtling down the highway at the then-breakneck speed of fifty miles per hour. When the two slowed down and stopped for the night to eat, the trailer was so light (at 18 feet, the Bowlus Road Chief weighed a mere 1,100 pounds, far less than any other trailer), it

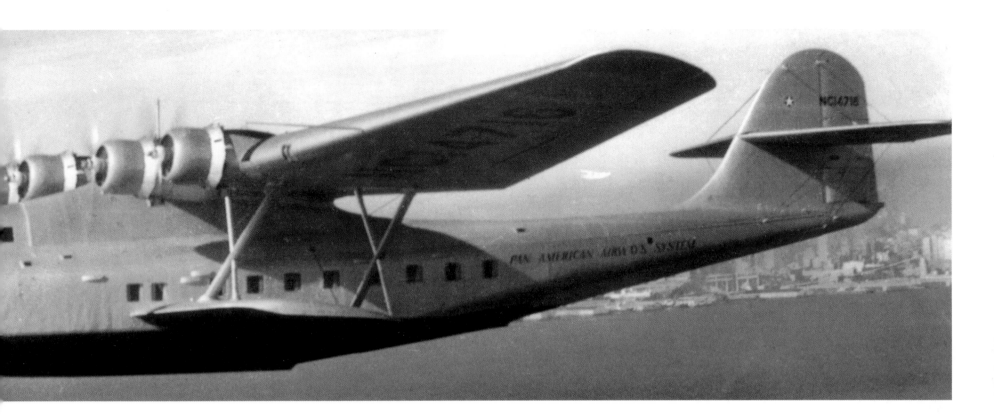

could be unhooked from the tow car by a single person almost like a baby buggy.

Bowlus got a bit ahead of himself, however, when he installed luxury options like an intercom system that allowed communication between the trailer and the towing vehicle, and a stainless steel cocktail bar. Imagine a new car with sun roof, electric windows, and compact disc player, but without comfortable seating, and you will have an idea of how Bowlus's vision often precluded market considerations. His door was placed on the trailer front, which both made entry and exit highly unsafe and greatly limited the flexibility of the floorplan. Wally later moved the door to the side of the cabin, thus neatly dividing the kitchen from the living quarters to give the illusion of two separate compartments or rooms. Bowlus offered four different models, the Motor Chief, Road Chief, Papoose, and Trail-Ur-Boat. With a base price of $1,050, these trailers were expensive at a time

when a brand-new Ford V-8 was $560. It should be obvious he wasn't shooting for the middle-class minivan or weekend sport utility vehicle crowd. Bowlus's partner, Jacob Teller, shared his taste for extravagance, and when Teller lavishly overspent on marketing and promotion for an audience that didn't really exist, the company teetered on the edge of bankruptcy.

Wally Byam, who was a salesman for Bowlus-Teller, selling the Road Chief and Papoose, approached Bowlus at the 1935 bankruptcy auction and asked him if he minded if Byam were to take over the company and continue production. In the famous line that clinched the future prosperity of Airstream Incorporated, Bowlus responded to his successor that "I neither mind, nor is their anything I can do about it." The official 1936 Airstream Clipper, so named because it was a dead-ringer for a Pan Am Clipper airplane on wheels, was soon to have added water pumps,

1929 (continued)

William Hawley Bowlus

Breaks the Wright brothers' eighteen-year soaring record by 14 minutes.

1930

Frank Whittle

Designs and builds the first turboreactor.

Mies van der Rohe

Designs the Brno chair.

1931

Bell Laboratories

Use the telex nationwide.

Harold Edgerton

Applies the electronic flash to photography.

Pierre Chareau

Model of Maison de Verre exhibited at the salon d'automne.

1932

Jean Mantelet

Founder of Moulinex, invents the food mill.

Otto Kuhler, Henry Dreyfuss, Norman Bel Geddes, and Raymond Loewy

All independent from each other, begin to design aerodynamic locomotives from 1932–1938.

Aldous Huxley

Writes the novel *Brave New World*.

William Hawley Bowlus

Designs the "Albatross Sailplane," which holds both distance and altitude records for the United States.

1933

J. Strauss

Designs the Golden Gate Bridge in San Francisco (construction continues until completed in 1937).

Friedrich Ruska & Max Knoll

Invent the electron microscope based on theories developed by Hans Busch in 1926.

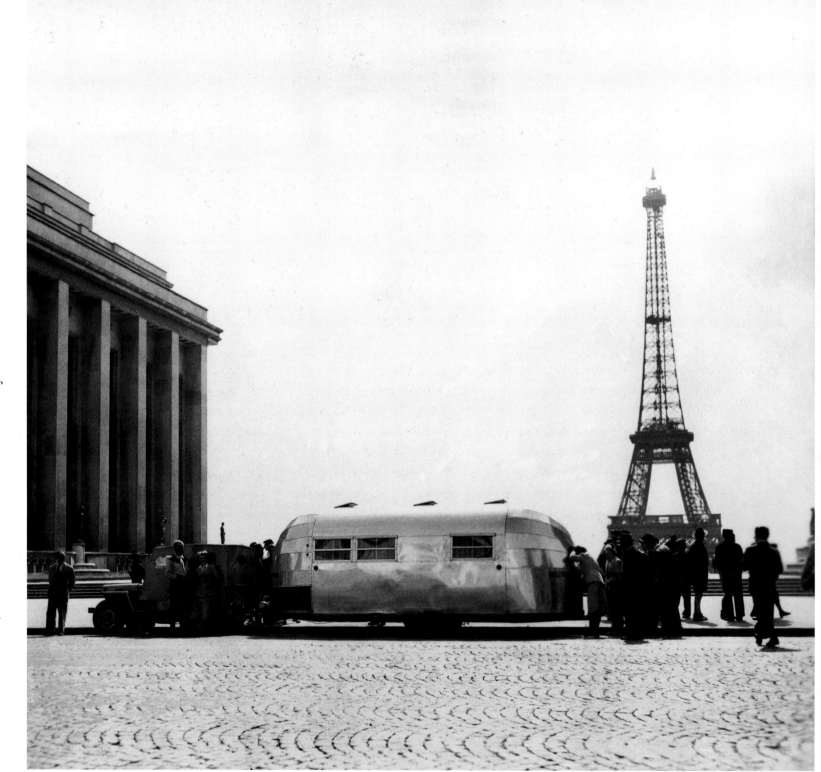

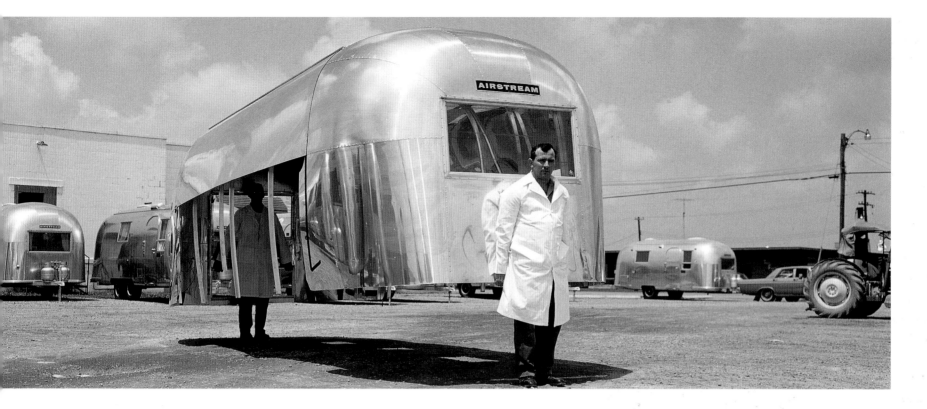

chemical toilets, iceboxes, and gas stoves—but, man, it
sure did look a lot like the 1935 Bowlus Road Chief.

Blessed with the ideal design he inherited from Bowlus,
Wally set about shoring up the flagging image of travel
trailers. For every wide-eyed child in the family station wagon
who stared in wondrous admiration yelling, "You lost your
wings" as an Airstream tooled down the highway, an equal
number of naysayers dismissed them as "silver twinkies"
or "sausages on wheels." Wally still had the element of
surprise, so to speak, and was eager to capitalize on the
mystery evoked by his rolling metallic vaults. He wanted to
demonstrate their lightness and maneuverability, and in
1947 he invited the famous French bicycle racer Latourneau
to visit the factory and actually pull a trailer with his bike. A
depiction of that event would become the famous Airstream
logo, with Latourneau, head-up breasting the wind, towing
an Airstream as if it weighed no more than a toy truck.

Wally paid as much attention to his interiors as he did
to the more recognizable outside features of the vehicle.
"Trailer tappers"—or curious bystanders who had no com-
punctions about coming straight up to an idle trailer and
knocking on the door to see what was inside—were always
treated to the lush spectacle of a fully modern kitchen and
cozy sleeping area that would make the designers at *Elle
Décor* blush. Wally always said, "Mechanics can work
better if they have good tools, golfers can play better
games if they have a fine set of clubs, and any woman will
tell you she can cook better if she has all the necessary
utensils, gadgets, and appliances in the kitchen." Even the
early Airstreams of the 1930s boasted the "most advanced
heat insulation and ventilating system" of the day and came
equipped with dry ice air conditioning and electric lights.

If Wally were alive today, he would be combing the
aisles of Home Depot, looking for more ecologically sound

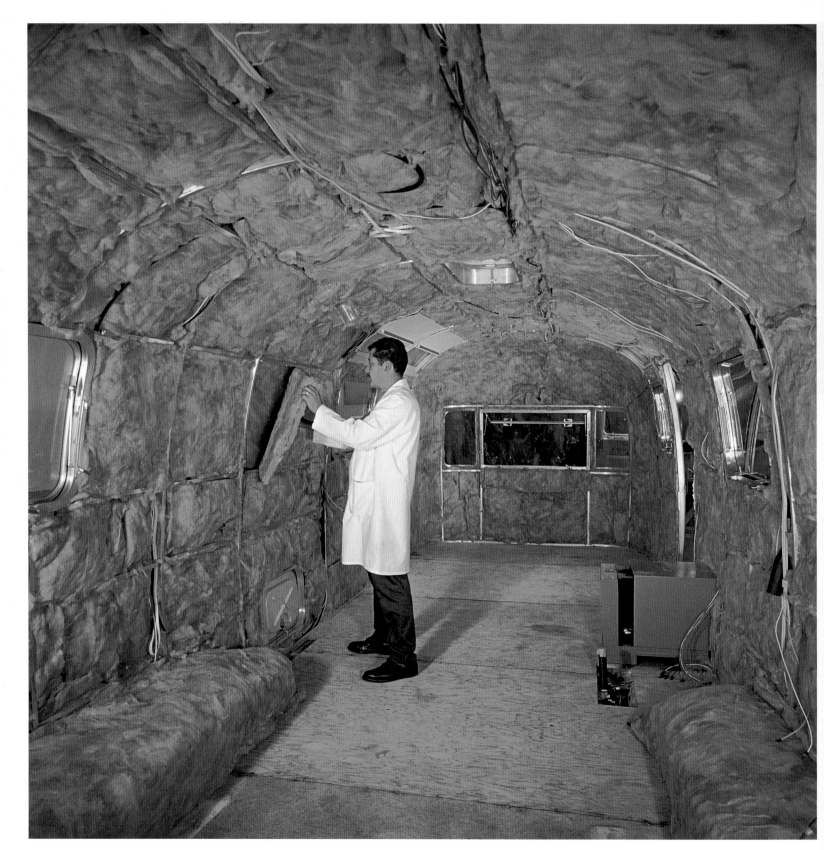

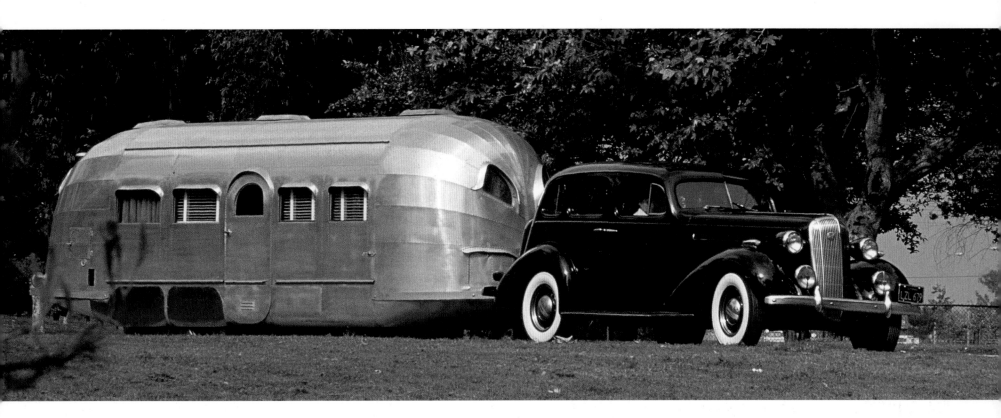

faucets, or a better water purification system, all to appease his love of gadgets and keep Airstreams as up-to-date and comfortable as possible. The practical knowledge and advice he freely dispensed to trailer enthusiasts was never limited to the benefits of owning an Airstream per se. Wally wasn't out just to sell trailers; he wanted instead to provide the safest and most efficient method of travel. He freely recommended tow cars from other companies that, in his caravanning experience, provided the soundest ride, or an essential tool that would get you out of a jam. He counseled, "If you have a lighter trailer, the Ford with a Cruise-o-matic transmission—a Model T with a college degree—is a sure bet. It is a rugged car, perhaps the single most popular model among those who have trailers under twenty-two feet."

Wally even played the role of an automotive "Dear Abby," offering rules of etiquette and comportment to intrepid travel-ers who found themselves in foreign lands without a travel guide to debrief them on local customs and rituals. He had this to say on parking: "I've parked behind the Ambassador Hotel in Chicago, with a telephone line and room service, though I must admit I didn't save any money doing it. I have also parked, with the permission of the Police Department, in Central Park in New York; and once in Paris I asked the Paris police where I could park my 'caravane.' We had a friendly ten-minute chat, and before you could say, 'Champs Elysees,' I was being escorted down it, beneath the Arc de Triomphe and into the Bois de Boulogne to the most perfect site you ever saw. The rules are simple: be friendly and gentlemanly and you will be received everywhere."[10]

No doubt this folksy sensibility masquerading as cor-porate imaging explains why, in the early 1930s, Wally

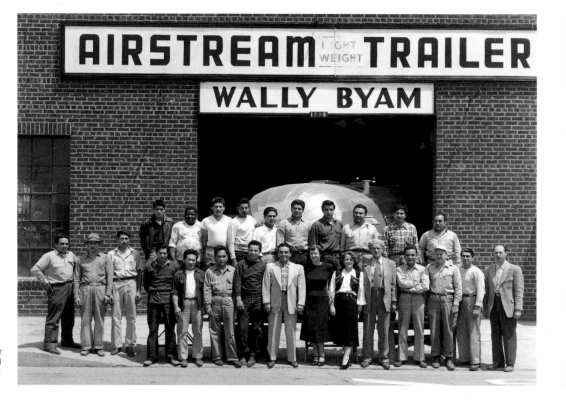

LOS ANGELES
(right) Wally at the West Coast factory, 1956. Today, Airstream's factory is in Jackson Center, Ohio.

EARLY AIRSTREAM
(far right) California, 1933. This trailer was built from a plan, and customized by the builder. Airstream trailers went into production in 1936.

could hardly fill orders for new trailers, even though he was competitively priced at a relatively steep $1,200. *Fortune* magazine pointed out in 1936 that "With the possible exception of Roycraft and Raymond, no trailer manufacturer reached a production of 1,000 units; they ran on the whole, between 400 and 800, which meant a gross business of $500,000."[11] Nevertheless, of the 300 trailer companies around in 1936, Airstream would remain the only survivor.

Airstream's staying power is largely based on its commitment to the simple notion that "streamlining is cleanlining," and that the shape that best embodies this is the 1936 Clipper. Though the Clipper is sometimes referred to as "Granddad," it is more out of respect and veneration for a timeless form than a sense of dated obsolescence. In fact, there have only been five major body changes since the early Clippers first rolled out, and those simply to increase the interior space without affecting the ease of towability or

the rounded, wind-piercing contours of the aluminum shell. Even "slide-out living," the current frontier of design, which morphs an Airstream into a temporary mini condo, only to slide back in when a family breaks camp and hits the road, does little to alter the timeworn beauty of the frame.

When designers and engineers at the factory do attempt to stray from this formula, they soon hear about it—and it's not pretty. The Airstream Land Yacht produced from 1989 to 1991 was painted beige and featured a more sawed-off, squarish front. It was instantly dubbed a "Squarestream" by Airstream purists, and trust me when I tell you that it carries all the negative connotations of the word "square." Likewise, when Airstream experimented with a fifth-wheel trailer (one with an extra axle), ironically named "Integrity," those unfortunate enough to be seen cruising around in this vehicle found it hard to shake the label "Tupperware trailer."

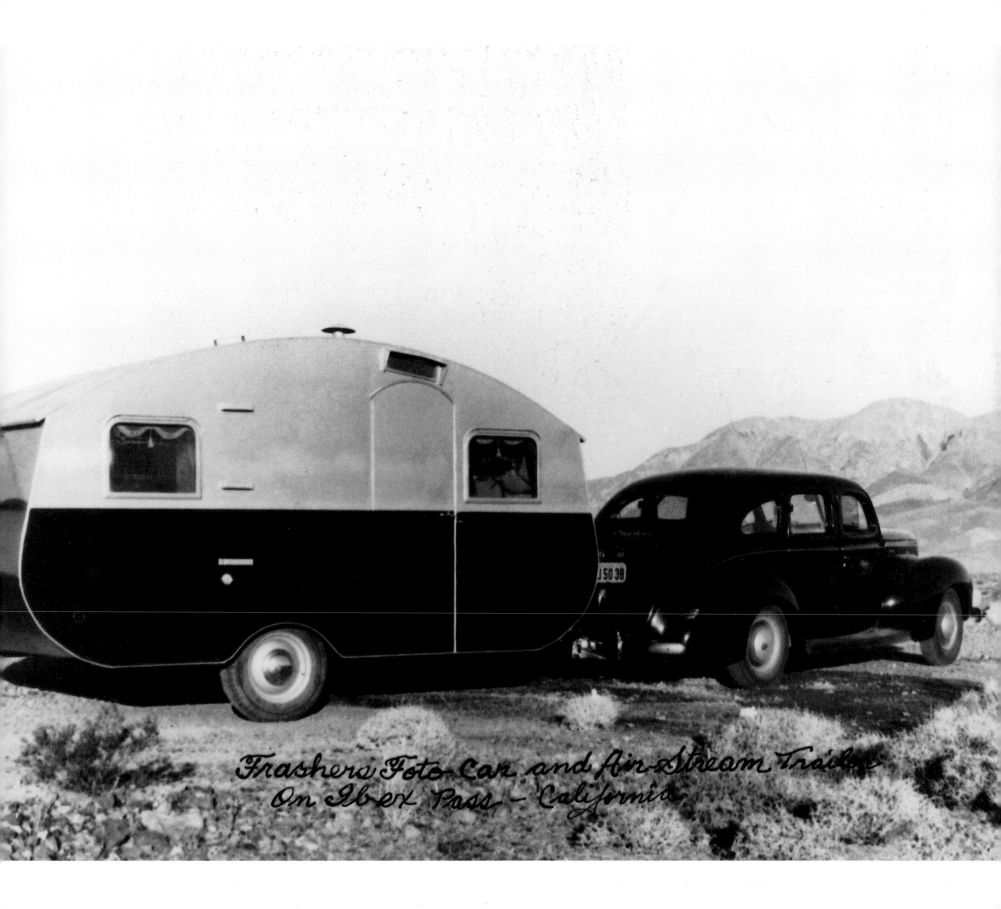

Frashers Foto Car and Air-Stream Trailer
On Ibex Pass - California

1939 (continued)

Igor Sikorsky
Develops the helicopter.

Isamo Noguchi
Designs the modern low table with a glass top.

World's Fair
New York hosts the World's Fair: Building the World of Tomorrow.

1940

Television
Start of commercial television in the United States.

Willy's Overland Incorporated & American Bantam Company
Produce prototypes of the jeep.

Orson Welles
Writes, directs, and stars in *Citizen Kane*.

Raymond Loewy
Redesigns Lucky Strike cigarette pack.

Winston Churchill
Becomes Prime Minister of Great Britain.

1941

John Huston
Directs the film *The Maltese Falcon*.

Siegfried Giedion
Writes *Space, Time, and Architecture*.

Aluminum
Structural aluminum listed as critical war material. Not available for civilian use.

1942

Wernher von Braun
Builds the V2 rocket.

Enrico Fermi
Constructs the first nuclear reactor in Chicago.

Le Corbusier
Creates a modular system of proportion that he will use after the war.

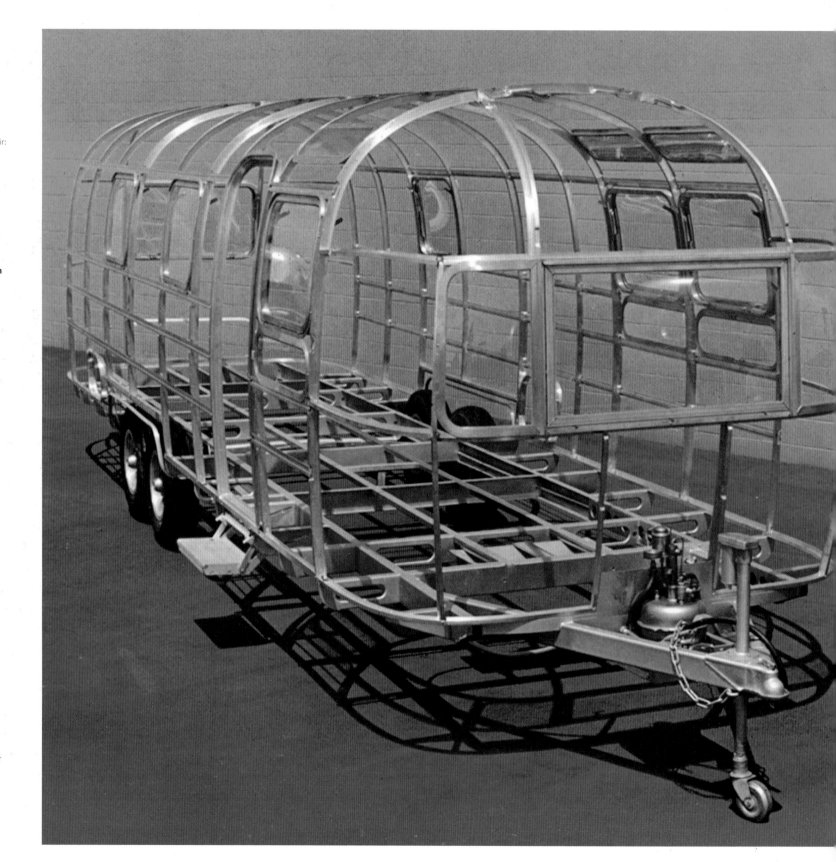

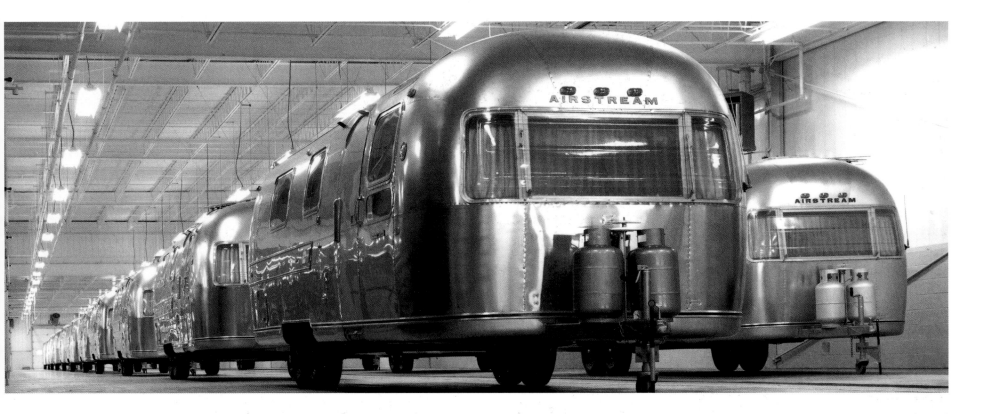

TRAILER FRAME
(left) For promotional advertising, the Airstream trailer frame is assembled before the aluminum skin is fastened. This is not the proper order of assembly, but creates a great diagram of the trailer's skeleton.

ASSEMBLY LINE
(above) Rows of Airstream trailers nearing completion in the factory.

Retailers and sports merchandisers would have us believe that "image is everything," a tongue-in-cheek way of shamelessly revealing marketing strategy to an increasingly educated and cynical consumer public, but Wally knew from the beginning that there is no substitute for a sound frame and a sturdy, lasting vehicle. The shift to structural aluminum alloy turned out to be a mixed blessing, however. On December 8, 1941, aluminum was classified as a critical war material—one not available for civilian use. The War Production Board ordered that "house trailers shall not be made for the duration of the war, except by manufacturers making them for the government or recognized and approved governmental agencies."

Even though the "house trailers" that were made for the government were really mobile homes designed to accommodate defense plant workers, who were constantly being relocated around the country to build planes and fabricate ammunition for the war effort, travel trailers came under this rubric, which effectively halted Wally's blistering production levels. As materials began to dry up, the company downsized to weekend production, never considering a compromise in the aluminum shell. If it had, the current design of using two aluminum shells, one inside the other, which sandwiches the insulation, would never have come to pass.

This format, nested like a set of Russian dolls, allows for the insertion of a 2-inch, temperature-resistant mattress of aerocore fiberglass, which is impervious to flame, water, vermin, or settling. It is the equivalent of a gore-tex lined jacket—cool in summer, warm in winter—and it provides the same wrinkle-free flexibility, the metal body expanding and contracting with the heat and cold in one homogenous unit. This lesson was also gleaned from the aircraft industry, which began employing heat-treated load-bearing aluminum for its lightweight properties without any requisite decline

1942 (continued)

Paul Arzens

Develops working prototype for the Egg electric car.

1943

Colossus

The first electromechanical computer, Colossus, is built based on the calculations of Alan Turing in England.

Henry J. Kaiser

Begins the mass production of Liberty ships, which were to be used in the Allied landings in Normandy.

Jackson Pollock

Abstract expressionist painter has his first solo painting exhibition.

Robert von Musil

Writes the novel *The Man Without Qualities*.

1944

Art Concret

Exhibition in Basel featuring Arp, Kandinsky, Klee, Mondrian, and Henry Moore.

D-Day

American troops land in Normandy.

Selman Abraham Waksman

Discovers streptomycin, which acts on tuberculosis.

Jean Prouvé

Designs demountable houses for homeless families in France.

1945

Nuclear bomb.

Oppenheimer and his team develop the nuclear bomb.

Percy le Baron Spencer

Invents the microwave oven.

Charlie Parker and Dizzie Gillespie

Make the first bebop recordings.

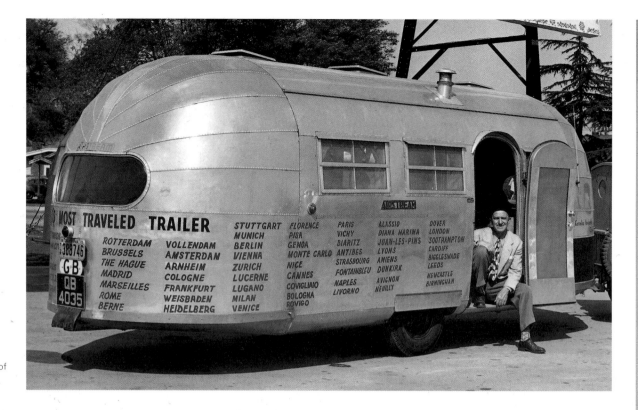

AROUND THE WORLD
(right) Wally posing with Airstream's most traveled trailer.

AIRSTREAM FACTORY
(far right) Factory demonstration of the Airstream structure's strength and lightness.

in structural strength. Since it possesses five times the strength of untempered aluminum, a plane's wings and fuselage can bend in an air current and spring back without weakening. Likewise, an Airstream body with a reinforced frame can absorb road vibrations without cracking or weakening.

Eventually, as production slowed, Wally went to work for an aircraft company, which provided the kind of knowledge and training not available in any book or magazine. Wally had seen firsthand the progression of materials used in the trailer-building industry move from plywood to masonite to metal, and anticipated the need for advanced power tools, a large warehouse for construction, and a team of highly trained mechanics to fulfill his vision. Even today, it takes two skilled mechanics to drive just one of the thousands of rivets that go into the final body. The Silver Cloud alone boasts 9,000 rivets. No screws or

nails are used since they tend to dislodge over time from excessive road wear. Had Wally not seen, and later incorporated, the advanced engineering methods being used in the aircraft industry during his brief stint there, he probably would have remained a bit player as the industry mushroomed from a $146 million enterprise after the war to $620 million just twelve years later.

Like Sherman and Bowlus before him, Wally needed a quick infusion of capital to make the leap from regional upstart to national powerhouse. Without modern intellectual property laws to protect him, however, Wally left himself vulnerable to exploitation when he agreed to turn over his trailer concept, design, and construction methods to another company with greater production capacity. When the relationship soured after a year, Wally had to buy his way out of the company to protect his name and ideas—ideas he had been mulling over for fifteen years.

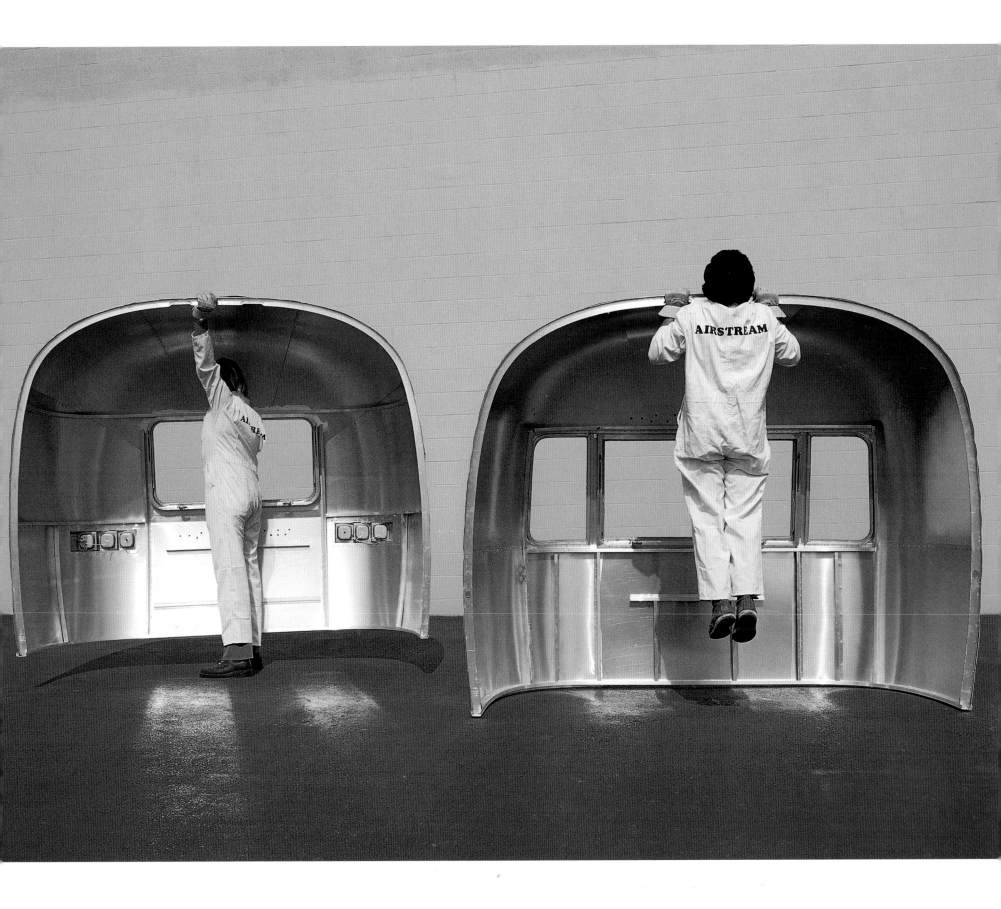

What had started off as a few sheets of plywood and a second-hand sink had progressed to become the only trailer with a truly "monocoque" design—that is, one that is fully rounded, with no flat spots on the top or sides acting as "traps" that would increase wind resistance and, hence, hinder speed. Wally was determined to continue the business, even if it meant starting off virtually penniless, with little more than his own set of tools.

It is a victory of sorts, and not an idle boast, that the Airstream promotional literature of the 1960s claimed "the luxury of a private stateroom, and the convenience of a fine hotel." Wally did get his factory in a small building near the Van Nuys airport, and in 1948 he declared Airstream Trailers Incorporated open for business with a little more than a hint of bravado and a commitment to expand his operation to the East Coast as soon as possible. He got his wish in 1952, opening a production center with $5,000

in a vacant paper-goods factory in Jackson Center, Ohio.

Wally's aircraft experience proved to be a coup as he continued to outpace his would-be competitors with design innovations lifted from planes. How else to explain the "dura-torque axle" running gear, which eliminated 148 extraneous parts—absorbing bumps and reducing slipping and side sway—than as an example of Wally turning his forced closure during the scarcity of the war years into a gain of theoretical knowledge that he eventually turned to his advantage. The new axle increased ground clearance by seven inches and solved the problem of lubricating the axle assembly. As plans for trailer building continued to proliferate in magazines, and rumors swirled as to the best combinations of comfort and design strength, the pretenders to the trailer throne were soon revealed. Shoddy workmanship was no longer tolerated.

Wally was fond of saying, "Conversation is cheap and

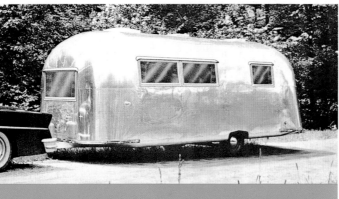

24 FT. TRADEWIND

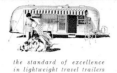

AIRSTREAM
TRAVEL TRAILER

SUPREMACY

*airstream's pre-eminence
in travel trailers is
unsurpassed by any product
in any industry. When
you own an airstream,
you know . . . and the world
knows . . . you own the finest
travel trailer built.*

*the standard of excellence
in lightweight travel trailers*

A new thrill awaits you when you take to the open road in this superb example of Airstream's advanced engineering. The 24 ft. Trade Wind is the answer for those who want the spaciousness of a larger trailer with the mobility of a smaller unit. Featured are the popular side-by-side twin beds that heretofore have only been available in longer models. With the installation of bunks it can comfortably sleep six. In no other trailer will you find all the features which contribute so much to the feeling of luxury and security that is yours in an Airstream and of course the famous Wally Byam developed off the road optional equipment is available to make your Trade Wind completely independent . . . As nimble as a mountain goat on any highway anywhere in the world your Trade Wind is more than merely functional, it will be the center of attraction wherever you park, at home or abroad. Tow it with the knowledge that you have the newest, finest trailer in a line that has set industry standards since 1932.

AIRSTREAM
TRAILERS, INC.

JACKSON CENTER · SHELBY COUNTY, OHIO

C.J. STOLL
(above, left) A classy
example of an Airstream
dealer's showroom.

SALES BROCHURE
(above) Promotes the new
24-foot model.

RALLY COMMUNICATION
(right) Wally Byam outlining
the day's event with the aid
of a microphone.

Airstream is not." He was aware of a growing chorus of unrealistic dealer claims, and of a get-rich-quick mentality that was flooding the market with second-rate vehicles without any kind of warranty. To counter this, he established a strong dealer network that would educate the public about Airstream's exclusive design features as well as eventually serve as a resource for parts and services. If you heard the buzzword "engineered contouring" being bandied about, you'd probably draw a blank. If its literal definition of "tensional, compressive, shearing, and torsional stresses acting in balanced support" were offered as explanation, you'd be equally in the dark. The dealer network acts as a go-between, translating the engineering theories concocted in the laboratory into functional terms for the layman.

This method undoubtedly helps sell trailers, but it also provides a sense of well-being for owners to know that a "Super Aerostress chassis" employs the aircraft principle of

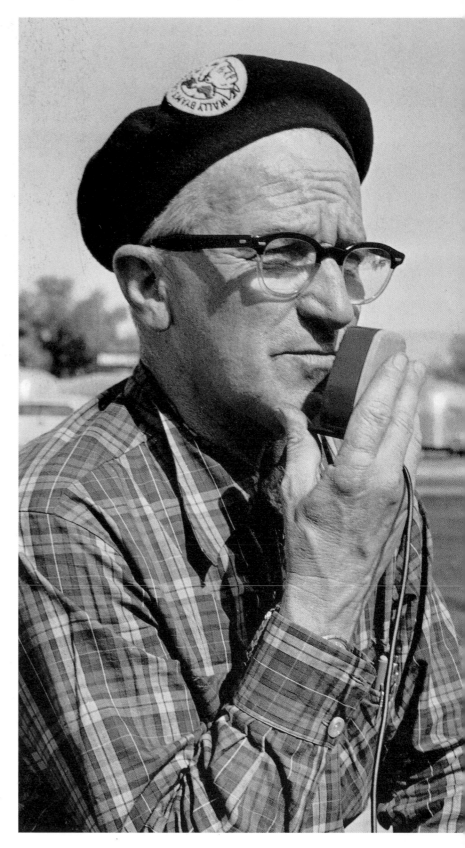

flanged, perforated beams resulting in 66 percent of the total weight of the vehicle resting from the floor line to the road. In layman's terms, this simply describes a lightweight body bolted and riveted to an electrically welded steel chassis, but it helps to have an expert on hand explaining the benefit to you as a feature that evenly distributes the weight of the trailer, allowing the heavy bottom to "hold the road."

We think of the modern CEO as someone racking up frequent flyer miles en route to conferences and board meetings, endlessly networking to raise the profile of a company in the public eye, or scouting out potential mergers to gain market share and increase brand name equity. The only miles Wally racked up, however, were as the personal leader of all the foreign caravans from 1951 to 1960, which allowed him to mix his love of travel with a hands-on philosophy of innovation though experience. He would return from a caravan in, say, Managua, and spend six months in Ohio and then six months in Los Angeles, often sleeping in his trailer, and awaking to impart his experiences fording a swampy marsh or crossing a rocky ravine to his team of engineers and craftsmen.

For instance, if the bumper wasn't an integral part of the chassis, the chances of it breaking off during a difficult mountain climb increased drastically; Wally had it welded directly to the chassis. If the underbelly wasn't as smooth as the top and sides of the trailer, rocks and dirt would kick up into the housing, increasing air turbulence; Wally

smoothed out the underbelly. In case of an emergency, he provided an 18-by-40-inch "escape window" in the back that was big enough to climb through in the event that the side door was jammed. Every contingency, every scenario eventually found expression in some design feature that set Airstream apart from the rest of the pack. Each square inch had a functional purpose.

Even after his death in 1962, Wally's handpicked lieutenants continued the dream of total self-containment by installing the Uni-Volt electrical system—a one-flick power source that made the lights, refrigerator, and pumps wholly independent of outside sources of power, allowing you, in Wally's words, to "turn it over to your lovely old grandmother who could tow it to the middle of the Gobi Desert to live in gracious metropolitan luxury for weeks on end without reloading, refueling, recharging, or regretting."

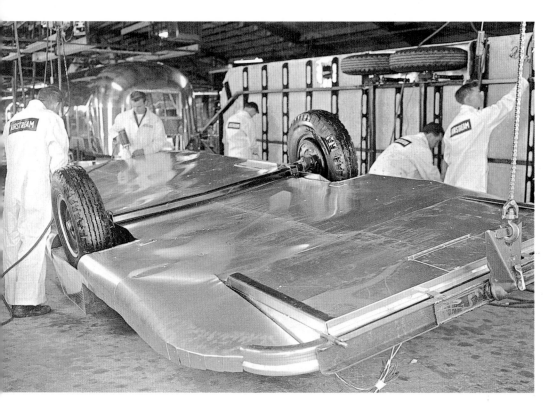

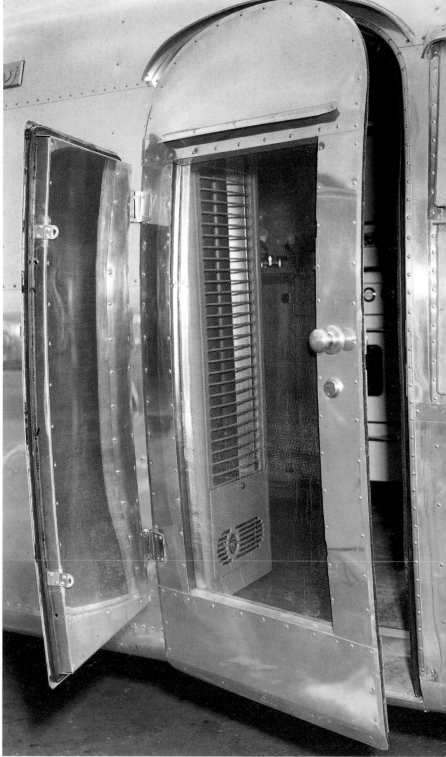

WALLY BYAM
(far left) Posing next to a new Airstream from 1957. Before 1957 the trailers had thirteen aluminum sections on the ends. After 1957, the sections are widened and reduced in number for a total of seven.

AIRSTREAM FACTORY
(above) The aluminum skin is attached to the trailer frame before the body is attached. The floor is insulated before the skin is attached.

DESIGN DETAIL
(right) The Airstream door is a marvel alone. Besides the curved radius and hinges angled to allow a perfect swing, the door has a center panel that can be opened, allowing you to either lock it completely or sleep with a screen door effect for extra ventilation.

Although Wally was gregarious and personable to the end, especially with his fellow caravanners, he retained a mystery about himself by parrying reporters' questions with the promise to "write it down and I will send it to you." He never did get back to those reporters, but his legacy lives on as part oral history, part legend in the form of fireside chats at WBCCI rallies, and anecdotal evidence spread by those who accompanied him to the "four corners of the earth."

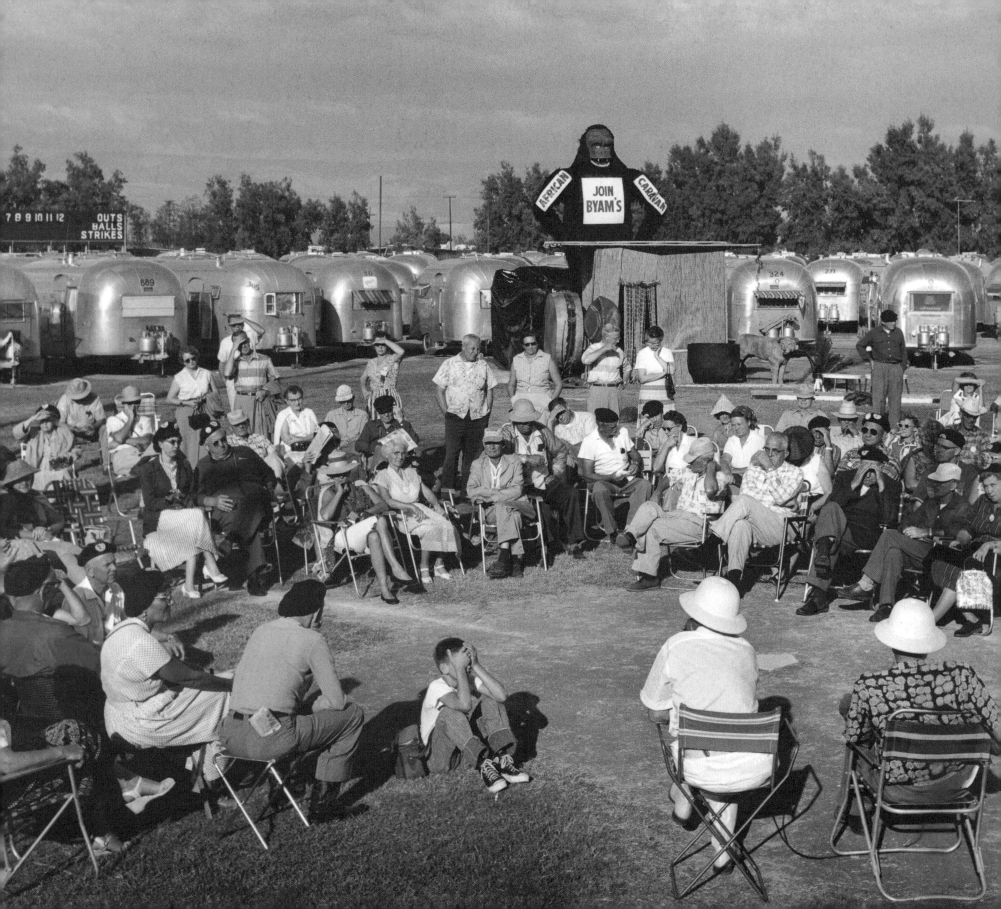

"In the heart of these words is an entire life's dream. To those of you who find in the promise of these words your promise, I bequeath this creed . . . my dream belongs to you."

THE WALLY BYAM CREED

To place the great wide world at your doorstep for you who yearn to travel with all the comforts of home.

To provide a more satisfying, meaningful way of travel that offers complete travel independence, wherever and whenever you choose to go or stay.

To keep alive and make real an enduring promise of high adventure and faraway lands . . . of rediscovering old places and new interests.

To open a whole world of new experiences . . . a new dimension in enjoyment where travel adventure and good fellowship are your constant companions.

To encourage clubs and rallies that provide an endless source of friendships, travel fun, and personal expression.

To lead caravans wherever the four winds blow . . . over twinkling boulevards, across trackless deserts . . . to the traveled and untraveled corners of the earth.

To play some part in promoting international goodwill and understanding among the peoples of the world through person-to-person contact.

To refine and perfect our product by continuous travel-testing over the highways and byways of the world.

To strive endlessly to stir the venturesome spirit that moves you to follow a rainbow to its end . . . and thus make your travel dreams come true.

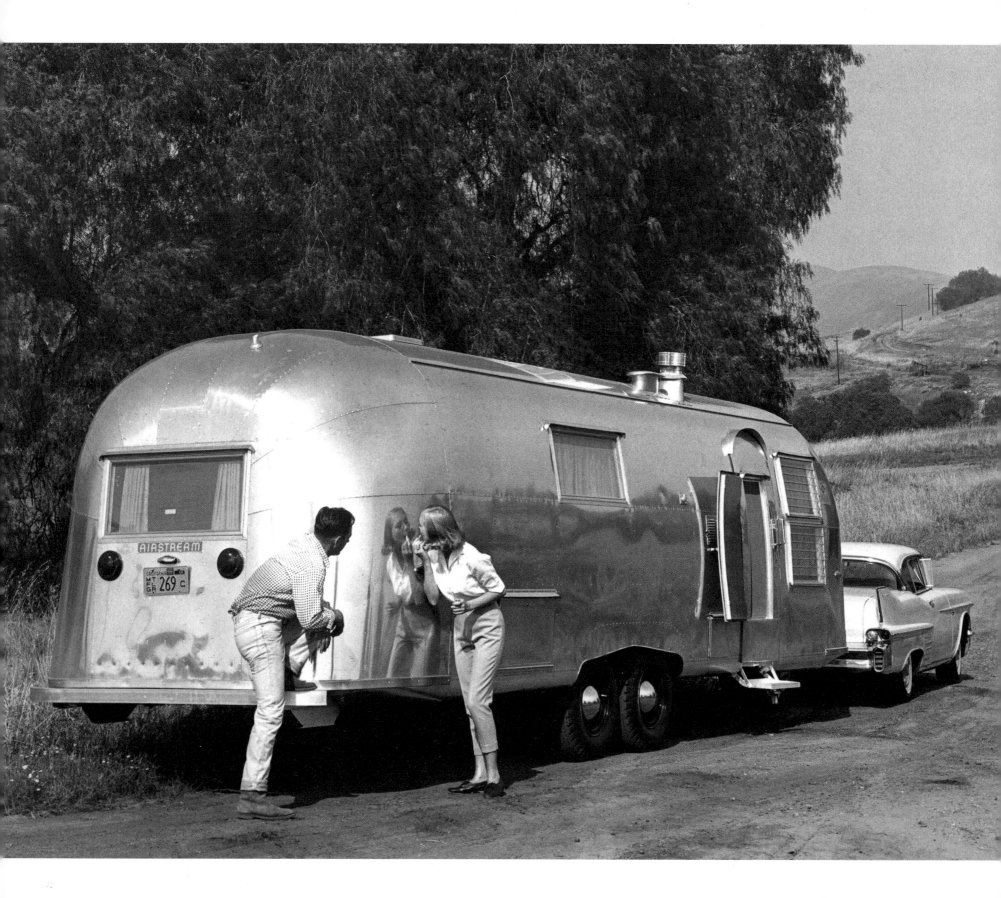

26-ft. Overlander

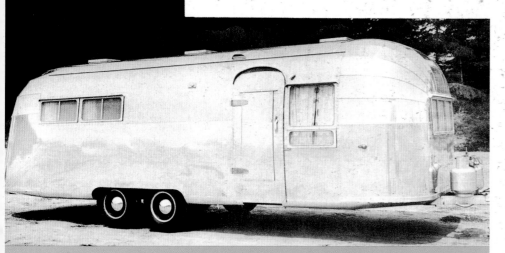

New Design! New Interiors! New Comfort!

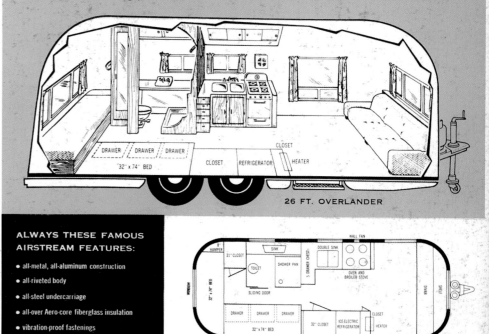

26 FT. OVERLANDER

ALWAYS THESE FAMOUS AIRSTREAM FEATURES:

- all-metal, all-aluminum construction
- all-riveted body
- all-steel undercarriage
- all-over Aero-core fiberglass insulation
- vibration-proof fastenings
- "see-thru" rear vision

DESIGNED AND BUILT TO TRAVEL

Here's a fabulous new model that enables you to take all the "comforts of home" with you wherever you go. Travel to exciting new places in glorious comfort for extended periods of time. It's fun in this sensational new Overlander. Everything you want in a large travel trailer at a price you can afford—made possible by a standardized interior arrangement, allowing only minimum modifications.

The Overlander is designed by travelers—to travel. Every new feature has its origin in long travel testing on Airstream trailer caravans all over the world. It's a genuine Airstream, lightweight but large with plenty of room for gracious living. Just consider these outstanding features: modern, large, dry-floor bathroom, adjacent to bedroom, with separate shower and toilet; large rear wardrobe convenient to bath; special sliding door for bedroom privacy; convenient galley with extra large working area; eye-level combination ice-electric refrigerator; apartment size stove—and many other great features too.

The Overlander is available for the first time in both single and tandem axle models. Be sure to see the Overlander for substantial savings without sacrificing quality or convenience. A luxurious standard Airstream model, ideal for comfortable living and traveling.

Airstream — since 1932 the world's finest lightweight travel trailers

SPECIFICATIONS AND STANDARD EQUIPMENT

TANDEM AXLE MODEL	SINGLE AXLE MODEL	EQUIPMENT COMMON TO BOTH MODELS	
Overall length—26 ft.	Overall length—26 ft.	Separate shower & toilet	Full screen door • 3 roof vents
Body length—23 ft.	Body length—23 ft.	Stainless steel door hinges	Formica galley tops
Overall weight—3850 lbs.	Overall weight—3550 lbs.	Comb. ice-electric refrigerator	2 large closets • Double tanks
Hitch weight—260 lbs.	Hitch weight—310 lbs.	Wall mount stove fan	Broom closet • 16-ft. awning rail
Box section frame	Box section frame	Apartment stove • Trunk door	Gear operated windows
Two 1¾" axles	2¼" axle	Divan front • Escape rear window	Aircraft curtains • Twin beds
Four 700-15 6 ply tires	700-15 8 ply tires	Inlaid linoleum • Porch light	Touch control built-in step
Electric brakes	Electric brakes	Double sinks • Outside outlet	Warp-free hollow core doors
		Hot water heater • Steel bumper	2" aircraft insulation

SINCE 1932 THE WORLD'S FINEST LIGHTWEIGHT TRAVEL TRAILERS

AIRSTREAM TRAILERS INC. • 1755 N. MAIN ST. • LOS ANGELES 31, CALIFORNIA

SALES BROCHURE
(above) This pamphlet details your ability to take all the comforts of home with you. The "Overlander" was both modern, and large, but by no means, the largest.

LIPSTICK
(left) This brochure photograph demonstrates the superior reflective qualities of the polished aluminum skin.

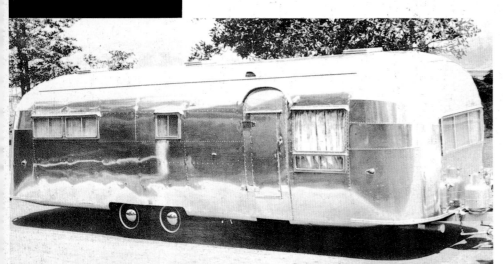

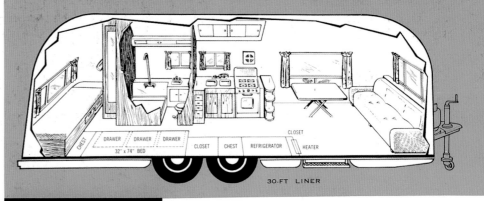
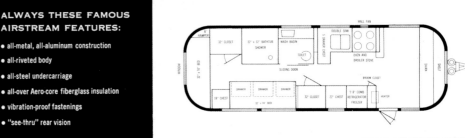
SALES BROCHURE
(above) The brochure's text for the 30-foot "Liner" really says it all. Each year new models were improved upon, and the technical improvements and featured are outlined.

NEVADA
(right) The beautiful Singing Sands Mountain, 1966.

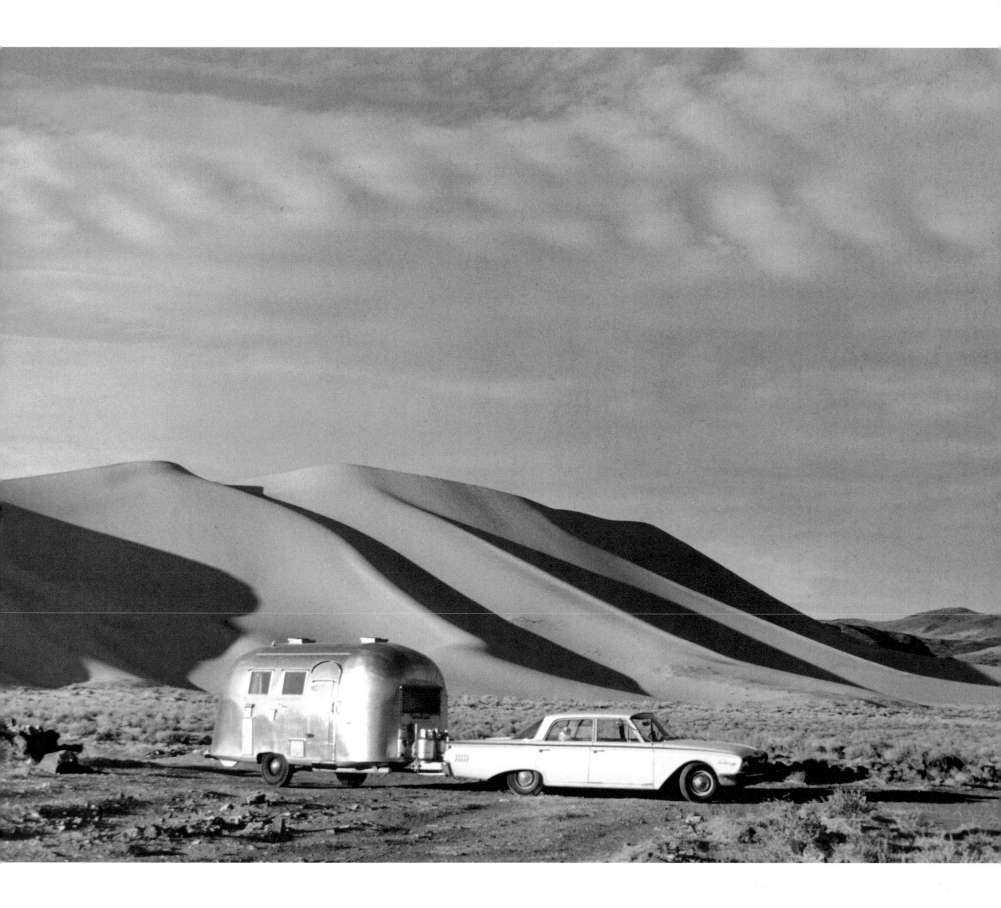

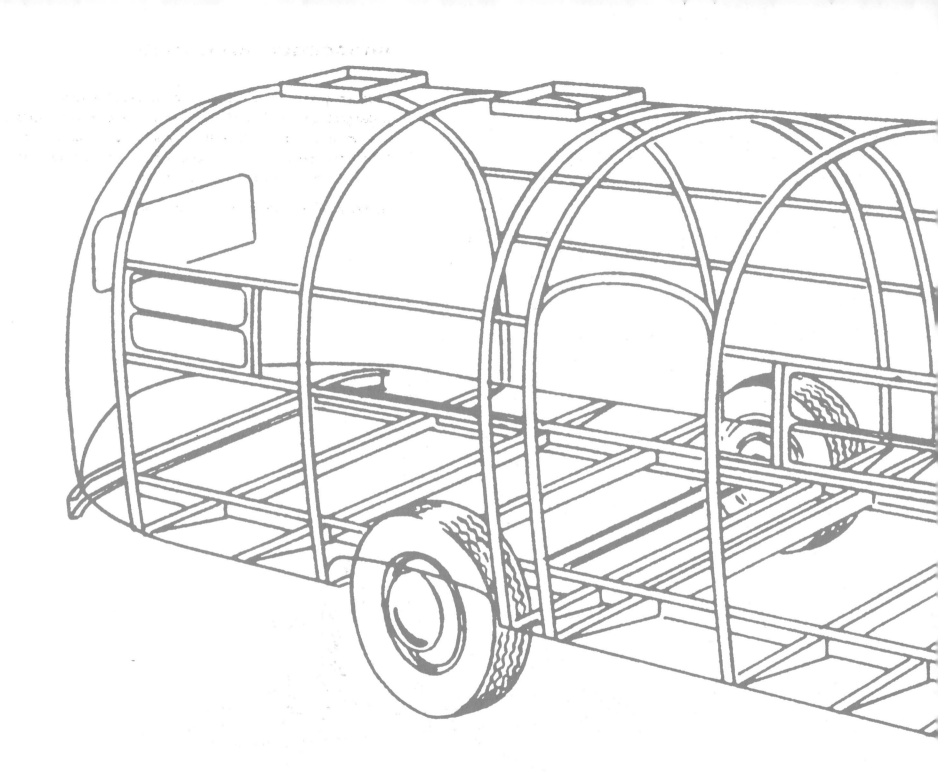

NEVER LEAVE WELL ENOUGH ALONE

MONOCOQUE (män′ə kōk′, -käk)

mono + coque, a shell. L. *coccum*, cocoon. a seed. a berry.

1. designating or of a kind of construction, as of an airplane fuselage, in which the skin or outer shell bears all or most of the stresses.

2. designating or of a kind of construction, as of an Airstream trailer, in which the body and chassis are one unit.

Etymology: French, from mon- + coque shell.

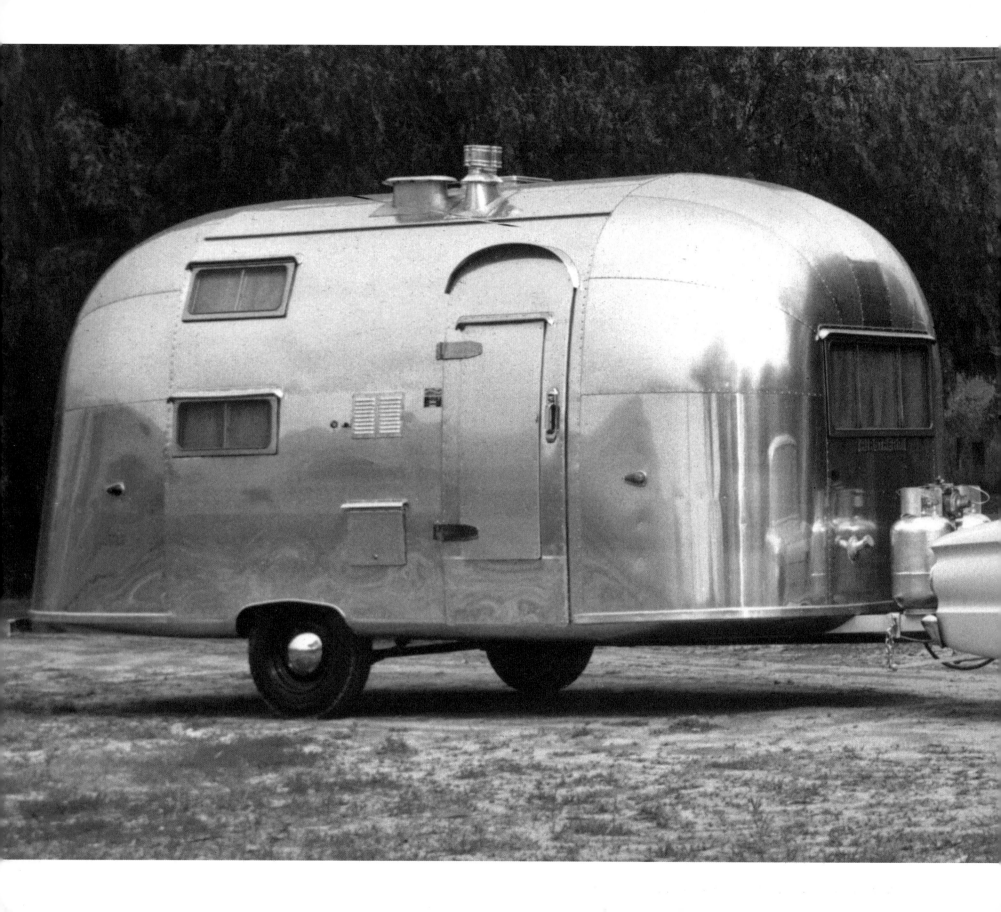

AIRSTREAM AND FORD (above) Promoting their respective "Falcons," 1964.

AIRSTREAM FLOOR PLANS

T H E 1 9 6 3 A I R S T R E A M F L E E T

THE 1963 AIRSTREAM

FLEET OFFERS YOU A

WIDER SELECTION THAN

ANY OTHER TRAVEL

TRAILER...13 EXCITING

MODELS, RARING AND

DARING TO GO. ONE

OF THEM IS MEANT

FOR YOU!

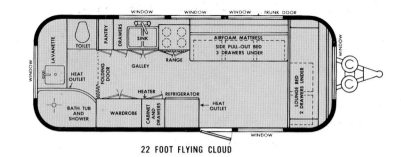

22 FOOT FLYING CLOUD

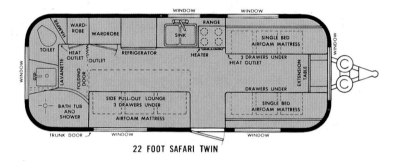

22 FOOT SAFARI TWIN

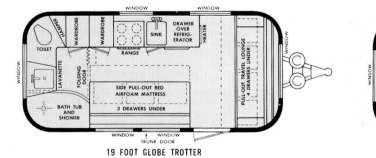

16 FOOT BAMBI

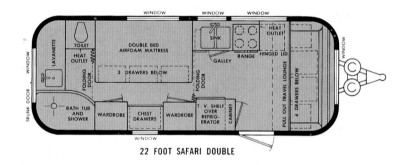

22 FOOT SAFARI DOUBLE

19 FOOT GLOBE TROTTER

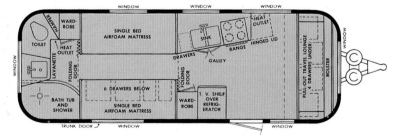

24 FOOT TRADE WIND TWIN

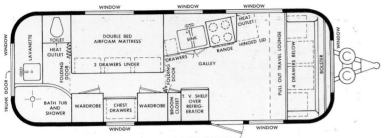

24 FOOT TRADE WIND DOUBLE

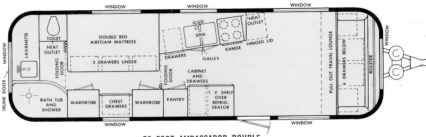

28 FOOT AMBASSADOR DOUBLE

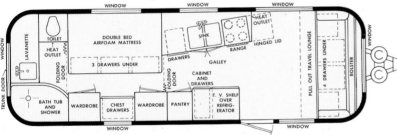

26 FOOT OVERLANDER TWIN

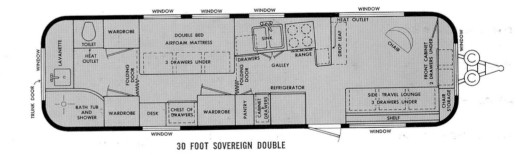

30 FOOT SOVEREIGN TWIN

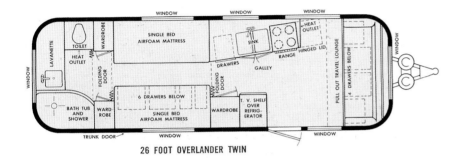

26 FOOT OVERLANDER DOUBLE

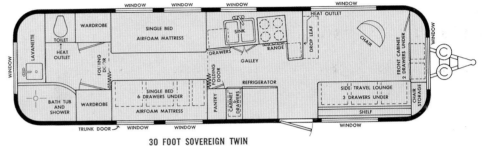

30 FOOT SOVEREIGN DOUBLE

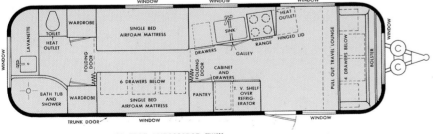

28 FOOT AMBASSADOR TWIN

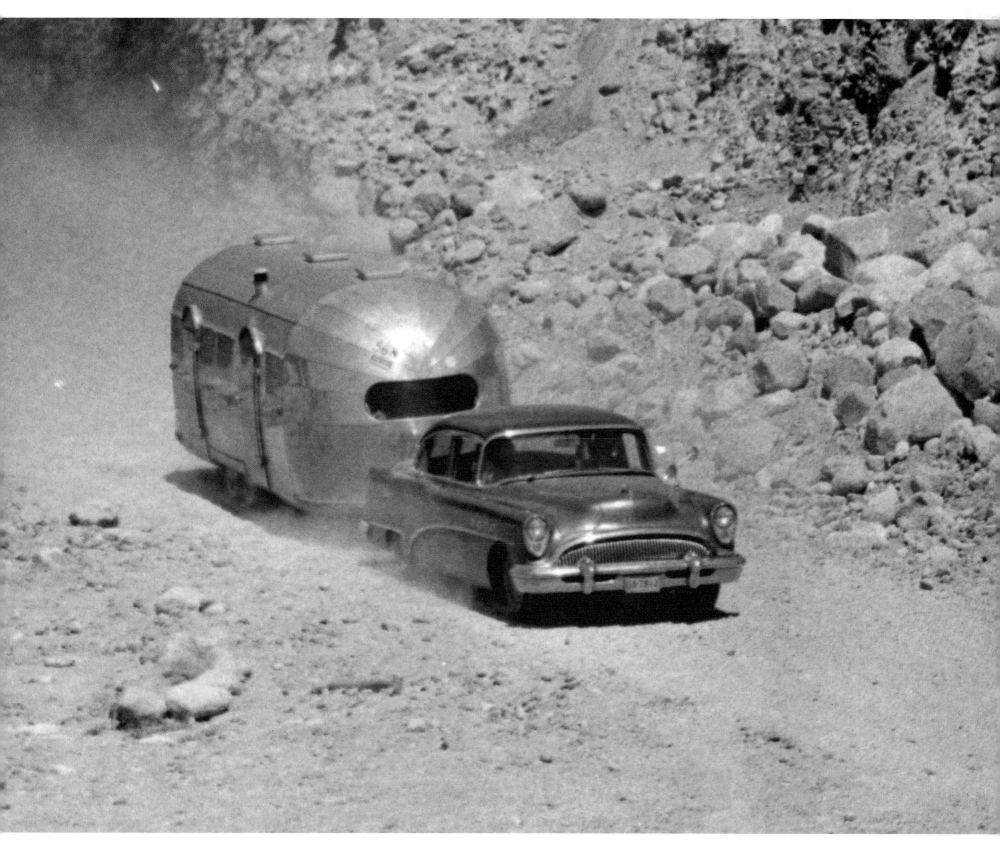

DISCOVERING BACKROADS (above) On the Central America Caravan, 1956.

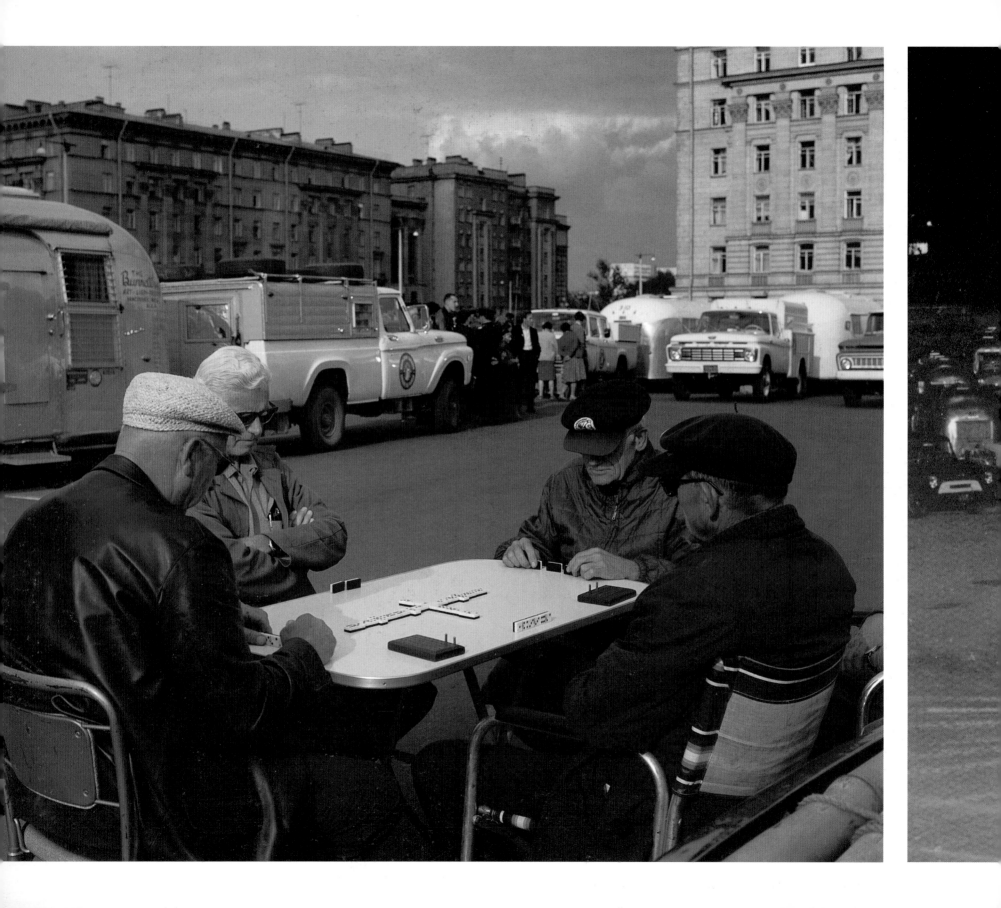

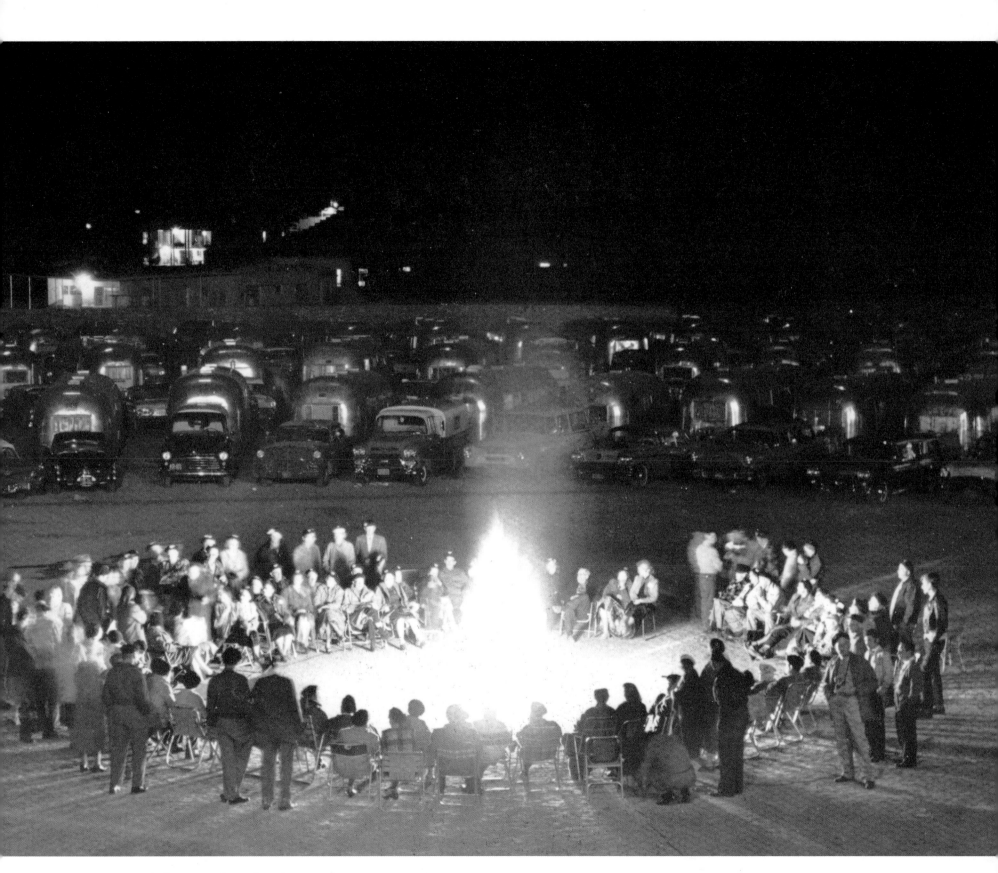

COMMUNITY (left) In Moscow, Russia. (above) A real bonfire, at an Airstream rally.

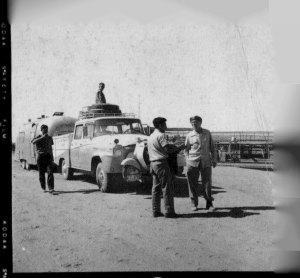

GJS-480-1

GJS-480-5

GJS-480-9

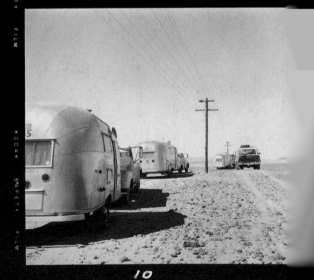

2

6

10

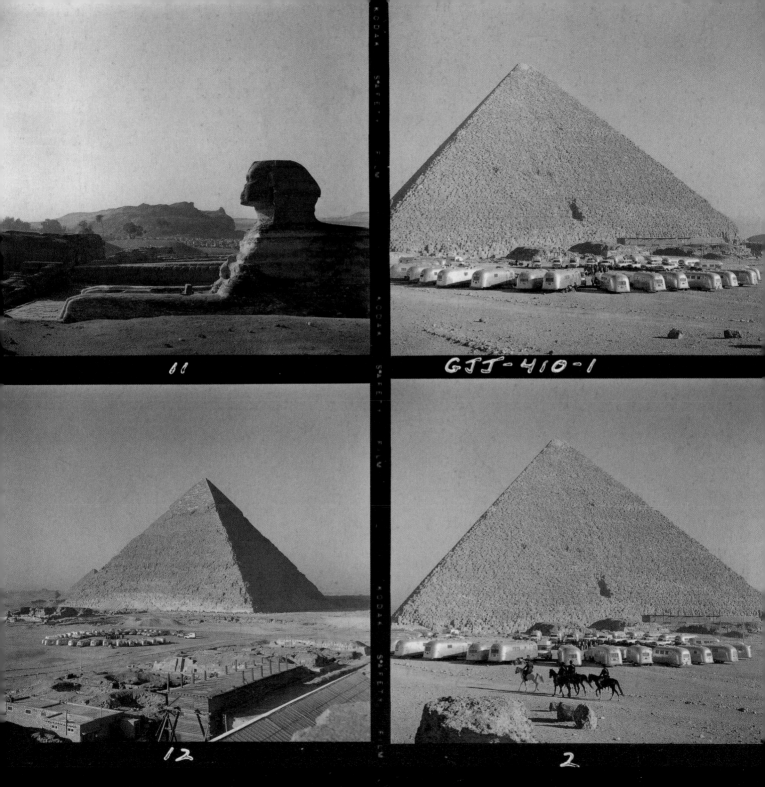

GJT-410-1

CAPE TOWN TO CAIRO CARAVAN, 1959
(above) Photographs of Airstream Wagon Wheel, Egypt.
(left) Broken hitches, beautiful landscape.

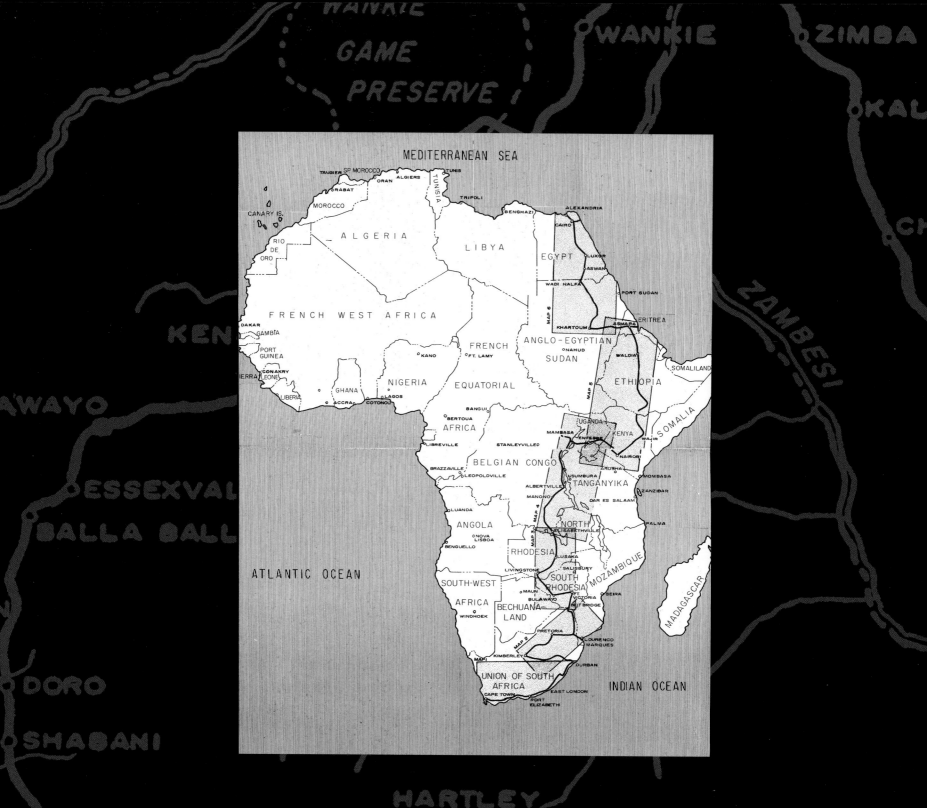

CAPE TOWN TO CAIRO CARAVAN, 1959
(above) Map of Africa delineating the route of Wally Byam's Cape Town to Cairo Caravan.
Map by Barton Wright..
(right) The log of days and miles.

1959 DAY AND MILEAGE SCHEDULE OF CAPE TOWN TO CAIRO CARAVAN

Date	Location	Miles	Days
June 30	Cape Town—**South Africa**		
July 13	Mossel Bay	239 miles	
July 14	Oudtshoorn	57 miles	2 days
July 16	Knysna	80 miles	
July 17	Jeffrey's Bay	125 miles	
July 18	Port Elizabeth	52 miles	2 days
July 20	East London	195 miles	
July 21	Umtata	143 miles	
July 22	Margate	201 miles	2 days
July 24	Durban	96 miles	
July 29	Ladysmith	160 miles	
July 30	Bethlehem	120 miles	
July 31	Bloemfontein	159 miles	2 days
Aug. 02	Kimberley	111 miles	
Aug. 04	Klerksdorp	197 miles	
Aug. 05	Farm	80 miles	
Aug. 06	Johannesburg	60 miles	4 days
Aug. 10	Pretoria	36 miles	3 days
Aug. 13	Nelspruit	200 miles	
Aug. 15	Komatipoort	80 miles	2 days
Aug. 16	Skukusa	90 miles	2 days
Aug. 18	Letaba	105 miles	3 days
Aug. 21	Shingwidzi	70 miles	3 days
Aug. 24	Louis Trichardt	143 miles	
Aug. 25	Lion and Elephant Motel	135 miles	
	Southern Rhodesia		
Aug. 26	**Zimbabwe**	100 miles	
Aug. 27	Bulawayo	200 miles	4 days
Aug. 31	Wankie National Park	177 miles	3 days
Sept. 03	Victoria Falls	140 miles	4 days
Sept. 07	Monze (N. Rhodesia)	173 miles	
Sept. 08	Lusaka	134 miles	2 days
Sept. 10	Ndola	195 miles	
Sept. 11	Mufulira	153 miles	
Sept. 12	Elisabethville	121 miles	4 days
	Belgian Congo		
Sept. 16	Bunkeya	135 miles	
Sept. 17	Kiubo Falls	63 miles.	
Sept. 18	Mitwabe	154 miles.	
Sept. 19	Manono	125 miles	
Sept. 20	Congo Village bear Kiambi	64 miles	
Sept. 21	Kashieke	98 miles	
Sept. 22	Albertville	94 miles	3 days
Sept. 25	Unused Sabena Airstrip	118 miles	
Sept. 26	Usumbura (Urundi)	146 miles	
Sept. 27	Bukavu (Congo)	100 miles	4 days
Oct. 01	Kisenyi (Rwanda)	145 miles	
Oct. 07	Ruindi Camp	80 miles	
	(Alberta National Park, Congo)		
Oct. 08	Lubero	80 miles	
Oct. 09	Beni	80 miles	
Oct. 10	Mambasa	93 miles	2 days
Oct. 12	Mt. Hoyo	70 miles	
Oct. 13	Beni	75 miles	
	Uganda		
Oct. 14	Queen Elizabeth National Park	82 miles	
Oct. 16	Fort Portal	82 miles	
Oct. 17	Kampala	207 miles	3 days
Oct. 20	Tororo	135 miles	
Oct. 21	Nakuru	181 miles	
	Kenya		
Oct. 22	Nairobi	97 miles	14 days
Nov. 05	Nanyuki	0 miles	
Nov. 06	20 miles north of Isiola	208 miles	
Nov. 07	Habeswein	-miles	
Nov. 08	On desert north of Wajir	-miles	
Nov. 09	Airstrip	-miles	
	(6 miles south of Ethiopian border)		
Nov. 10	4 miles north of Moyale	10 miles	
	Ethiopia		
Nov. 11	31 miles north of Moyale	27 miles	
Nov. 12	96 miles north of Moyale	65 miles	
Nov. 13	Dawa River	90 miles	2 days
Nov. 15	25 miles north of Dawa River	25 miles	
Nov. 16	Neghelli	32 miles	3 days
Nov. 19	45 miles north of Neghelli	45 miles	
Nov. 20	49 miles north of Neghelli	4 miles	
Nov. 21	55 miles north of Neghelli	6 miles	
Nov. 22	Adola	42 miles	2 days
Nov. 24	Irgalem	103 miles	
Nov. 25	Addis Ababa	205 miles	14 days
Dec. 09	Debra Berhan	-miles	
Dec. 10	Kambolchia	-miles	
Dec. 11	Dessie	270 miles	
Dec. 12	Alomata	145 miles	
Dec. 13	Quiha	90 miles	
Dec. 14	Senafe	-miles	
Dec. 15	Asmara	195 miles	3 days
Dec. 18	Massawa	60 miles	4 days
Dec. 22	Asmara	60 miles	4 days
Dec. 26	Agordat	108 miles	
Dec. 27	Tessenei	-miles	
Dec. 28	Kassala	165 miles	
	Sudan		
Dec. 29	Khartoum	290 miles	13 days
Jan. 10	Khartoum on flatcar	-miles	
Jan. 11	En route to Wadi Halfa	-miles	
Jan. 13	Wadi Halfa	584 miles	
Jan. 16	On Nile river barge	-miles	
Jan. 17	Aswan	260 miles	12 days
	Egypt		
Jan. 29	Edfu	-miles	
Jan. 30	Luxor	145 miles	3 days
Feb. 03	Selah	-miles	
Feb. 04	El Minya	-miles	
Feb. 05	Giza	-miles	4 days
Feb. 09	Cairo	427 miles	8 days
Feb. 16	Alexandria	132 miles	3 days
Feb. 19	Aboard M.S. Massala on Mediterranean Sea		

Time in Africa: 221 days
Overnight Stops 99
Mileage on Truck 14,307

Original Schedule

July 7 thru Dec. 4, 1959

the beginning of the caravan

Pick up any issue of *Condé Nast Traveler* and regale yourself with lithe models posing in this season's latest fashions at the base of Mayan ruins. Check out the photographers outfitted in khaki safari gear crouching to take photos of a lush, verdant rainforest as their raft slowly glides down a river in the Brazilian jungle. Start compiling a list of all the hip new boutiques in a trendy London shopping district, then turn the page to see fishermen trawling their nets in a crowded Singapore harbor. Close the magazine and ask yourself if this armchair traveling satisfies the wanderlust of your imagination, or if it just leaves you with a restless, uneasy feeling.

For those who first encountered the ruins on the Acropolis or the mosaics of a Turkish mosque in a seventh-grade history book, the soft-focus blur of a teeming Indian bazaar in a weekend get-away brochure, or monthly installments of a honeymooning couple clad in billowing linen, crystalline waves lapping at their feet, photographs may provide all the illusory, hassle-free travel one needs. Others are drawn to prepaid seven-day/six-night, luxury Club Med packages, where all activities are planned in advance and the only thing to stir your sense of adventure is the mystery of who you'll be sitting next to at the "authentic" Hawaiian luau, or which Speedo-clad snorkeling instructor will lead you through those shallow reefs. These trips give new meaning to the phrases "comfort zone" and "leave

ETHIOPIA (left) Caravan winds its way through the scenic mountains of Ethiopia, 1959. Map by Barton Wright.

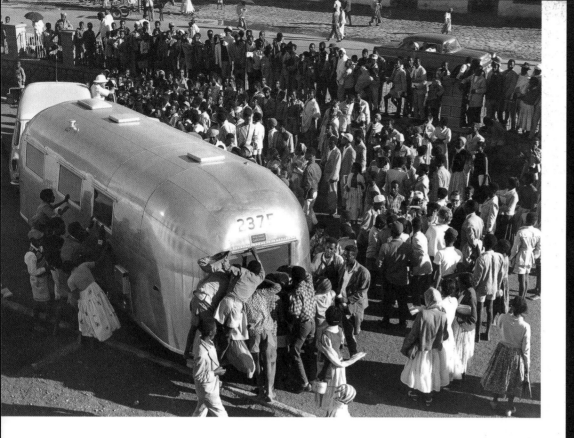

ETHIOPIA
(above) People form a crowd around a new arrival. At right, Ethiopian school children are photographed while peering into the rear window.

your troubles behind" in that, at best, they exist as temporary escapes from the day-to-day grind of life, while more often than not they serve as a substitute for actually hitting the road and controlling your own destiny—taking in exotic cultures in their natural habitat without a fixed schedule or tour guide.

Members of the Wally Byam Caravanners Club International (or WBCCI) found themselves sipping scalding-hot tea laced with she-camel milk, rather than guzzling mai-tais on a beach towel, steps from their own private cabana. The monkeys that hung from the trees were real, not plastic swizzle sticks swirling in a blue drink. "Caravan" simply refers to a long line of trailers traveling single file through an agreed-upon region, taking in the local sights as they go. The Byam caravans began in the late 1950s when Wally and a few others expressed a desire to see the rest of the world. A caravan will stop at an ostrich farm in the

"I've got so many keys to so many cities, I'm going to start a museum just for keys."

Wally Byam

middle of the uncharted African desert and break an egg big enough to make a twenty-serving omelet, rather than eat American waffles and pancakes, imported as a taste of home by an upscale resort catering to tourists. And while time-shares, condos, and chalets continue to dot the well-traveled tourist routes, caravanners are only limited by a flat expanse of land, usually an abandoned airstrip or soccer field, to make camp for the evening, hooking up to the nearest water supply.

The WBCCI caravans were a way for trailer enthusiasts to engage in a give and take with a native people who are as curious about your culture as you are of theirs. On that first African Caravan in 1959, Airstreamers were happy to bestow reading material on village children who jogged behind their trailers yelling, "Buk please, buk." School kids in Ethiopia who had been taught English from a battered seventh-grade Canadian speller and a book by Sir Arthur

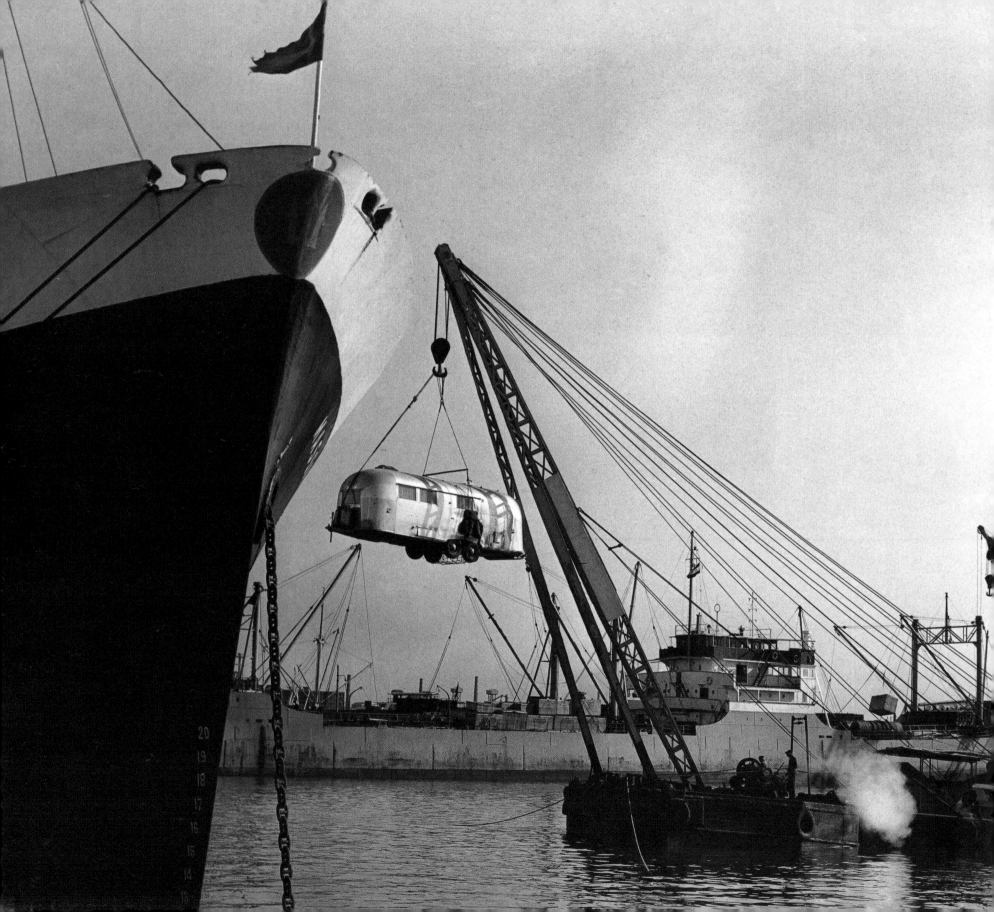

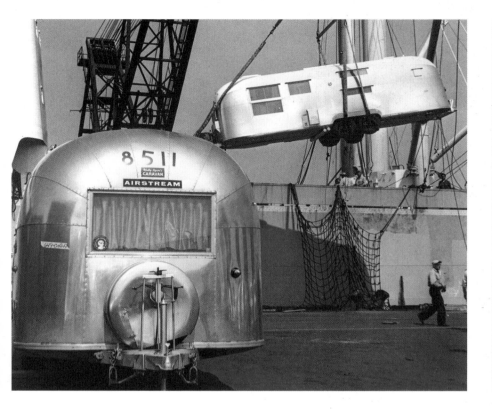
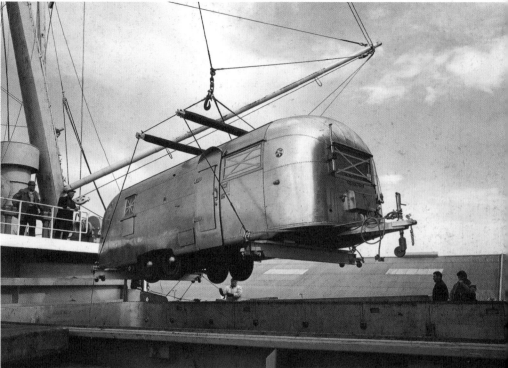

TRAILER AS CARGO
(left and above) Several views of Airstreams being loaded on and off cargo ships.

Conan Doyle were desperate for anything with English words in it. Natives in Bechuanaland parted gratefully with gifts of seashell necklaces, and the favor was returned in the form of medicines and instruments from caravan doctors. Spear and arrow collections, axes, bows, snake skins, hides, and drums were accepted as mementos from villagers in exchange for clothes and soap, and sure beat returning home with a kitschy pinata or sombrero from a tacky Tijuana roadstand.

Worlds away from the international jet set that descends from first class loaded down with Louis Vuitton trunks, hopping into a taxi that shuttles them to the air-conditioned luxury of the Bali Hilton, a caravanner will travel "schooner rigged," carrying only the essentials, with the hatches battened down to prevent supplies from flying all over the cabin on rough, bouncy roads. In fact, before embarking on a caravan, it's generally recommended to conduct a trial "shakedown cruise" or test drive around your neighborhood to make sure that pots, pans, tools, books, and anything else you might need stay in their respective cabinets.

When caravanners arrive at the "bivouac point," the meeting place for trailers at the beginning of a trip, they can look around and see people from all walks of life—doctors, nurses, executives, contractors, engineers, ranchers, merchants, and farmers—and know they will learn as much about cooperation with different people from their own culture as they will with people from Japan or Holland. The relatively low cost of trailer travel and the simple prerequisite of a love of adventure do not discriminate in the same way that expensive airfare and penthouse suites do.

Caravans have always crossed class, age, and professional lines, and they always will. A trip for two to Paris on your honeymoon is one thing, but if you want to give your children a firsthand view of the world that beats any book

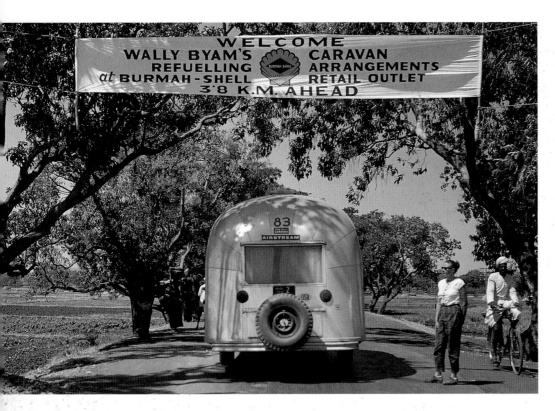

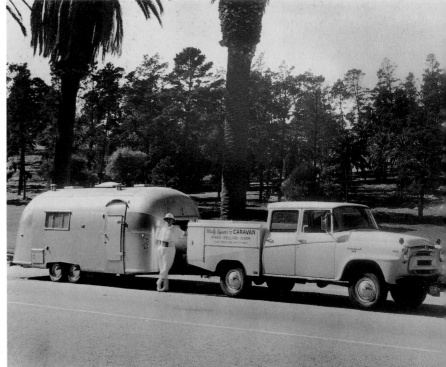

report they might give in grammar school, trailers are unparalleled. Ask the thirteen families who brought children on the 1959 African tour, and they will tell you that seeing the zebras, giraffes, wildebeests, and spotted hyenas in the 8,000-square-mile preserve of Kruger National Park will top a trip to the local zoo any day. Even the upper-class residents of Cape Town whom the caravanners met as they embarked on their trip spoke longingly of Victoria Falls with no intention of ever visiting it. They thought the caravan was impossible and were amazed to find that there were no maids for laundry and cleaning, or chauffeurs to drive the tow cars.

While Airstream promotional literature of the 1960s may have touted the ease of trailer travel in relation to conventional tourism, crossing 13,000 miles of African desert is not something one does on a whim. Extensive preparations, including vaccinations for smallpox, typhoid,

tetanus, cholera, and yellow fever, need to be made. True, you "ignore timetables, tickets and crowds; you snub taxis and porters and restaurant queues; forget about luggage packing and unpacking, toting and tipping; public washrooms are a thing of the past for you"; but possessing an Airstream does not immediately confer the carte blanche that allows you to show up in Thailand without a passport, visa, or international driver's license. Books must be read, maps should be consulted, and a hierarchy of command needs to be established even before the trailers are lifted by giant cranes onto the ships that will transport them across the ocean. In Africa, the water purification process alone involved treating the water with chlorination powder, running it through a charcoal filter, boiling it for twenty minutes, and then cooling it in plastic containers—all for a cool drink at the end of the day.

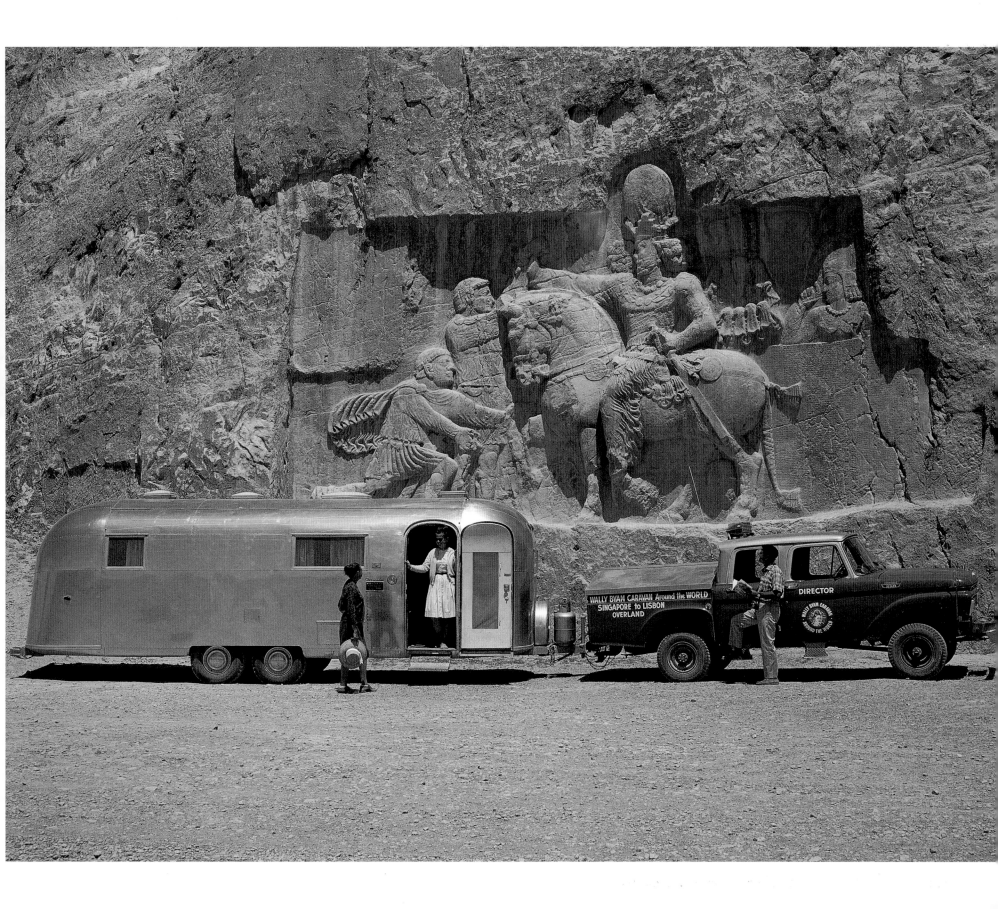

In 1959, there were no signs along the road through the
Belgian Congo offering rest stops to refuel and refresh.
The "thunder mugs," or crude chamber pots that were used
before plumbing was added to trailers, could not simply
be emptied on the side of the road as the caravanners
broke camp, so they devised a small wooden cart that
sewage was dumped into that came to be known ironically
as a "honey wagon"–transporting the refuse to an open
pit, or "gopher hole," that could later be piled with dirt
or sand. Wally consulted with national gas company
representatives in advance so that the hundreds of gallons
of fuel the trailers needed would be waiting when they
crossed national borders. His familiarity with octane levels
all over the world prompted him to say at one point,
"Spanish gas is easily the worst in the world, just one step
ahead of crankcase drainings, and guaranteed to make a
high compression engine sound like a threshing machine."

Once the caravan was underway, while Wally was
busy consulting diplomats to assure safe passage and
finding mechanics to fix the endless flat tires, broken rims,
and cracked frames, it became more and more clear that
a hierarchy of command was necessary to plan the
day's events and keep the line of trailers in tight formation
as a matter of safety and protection. In her book that
documented the African adventure, *Cape Town to Cairo*,
Lillie B. Douglass commented that "in Africa, beauty
and danger are never far apart. Just upstream from the
falls a sign stated succinctly: 'Swimming is suicidal
because of crocodiles.'"[12]

A "caboose" was designated as the final trailer in the
caravan line, bringing up the rear to make sure no trailer
was passed without first being asked if it needed help.
Three self-contained trucks: one for a professional
photographer, one for the advance scouts who checked
for parking sites, and a third with a full-time mechanic
that towed a small luggage trailer with spare parts–all
communicated with the other trailers via shortwave two-way

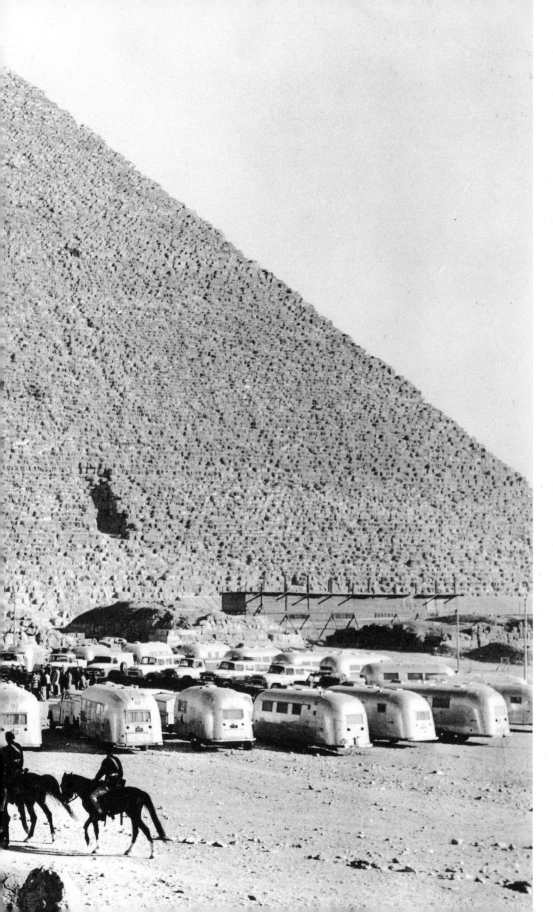

radios to stop the caravan for emergencies or warn of difficult roads ahead.

The caravan appointed a "Wagon Boss" to determine the route of the day, but that route was often simply a strip road, two narrow tarred bands on a dirt roadbed. Maps were often useless since so much of the land was uncharted, not to mention the fact that the unimproved roads that were shown were never designed to carry the weight of a trailer or made wide enough for two-way traffic. At one point, the group was forced to cross the Belgian Congo's Luvua River on a rickety ferry made of some planks and two small boats acting as pontoons. This makeshift catamaran, accustomed to carrying small cars, buckled under the weight of a trailer. Each round trip took forty-five minutes, but eventually all the vehicles made it across.

It became a running joke that a "Byam Boulevard" described a stretch of road ahead that Wally, in his perennial optimism, assured the travelers could be easily passed. As the caravanners gazed from their windows at Rwanda's snow-capped mountains, its active and quiescent volcanoes, and rolling lava plains, the trailers would often hit a "thank you, ma'am," or sharp dip or depression in the road, forcing the tow cars to lose traction, wreaking havoc on frames. The Watusi giant people must have chuckled to themselves as they farmed their thousands of terraced acres, watching the trailers in a tight, single-file military formation, winding their way precariously around mountainous curves. As they rolled into one village, a boy yelled, "Man, dig that oversized toolbox."

Although the terrain of Africa and Central America possessed the lion's share of pitfalls, frequently forcing the caravanners to pull out their nylon tow ropes to yank a trailer out of a windswept dune or craggy marsh, Western Europe was no picnic either. Trailers have a knack for getting stuck in the unlikeliest of places, and one quirky episode in France shows Wally's resourcefulness and ingenuity. "Suddenly I remembered an old Cecil B. DeMille

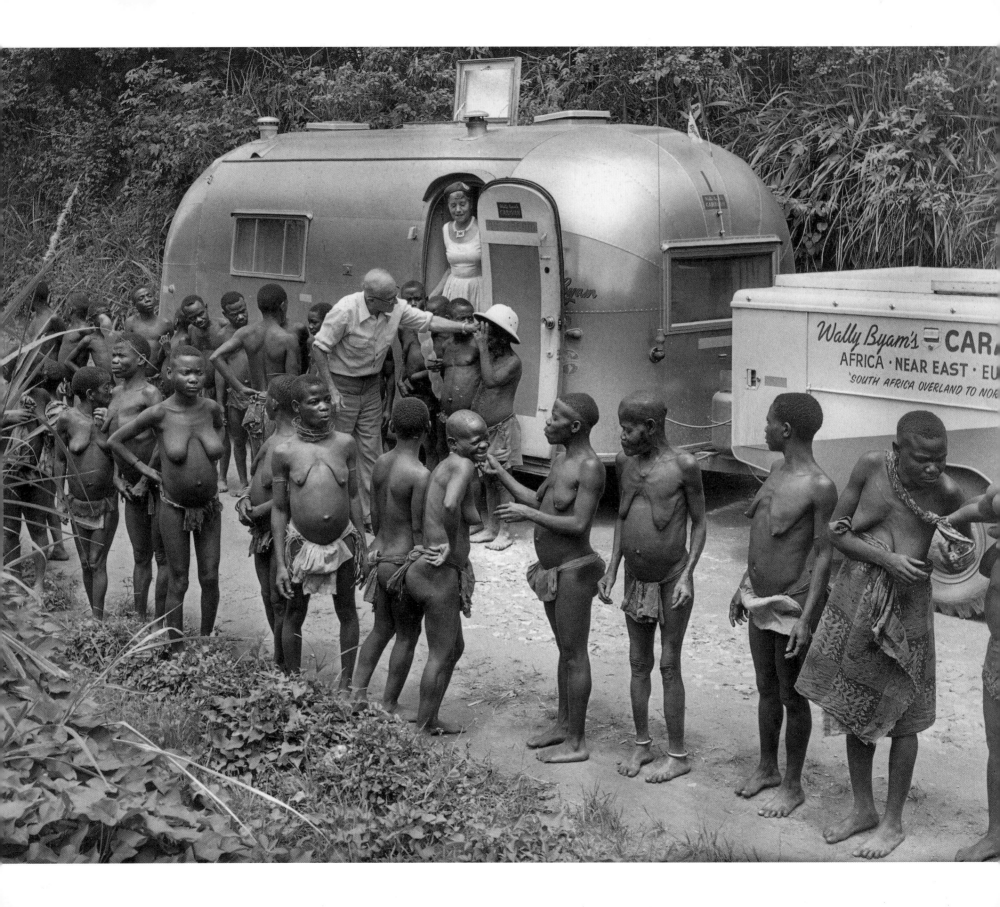

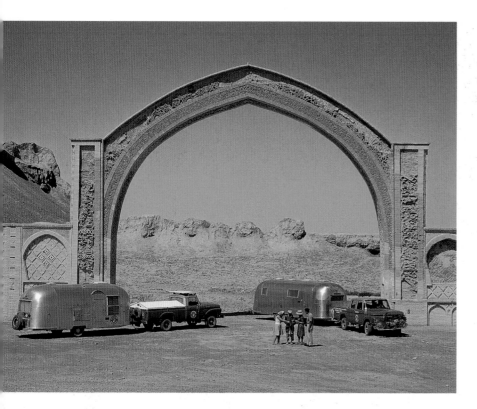

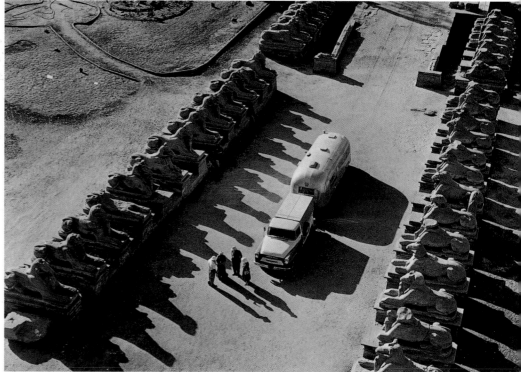

picture about the Egyptians, with a thousand Hollywood extras dressed as slaves pulling on a rope. I got out my trusty old bullhorn and managed to rally about a hundred Frenchmen. When it comes to getting a trailer out of the mud, a hundred Frenchmen on a rope are better than three-hundred horses under the hood."[13]

In scoping out the globe, Wally dreamed of eventually building "Land Yacht Harbors" for trailers to stop anywhere they might find themselves. These were to be permanent facilities similar to mobile home parks, but without year-round occupancy or foundations built underneath the trailers; that way a steady stream of guests could take advantage of them as extended way stations. The idea of a trailer as a boat adrift in an ever-widening expanse of sea seemed particularly fitting in light of the rolling sand dunes of Africa. Wally fancied himself a skipper cast out on the wide-open sea, stopping at ports of call on a sailor's furlough. Lillie B. Douglass, commenting poetically on the unexplored African continent, noted that "the world seemed a watery blur, without end, and we afloat in it."[14]

The Cape Town to Cairo trip began auspiciously with an enormous cake in the shape of Africa bearing the legend "Wally Byam Caravan Club of America–Cape to Cairo, 1959." An honor guard of twenty policemen on scooters, bearing an American and a South African flag, led forty-one trailers carrying 106 people ceremoniously through the city past ancient trees as old as the California redwoods. The travelers quickly got used to this red carpet pageantry—whether it was a band of mariachis in Mexico serenading them around a campfire till dawn or curious natives in their own country who sensed the caravanners' good-natured diplomacy. After all, they resembled a bemused group of Spanish Conquistadors, tracing the same path Bartholomew Dias had covered five years before Columbus discovered America, and later Vasco da Gama, all in the "Good Hope" of finding a trade route to India and its spices.

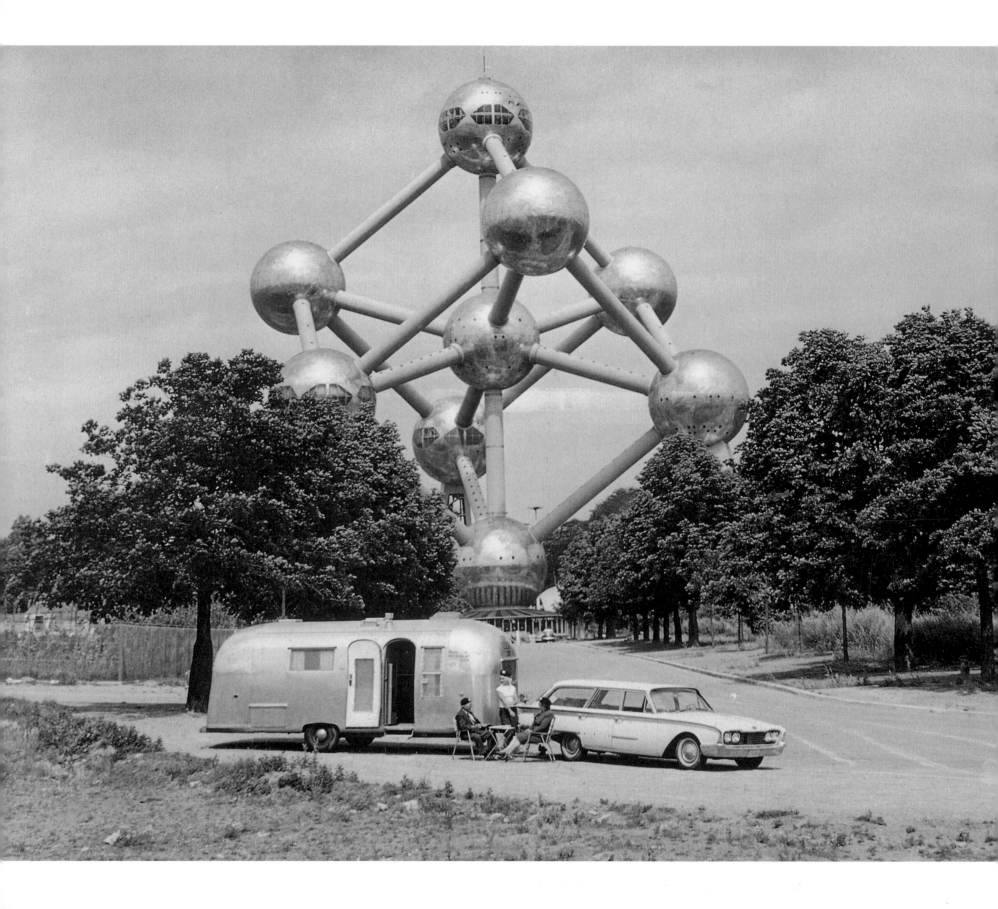

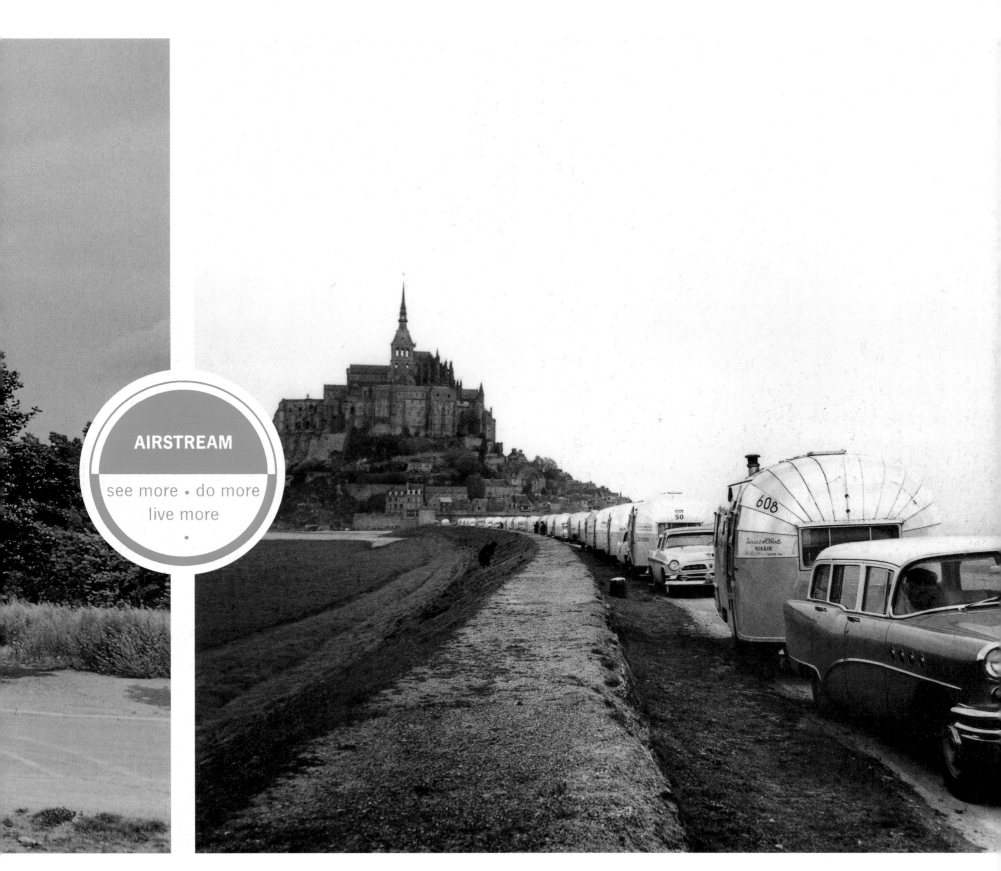

CARAVAN IMAGES (left) Atomium, Brussels, Belgium. (right) St. Michel, France.

Sometimes all it took to find a plot of land where the caravan could stop for the night was a good faith reconnaissance mission with the owners. Wally, always the ham-handed raconteur, recounted this anecdote in *Trailer Travel*:

"Our campsite on the Blackfoot Indian Reservation was magnificent—Don had smoked several pipes of peace in solemn council with the tribal leaders in order to wangle an invitation—with a backdrop of gorgeous snow-clad peaks reflected in the clear blue of the lake. Our shiny wigwam on wheels excited as much interest among the Blackfeet as their teepee village did among our junior members, anxious to check their TV absorbed Indian lore against the real thing."

At the end of the day, the caravan was relieved to set up its "sidewalk cafés"—a loose assortment of lawn chairs and tables patterned after European bistros—where the group would relax with a cool drink and mull over the day's events. These were affectionately dubbed "cow sessions," a sort of female spin on the phrase "bull session," in which everyone was given equal say in planning the next day's itinerary. WBCCI member Eunice Halifax was the first to establish the cafés, and they continue to play a large part in communal caravan life to this day.

The caravan was able to steer clear of trouble in Africa, as well as in future trips, when they realized their role was as tourists, not as United Nations ambassadors on a peace-keeping political mission. The Afrikaans locals of Dutch descent they met while getting organized in Cape Town often wined and dined them in their homes and were interested in engaging a foreign perspective on the topic of racial separation. This of course, was before Nelson Mandela's imprisonment and before the boycotting of foreign corporations investing in South Africa became a staple of U.S. activism. One confident Afrikaans couple asked some wary trailerites, "Do you not agree with our policy of apartheid? Can't you see that we must have a complete racial separation or the nine million native peo-

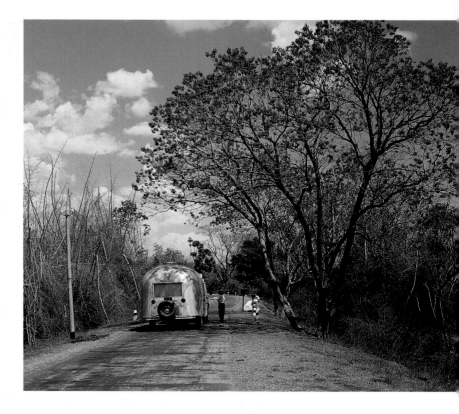

ples will gradually absorb three million European whites?"

The caravanners had enough problems getting acclimated to Africa without having to worry about the climate of racial tension and the constant threat of civil war. Thursdays and Sundays were designated as "pill days," when the travelers took their anti-malarial pills. Despite the open air markets that carried fresh fruits and vegetables, and the occasional exotic *braai vleis,* or "fry-meat"—a kind of African barbecue—the caravanners all experienced serious weight loss. A combination of the heavy manual labor required to fix trucks and trailers, and the hectic schedule they kept to, conspired to wear down even the fittest members of the group. Wally was rumored to have lost close to 30 pounds during the thirty-two-week trip.

Even so, the caravanners were lucky to have skirted real conflict. One year after they left the Belgian Congo, a bloody massacre erupted in an attack on United Nations

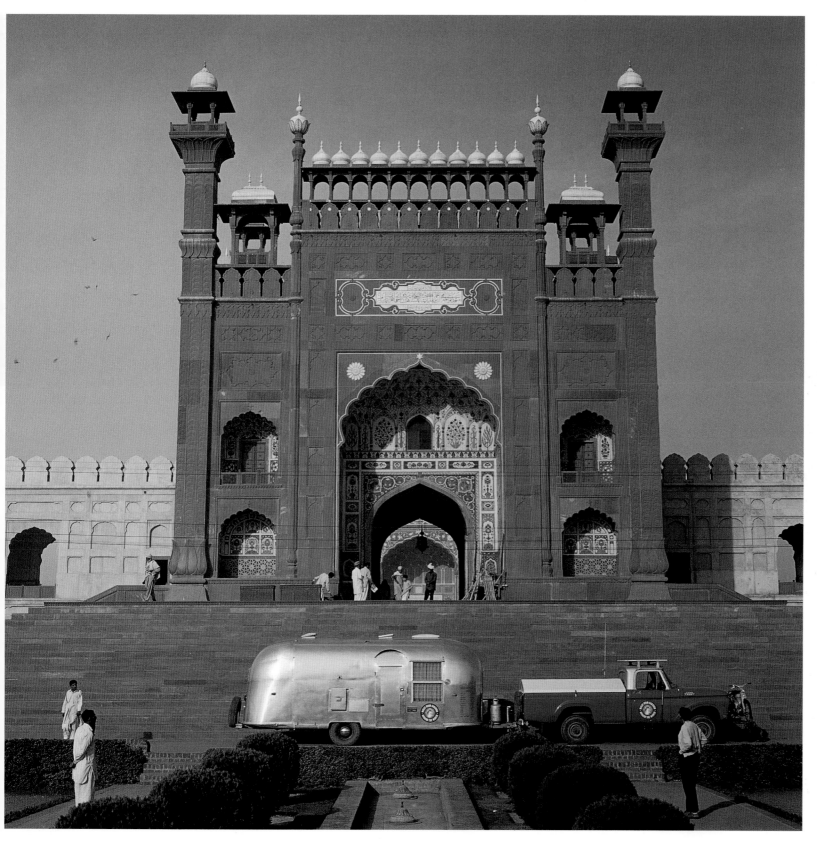

INDIA
(left) A monument outside of Hyderabad, India, was visited on the Around the World Caravan, 1965.

INDIA
(middle) Under a giant Jacaranda tree near the Mudumulai sanctuary, a short distance from Octacamund.

CARAVAN BOOKS
(far left) Caravanners documented their journeys on these large caravans, several publishing them in detailed narratives; by McGregor W. Smith, Wally Byam, Etta Payne, and Lillie B. Douglass.

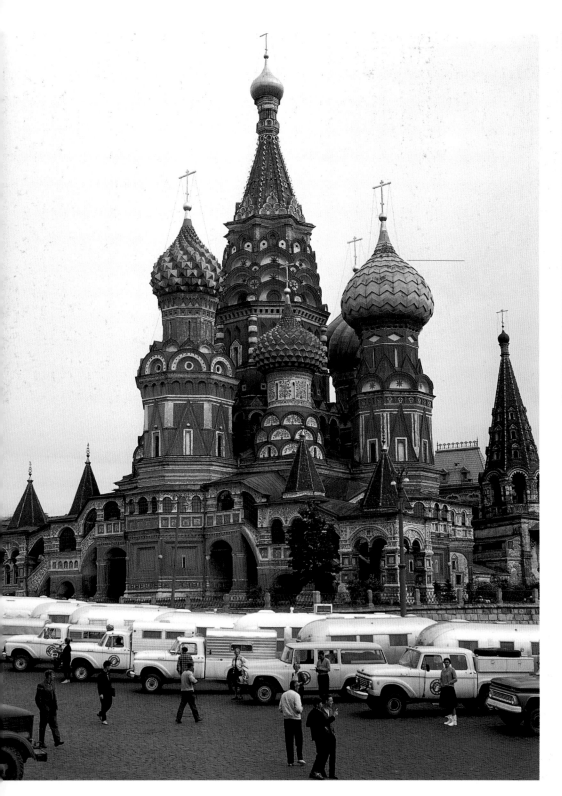

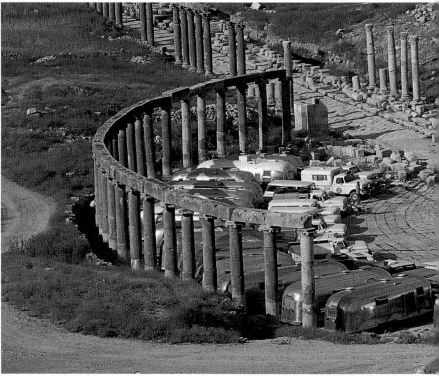

peacekeeping troops. In El Minya, Egypt, the caravan was ordered to disperse since Egypt was technically at war with Israel and trouble was in the air. When ten armed soldiers with bedrolls joined the caravan for protection in Kenya, it was clear the travelers weren't in Kansas anymore. The caravanners were more content viewing danger from a distance, like when they toured the Port Elizabeth Snake Farm and saw cobras, spitting ringhals, puff adders, boomslangs, and the deadly black mamba.

Along the way, one driver installed a platform and tripod on the roof of his truck so he could take pictures from a comfortable perch, while another snapped photos from a sunroof. The travelers were careful to obey the signs that said "Hou Links," or keep to the right side of the road, even as they yielded to elephants who, not surprisingly, claimed the right of way. Only on the streets of Bulawayo, in what was then Southern Rhodesia, were the trailers given

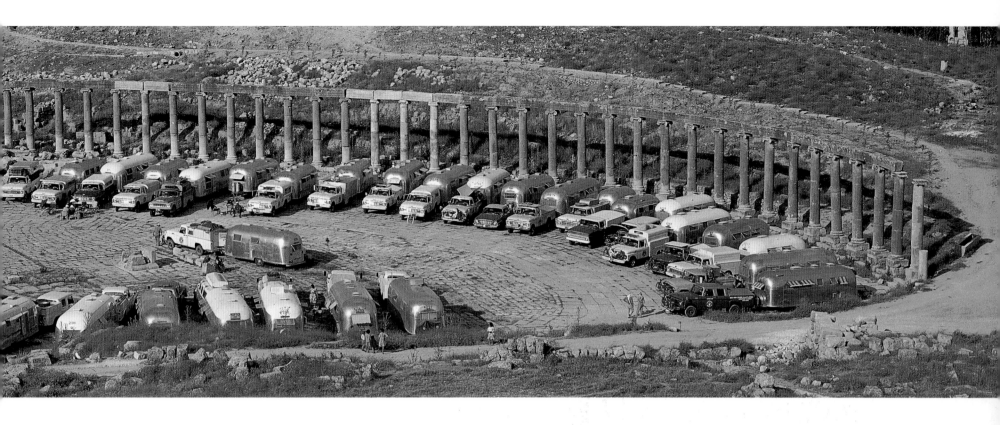

wide berth to cruise as they pleased. Here the streets were so broad a span of eight teams of oxen could easily have made a U-turn.

Wandering into a city after they set up camp, the caravanners would often mingle with the local population, who they greeted as equals, not as emblems of an exotic cultural other consigned to a scrapbook in the manner of *National Geographic*. Whenever possible, they shook hands, traded goods, inquired about daily life, and observed from a respectful distance, overcoming the language barrier with a smile and some hand gestures. In Kenya, they marveled at the pierced earlobes of the Kikuyu tribesmen that rested on their shoulders, studded with pendants, ribbons, or bits of wool yarn. They courted the shy Pygmies who at first cowered and ran away from their trailers, naked except for a loincloth of simple ficus bark, but later warmed to the gentle trailerites, demonstrating the making

of curare poison for their arrows and proudly showing off their skill in an impromptu archery exhibition.

After basking in the rainbow arches shimmering over the cascading tumult of Victoria Falls, twice as high as their homegrown Niagara, the caravanners gazed in wonder at the native rite of scarification—blue-black, glossy indentations over breasts, abdomen, shoulders, and noses. They were swept up by a throng of bicycles in the streets of Uganda, where locals wore *kansus,* or long white, beige, or pink robes, draped lightly over their more formal sportcoats, and tucked away from the spinning spokes and pedals. As the caravan postman passed out mail, the children took camel rides given by the mounted police. In the evenings, trailerites cleaned up the spilled food that had jostled to the floor on the day's shaky ride and regaled each other with memories of their trip to the African diamond mines or their stop in

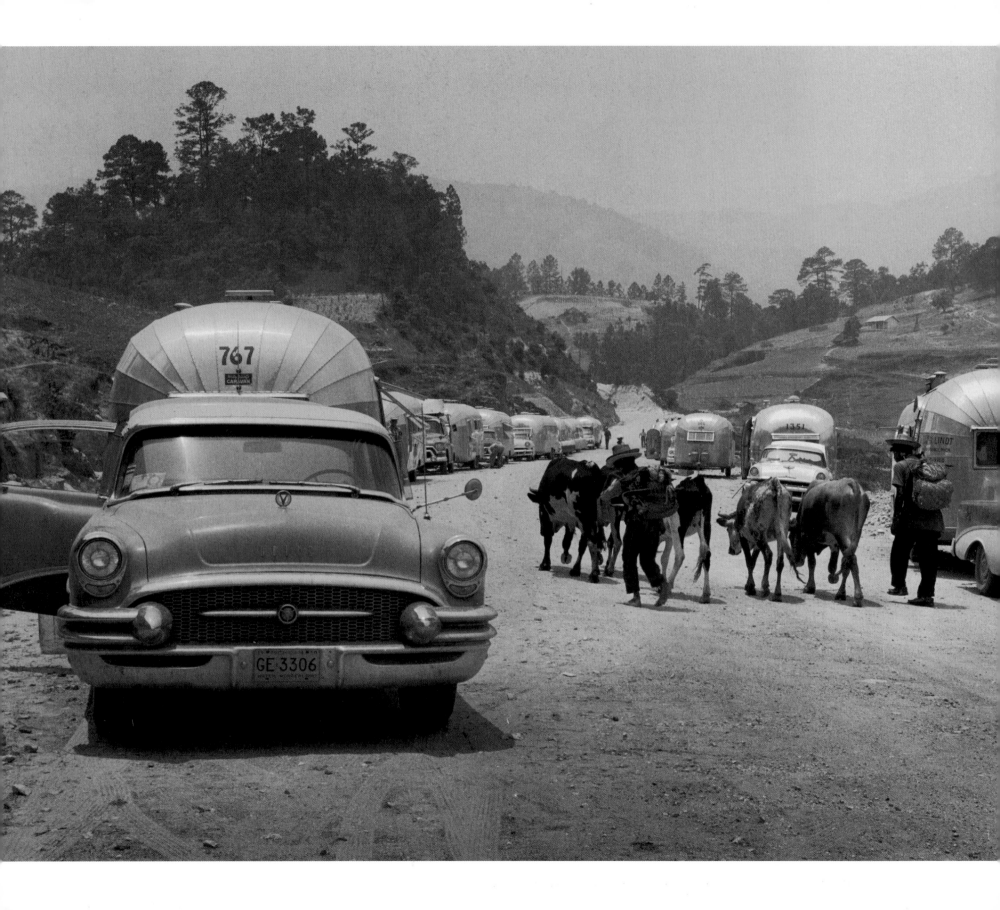

WALLY BYAM CARAVAN

AROUND THE WORLD

767

CARAVAN IMAGES (left) Central American Caravan, 1956. (right) Cape Town to Cairo Caravan, 1959

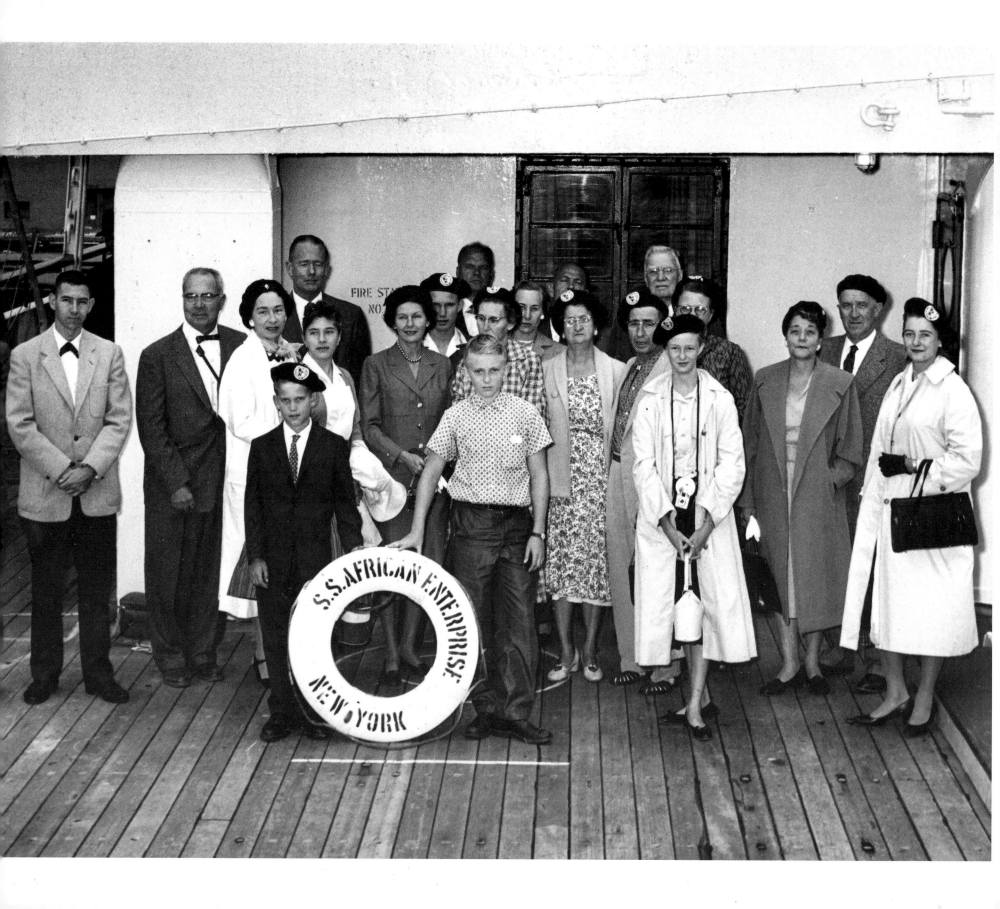

"Airstreamers don't go on trips; instead they embark on a unique way of life."

Ben Sussman

DEPARTING NEW YORK
(left) Stella and Wally Byam along with caravanners young and old set sail for Cape Town, South Africa. This is the same group shown making a wild river crossing.

NO PROBLEM
(above) Crossing Congo's Luvua River on a rickety ferry made of some planks and two small boats acting as pontoons. Not your ordinary river crossing, caravanners are not your ordinary travelers either.

Pretoria, "The Jacaranda City," noted for its taxidermist who, with a two-year waiting list for orders, was busy preparing elephant feet for coffee-table supports or stuffing a rare albino zebra skin.

At the mines in Johannesburg, they visited a diamond washing plant where a twenty-five-carat diamond was washed from the soil concentrate right before their eyes. "The Big Hole," at that time the largest man-made excavation on earth, at over 1,200 feet deep, was fiercely guarded by the "DeBeers dogs"—a crossbreed of bull-mastiff and Alsatian trained to attack or scale a ten-foot fence on command. The caravanners were sadly aware that the arranged bus tours of the city took pains to avoid the "locations" outside the city where natives worked the mines on six-, nine-, and twelve-month contracts, sequestered from their families. Unlike a carefully edited documentary travelogue for public television focusing on hippos bathing

in shallow pools or wild vervets grasping proffered cookies in their tiny paws, the caravanners were, for the most part, wise to the daily struggle and exploitation of the indigenous people. As they rode rickshaws or Zulu pedicabs (manufactured in New Jersey!) through the teeming South African streets, they reflected on the rigid class system and the rites that bonded each tribe.

Winding through the rondavels, or round huts, fashioned from a homemade adobe mixture of mud and cow dung, the caravan stopped to watch in hushed silence as worshippers adorned in blue and green ceremonial robes gathered in a small ring and began "beating the devil out of a new female convert, driving her into a catalyptic trance," in the words of Lillie B. Douglass. Perhaps the greatest tragedy of the trip was a female witch doctor in one village who, in a distraught state, hanged herself for fear that the caravanners were

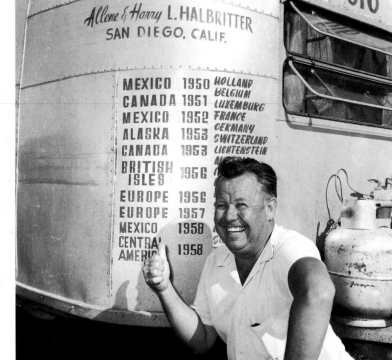

CENTRAL AMERICA
(above) Border check in El Salvador.

HAND LETTERING
(above middle) Airstream caravanners painted their travel histories on their units. Harry Halbritter shows his caravanning enthusiasm. A serious traveller.

REST STOP
(far right) At scheduled stops along the Cape Town to Cairo Caravan, caravanners take in local dance performances, trade goods, and share evening dinner in Nanyuki, Nairobi.

themselves powerful witch doctors intent on overpowering her own black magic. The travelers were assured there was nothing they could have done to prevent her death, but they still felt conflicted that their presence led to such a disaster.

They respected the religious rites of each tribe they encountered even as they practiced their own, sometimes partaking in nondenominational services that embraced a bit of African ceremony, a bit of American-style prayer—in a hybrid of rhythmic chanting with preaching from the pulpit. In one town, an American missionary conducted a church service based on the traditional "Zulu love letter," a piece of beadwork that, when bestowed, symbolizes faithfulness and friendship. The caravan always stopped for the Sabbath on Sundays and made an exception for a couple of Seventh Day Adventists who would rest on Saturdays and catch up with the rest of the trailers the next day. Like the early New England colonialists who fled England

to worship as they saw fit, the caravanners made exceptions for any organized religion among their group and were treated to some rituals distinct from their own. In Aswan, Egypt, the Muslim call to prayer was broadcasted over a loudspeaker from a mosque, and at night the same song was played over and over for six hours as entertainment.

Considering some had never towed a trailer before coming to Africa and others had merely made weekend trips, the caravanners dealt reasonably well with the minor obstacles thrown in their path. A gasoline leak in one trailer spoiled all the food that was aboard, while an extremely flammable combination of butane and gasoline in another caused a dangerous fire that was soon contained. They had begun to anticipate collapsed bridges and jack-knifed trailers splayed out in the center of a rocky pass, and they gladly traded these misfortunes for a glimpse of

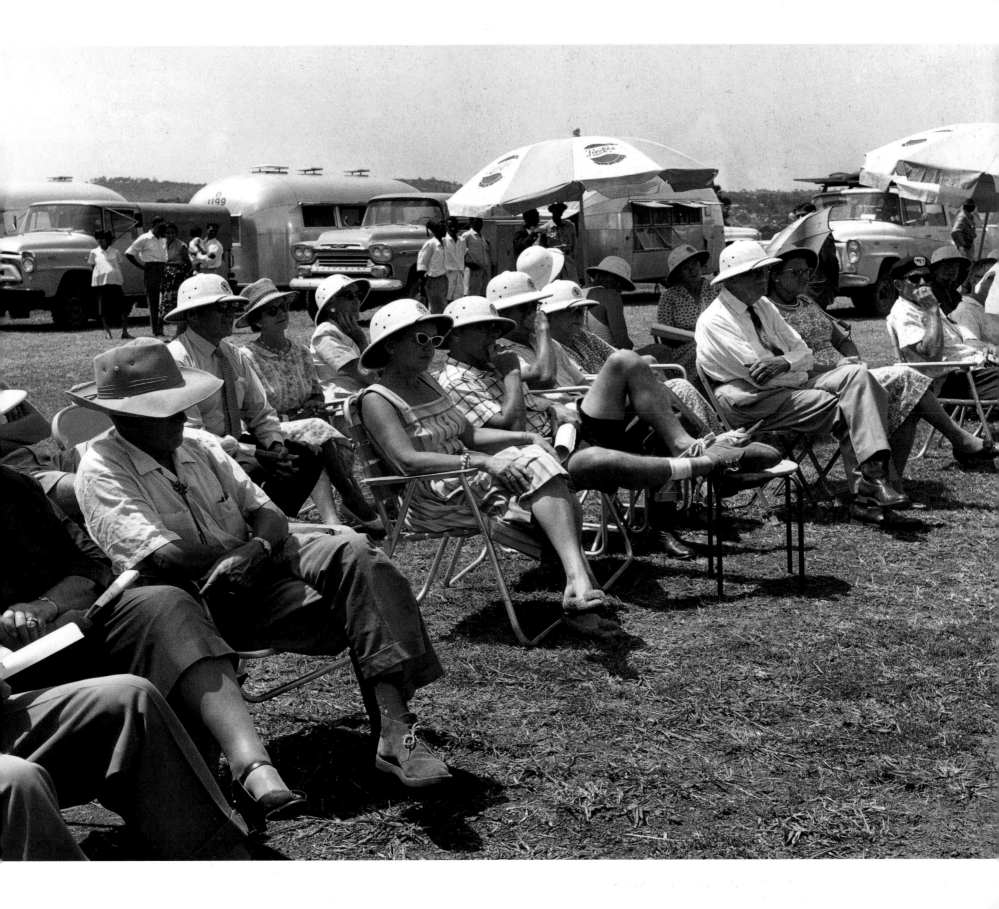

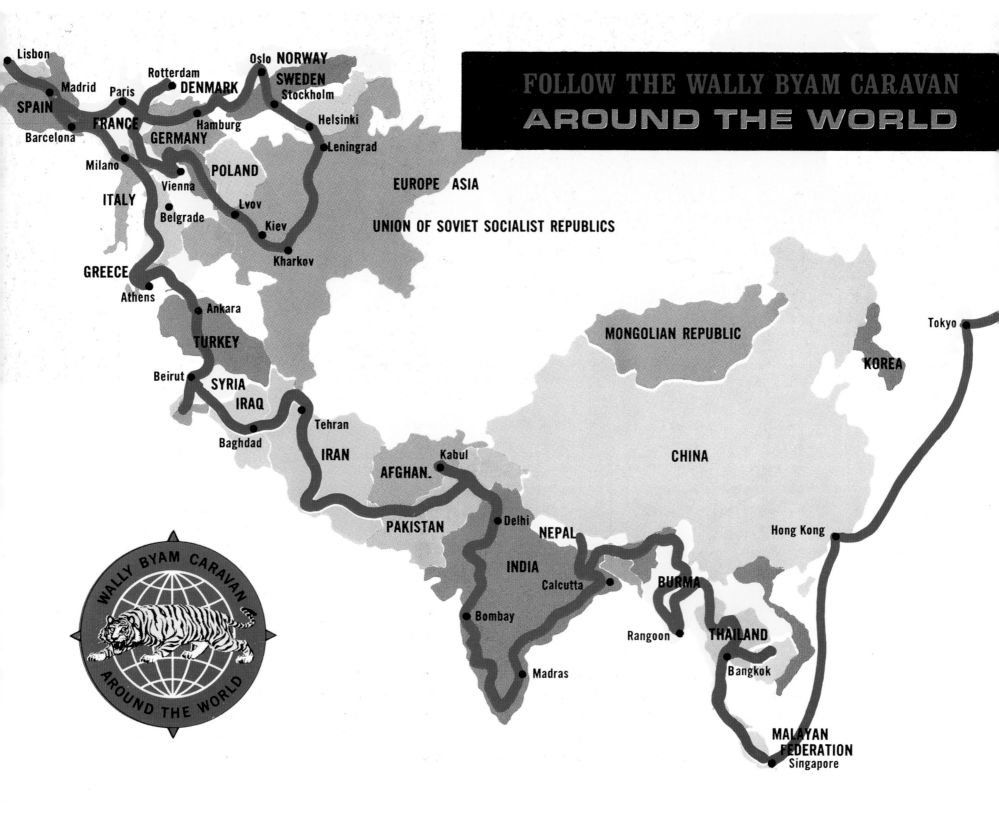

Lisbon

Madrid Rotterdam Oslo NORWAY

SPAIN Paris DENMARK SWEDEN

FRANCE Hamburg Stockholm

Barcelona GERMANY Helsinki

Milano POLAND Leningrad

Vienna

ITALY Lvov EUROPE ASIA

Belgrade Kiev

UNION OF SOVIET SOCIALIST REPUBLICS

Kharkov

GREECE

Athens Ankara MONGOLIAN REPUBLIC Tokyo

TURKEY KOREA

Beirut SYRIA CHINA

IRAQ Tehran

Baghdad IRAN Kabul

AFGHAN. Hong Kong

Delhi NEPAL

PAKISTAN INDIA

Calcutta BURMA

Bombay

Rangoon THAILAND

Madras Bangkok

MALAYAN
FEDERATION
Singapore

FOLLOW THE WALLY BYAM CARAVAN
AROUND THE WORLD

WALLY BYAM CARAVAN
AROUND THE WORLD

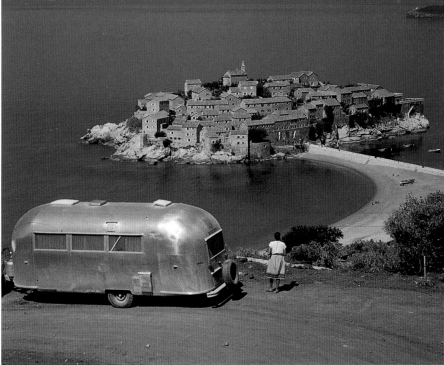

RIVER CROSSING
(above) Airstream "Bambi" crossing a river in Canada.

CARAVAN MAP
(left) The Wally Byam Caravan Club's route around the world, 1963.

YUGOSLAVIA
(above right) A caravanner stops to look at one of the jewels of the Mediterrean, Sveti Stefan.

the depths of the Great Rift Valley, which easily would contain a dozen Grand Canyons, or a day trip to the granite sarcophagus of Cheops in a 481-foot pyramid. It didn't hurt to have a sense of humor when nerves inevitably frayed. Looking back on the Central American Caravan, Wally mused, "I began to cannibalize my own trailer to repair others and finally abandoned it on the side of the road, a stripped and gaunt monument to our first Central American expedition. Years later, curiously enough, we received a letter from someone in Guatemala, ordering parts for a trailer which coincided mysteriously with the state of the trailer I had left behind."

Tracing the caravan's jagged route on a map of Africa today—through Rhodesia, Tanganyika, Ethiopia, Sudan, and finally Egypt—it's amazing how much the borders, topography, and even the names of the countries themselves have changed. As borders shift, however, some things

remain constant. Mount Kilimanjaro will always remain the "Shining Mountain" that pierces the clouds, while the ghosts of the slaves that made up Zanzibar's once-thriving slave market will always haunt the caravanners in mute reproach. The tomb of Rameses II, the fifth ruler of Egypt after King Tut, adorned with 120 likenesses of himself, has lasted centuries and shows little sign of decay. We are familiar with Stanley's famous remark to his colleague, "Dr. Livingstone, I presume?" but most people will never make it to the town of Ujiji, on Lake Tanganyika, where this occurred. True, you can visit these monuments today with your own personal guide, but how often can you barter with a remote tribe, trading a pair of jeans for a *kalimba,* a handheld piano with metal keys that is played with the thumbs, or befriend a baby antelope named Tammie, feeding it out of your hands, winning its trust, and bringing it back to America as a domesticated house pet?

Airstream Trailers are
Guaranteed for Life
—Your Life!

The trip may have ended when the caravan parked "wagon wheel" style at the base of the Sphinx, or "Father of Terror" in Egypt, but the journey from the most southern reach of the Atlantic Ocean to the Mediterranean Sea set precedents in motion that have characterized all the international caravans, and even the annual rallies that take place in the United States today. The parking committee always greets an incoming trailer with a hearty "Welcome Home" as it pulls into its allotted space. And Airstreamers never say goodbye at the end of a trip, but are content with a wave and a wistful "See you down the road," confident that one day they will meet again, whether in the streets of Milan or the mountains of the Swiss Alps.

ORIGINAL OWNER'S GUARANTEE
(above) Guaranteed for life—your life.

AIRSTREAM DETAIL
(left) Streamlined seams and blind rivets. Door detail.
Photograph: Woods Wheatcroft.

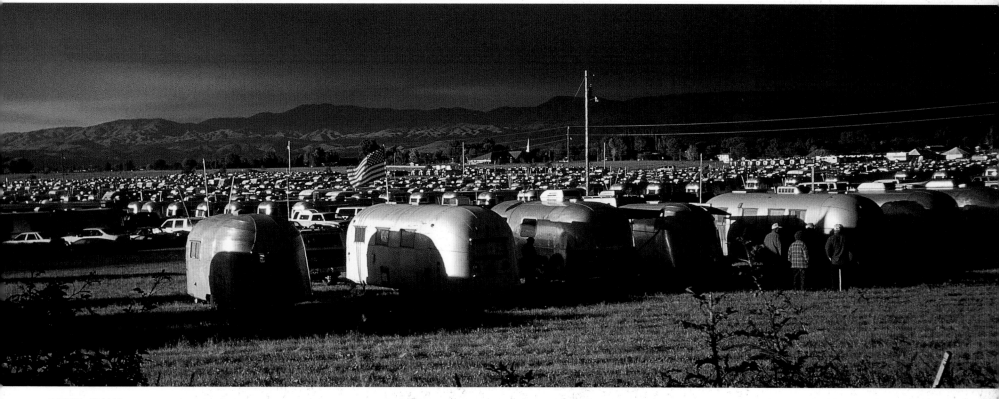

BOISE, IDAHO
(above) Over 2,500 Airstream trailers (along with their owners) gather each summer from all over the country. Many travel to the chosen site with caravan clubs from their respective states.
Photograph: Bryan Burkhart

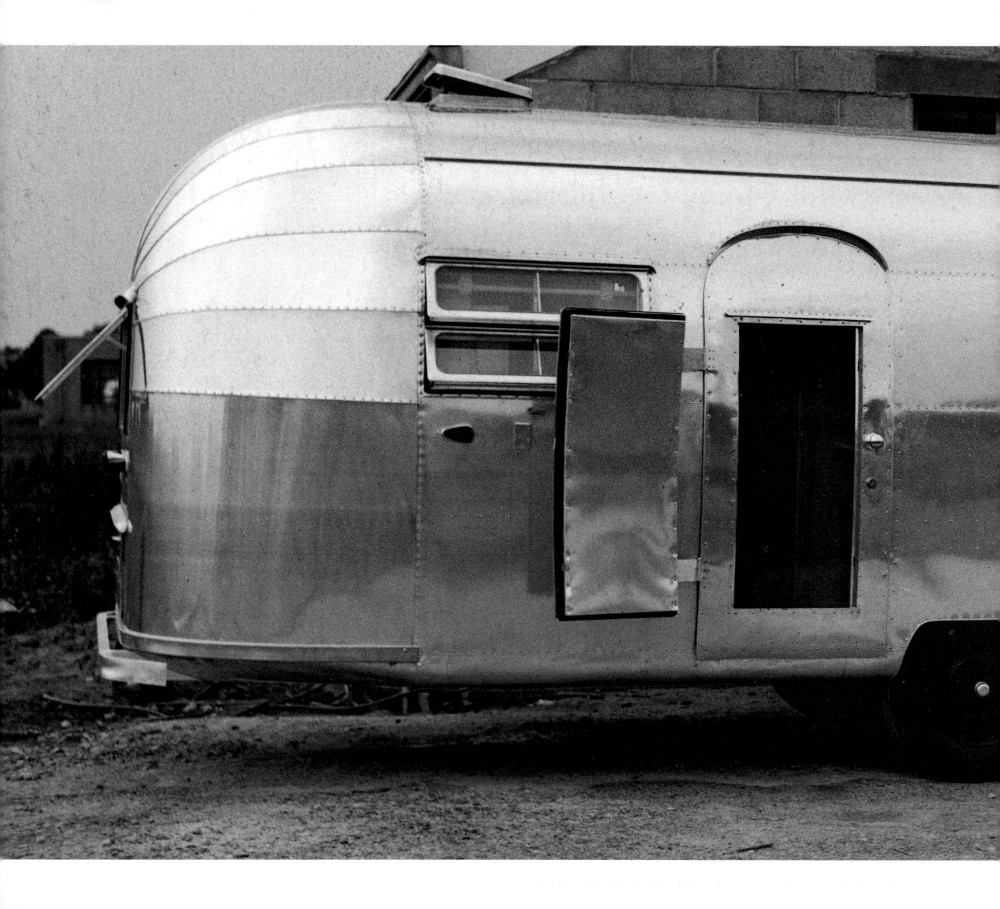

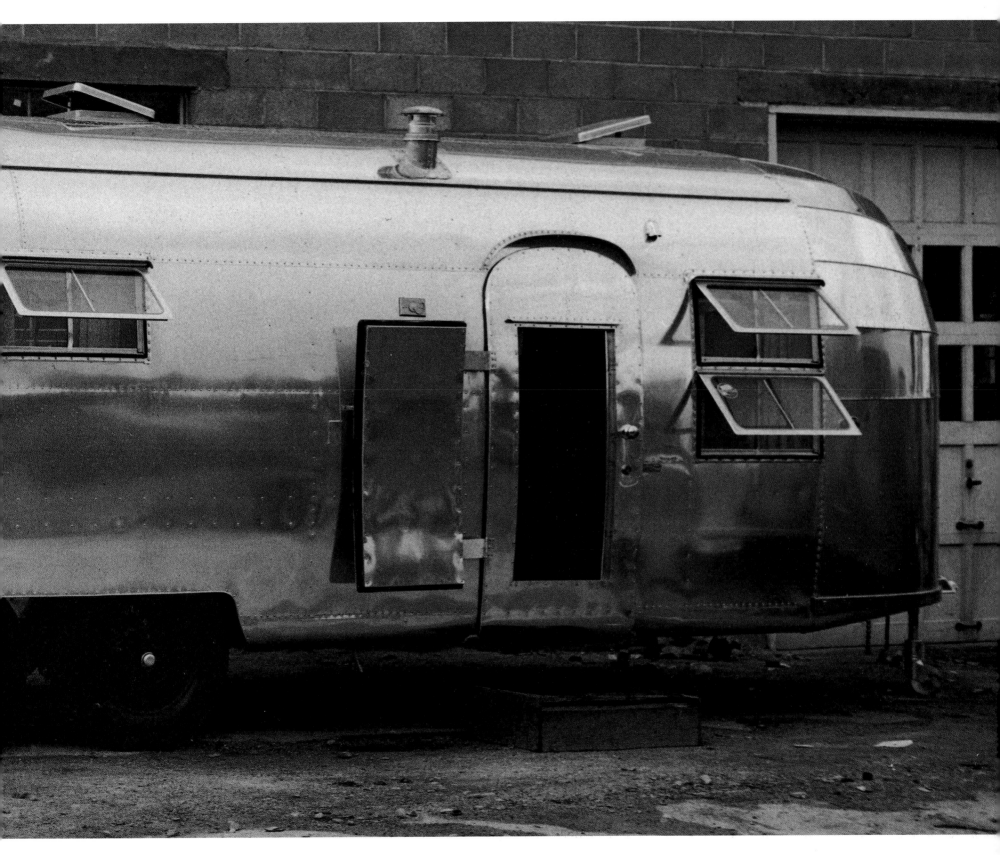

DOUBLE DOOR TRAILER A trailer anomaly parked outside the Airstream factory, 1958.

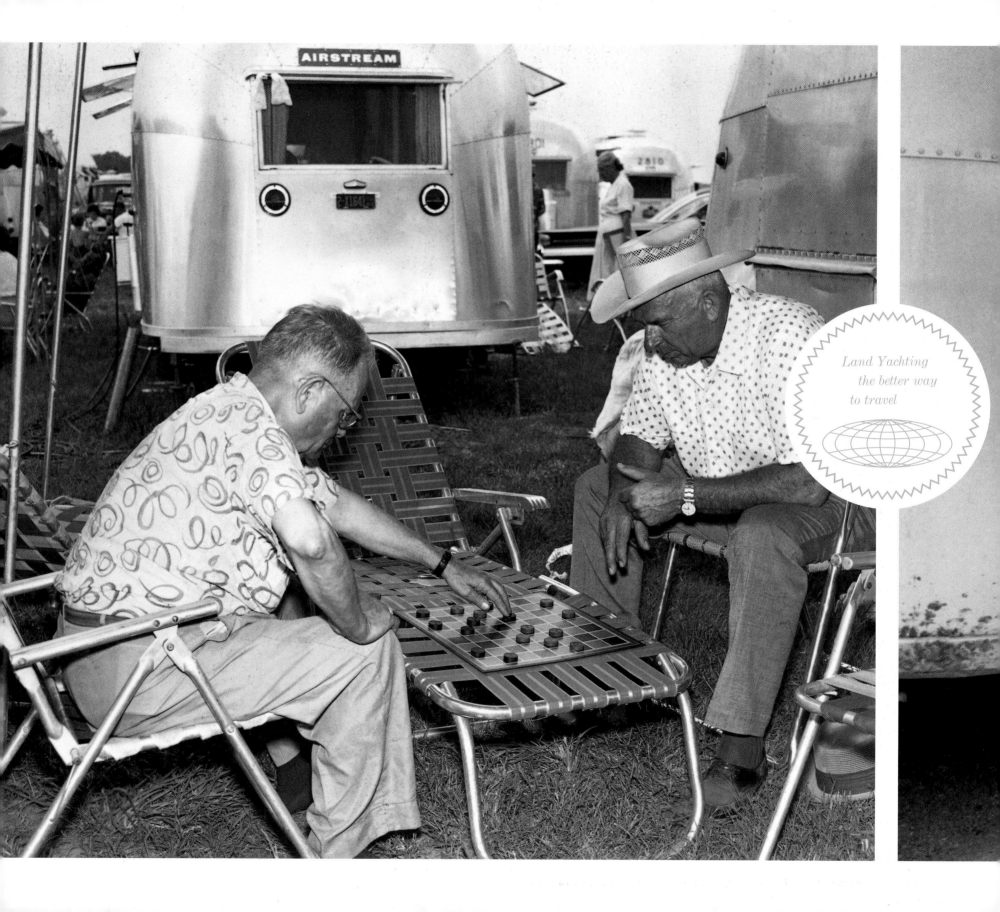

AIRSTREAM

Land Yachting
the better way
to travel

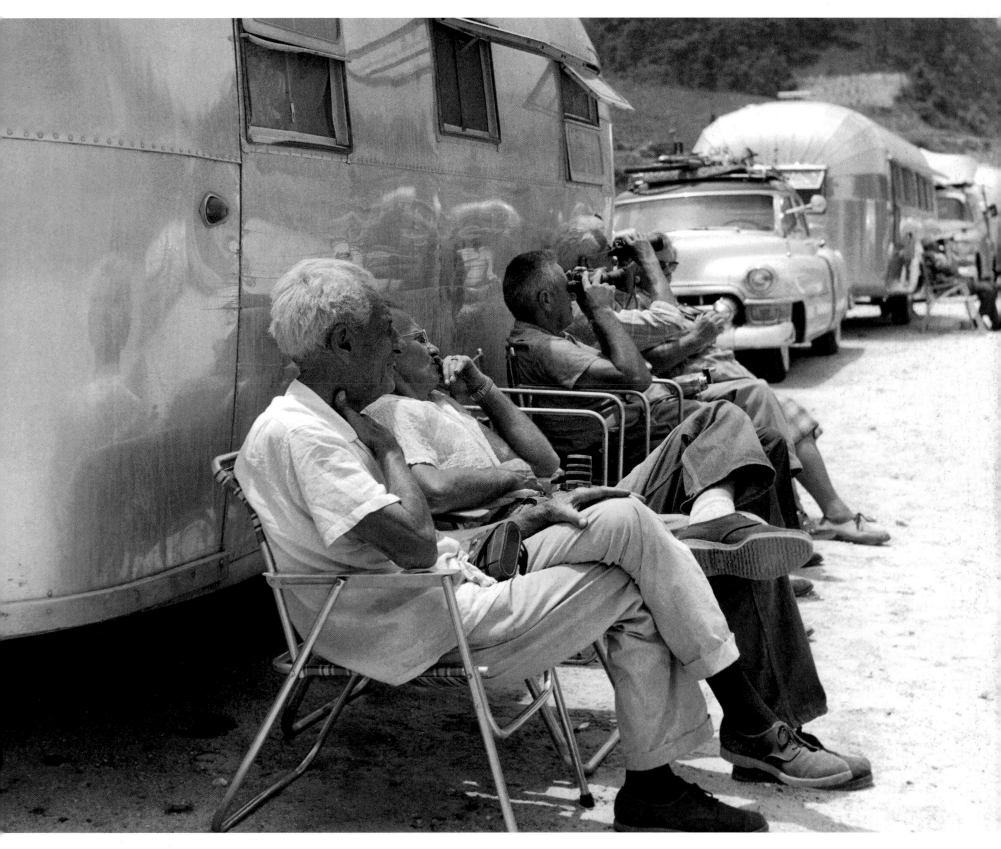

CARAVANNERS TAKE FIVE (left) At rally. (above) On the Central America Caravan, 1956.

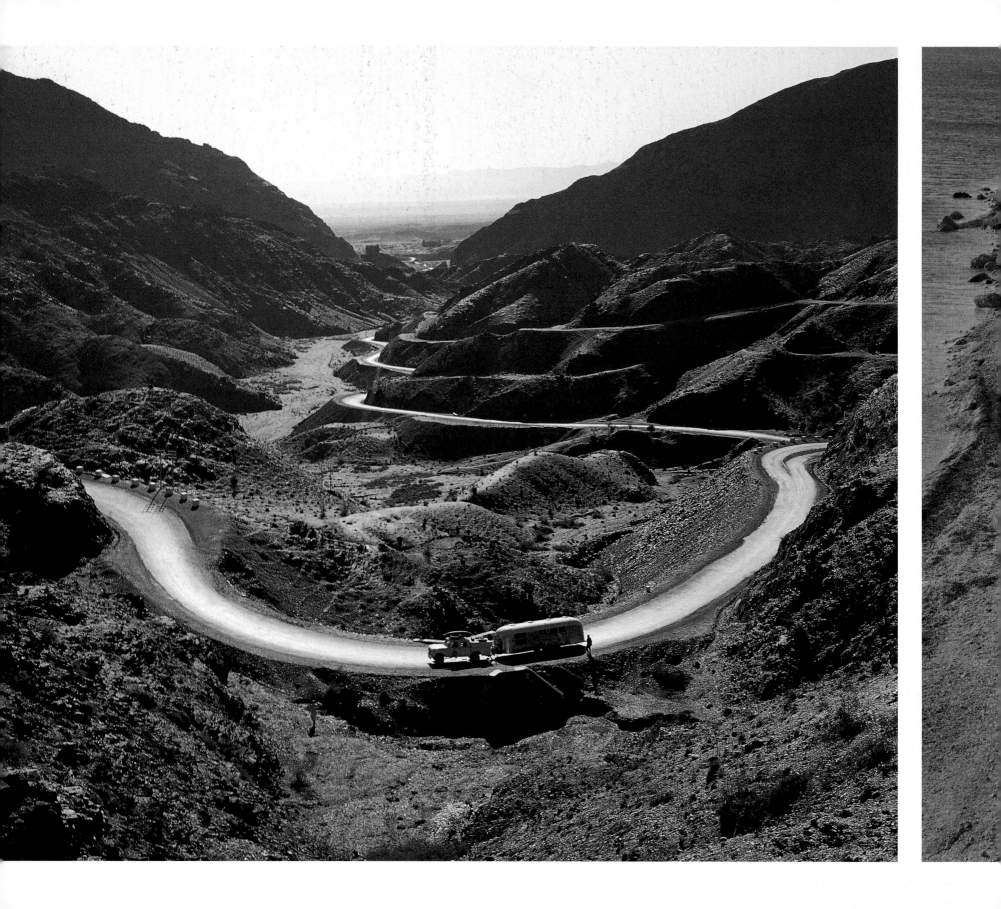

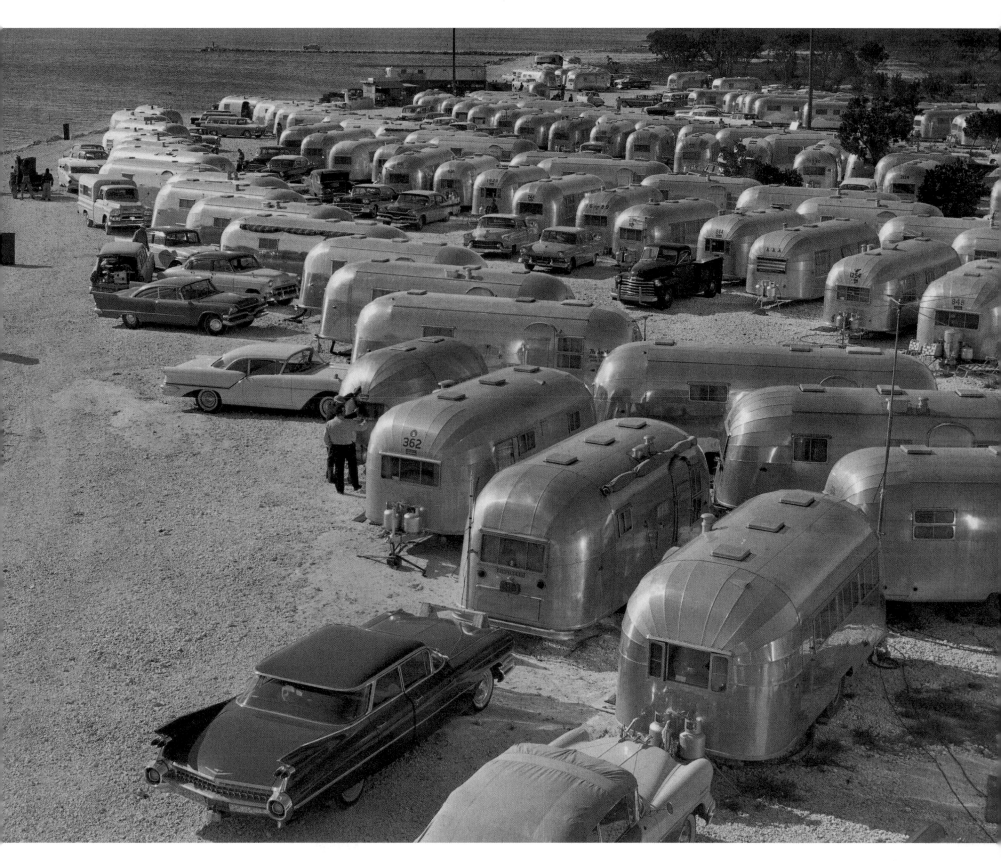

AFRICAN CARAVAN (left) 1964. **FLORIDA RALLY** (above) 1959.

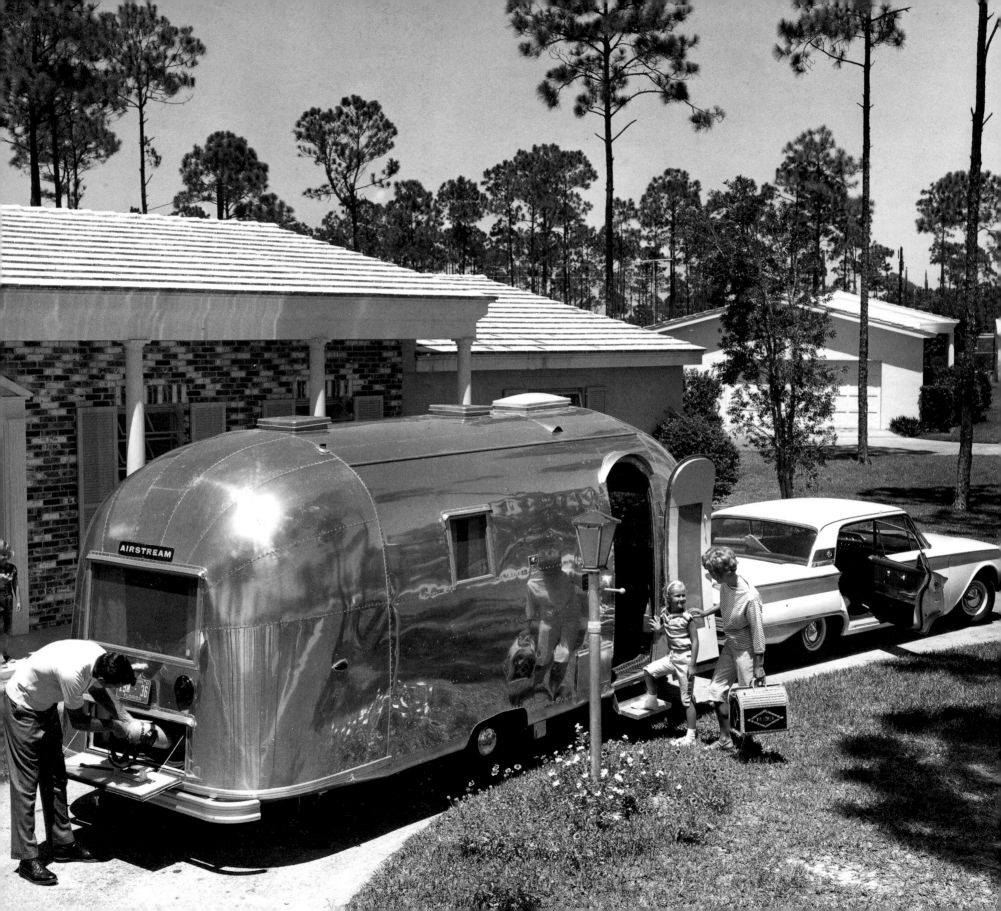

see more, do more, live more

The African Caravan and later, the Around the World Caravan of 1964–1965, which left Singapore and covered 34,000 miles through Cambodia, Thailand, India, Scandinavia, and Europe, were immortalized in a *Masterpiece Theater*–style television miniseries narrated by Vincent Price. They appeared on the covers of the periodicals of the day such as *Trailer Life* magazine, whose cover story asked "Caravanner or Loner–Which is for You?" and *Mobile Home Journal,* which sported three twirling senoritas in frilly cotton dresses clicking castanets as they mimed, "Ole!" for the camera in a Cascals, Portugal, photo shoot. In the television series, Vincent Price arose from a sturdy leather chair to take viewers on a televised tour of the world, tracing the same route Marco Polo took in 1273. His telegenic presence led the audience through the caves of the Dead Sea Scrolls in Jordan to a tug of war between elephants and Airstreamers–from belly dancers in Iran to opium smokers in Chang Mai. Since anywhere an Airstream could go a movie camera could go too, scenes of the travelers baking an apple pie in an Airstream stove in the middle of the Afghan desert, or preparing dinner with yak butter next to the Palace of Cyrus the Great in the ruins of Persepolis, was merely a channel switch away.

No doubt these travelogues contributed to the huge rise in trailer travel in the late 1960s and 1970s, but there's no substitute for being there when a camel driver in Egypt calls his

FAMILY HOLIDAY (left) Packing up the trailer for the weekend. Many trailers were used as a mobile second home, allowing the owner to chose their destination on a whim.

The polished aluminum of an Airstream was itself a kind of secret password that, once spotted, magically opened doors for the group. Even the blue berets caravanners wore began to confer a first-class prestige that allowed them to skip lines, blow through customs, and avoid traffic hassles.

mount "sweetheart" or "hot baby" in an impromptu street performance for the kids. And besides, Wally never would have known that "you cannot pull a twenty-eight-foot trailer up a mountain with a Hillman Minx, but neither do you need a diesel truck," unless he personally made the attempt to cross that mountain himself. Unlike Mohammed who was waiting for the mountain to come to him, Wally went to it, experimenting with every type of terrain, making adjustments and design innovations as he went. After leading as many as twenty-seven caravans, including nine to Canada, nine to Mexico, two to Central America, two to Alaska, and one to Europe and Africa, Wally proudly exulted, "I've got so many keys to so many cities, I'm going to start a museum just for keys."

Indeed, as die-hard caravanners began to log more and more trips under their belt, their fame began to precede them. A Carnet du Passage, or "carnay" for short, was like a VIP pass for international travel—a passport that opened up borders to the trailers that were closed to other motorists.

FOR THOSE AT HOME
(above and left) To document their journeys, caravans often traveled with film crews. The *Caravan Around the World* featured a narration by Vincent Price.

CANADA
(right) Caravanner stops under an arch in Alberta, Canada. 1965.

The polished aluminum of an Airstream was itself a kind of secret password that, once spotted, magically opened doors for the group. Even the blue beret's caravanners wore began to confer a first-class prestige that allowed them to skip lines, blow through customs, and avoid traffic hassles. Wally noted a perfect example from the Mexico City Caravan. "S. J. McDonald, a caravanner from San Diego, was wearing a big black sombrero when he caused a huge traffic jam around a *glorieta* (circle) in Mexico City. As the policeman started to write the ticket, Mac made a quick switch to the blue beret and beamed out the window. The cop threw away the ticket and, with a wave of his arm, said, 'Pasa, amigo.'"

While many Airstreamers are retirees, not everyone can drop what they're doing and take six months off to travel around the world, especially if they have jobs and families waiting back home. To accommodate this segment of trailerites, the annual international rallies that take place in the United States are open to anyone with an Airstream from anywhere in the world and are designed to bring the flavor of an international caravan back to the homefront. The 1992 documentary *Silver Palace,* which focuses on a summer rally of 3,400 trailers at Notre Dame University in South Bend, Indiana, perfectly counters the stereotype of the "rocking-chair retiree," illustrating in one participant's words, "an independent, self-owned, self-run, nonprofit corporation dedicated to the enhancement of one unique lifestyle." *Silver Palace* begins fittingly with an image of the earth as a big blue marble beamed back from a distant satellite, while voices crackle above the static of a CB radio. Not content to putter around the house or chill out in front of the TV, the video depicts Airstreamers waking at the crack of dawn for a busy schedule of barbecues, ice cream socials, square dancing, and even an Airstream beauty pageant, clinched by a budding young singer whose impassioned

rendition of "Somewhere over the Rainbow" would put *Star Search* contestants to shame.

The *Silver Palace* interviews with trailerites are relaxed coffee table discussions in the comfort of their Airstreams, where enthusiasts relate their feelings of safety, protection, and friendship among those that feel Airstreaming has kept them "emotionally, physically, and spiritually" alive. A few "full-timers," those who have forsaken their homes to travel and live year-round in their vehicles, note that the group is tribal, but not insular. They explain that the rallies counter the inevitable claims of elitism that arise from Airstreams being deemed the Rolls Royce of trailers. A group of Australians in Winnebagos is warmly embraced when it's learned that they have their own International Club back home and share the same enthusiasms. As is typical with most rallies, a small posse of forty trailers broke off from the group for a mini-caravan through Glacier National Park, Montana, to Calgary, Canada. Typically when a caravan returns from one of these short reconnaissance pleasure trips, those members have become closer than the larger group but are still eager to present a hilarious campfire skit or abundant banquet spread to a willing if jealous audience. Another documentary, *Caravanners,* made by the National Film Board of Canada, recounts exactly this kind of trip, beginning in British Columbia and winding up in Great Falls, Montana. *Caravanners* is an excellent introduction to the quotidian tasks that make up a day in the life of an average Airstreamer. Fixing axles, polishing chrome, cooking dinner, and even taking out the garbage get as much play as the more glamorous free-wheeling down the highway with a background of granite precipices against a clear azure sky.

Within the Wally Byam Caravan Club International a splinter group was founded by Rutherford "Bud" Cooper

to preserve the legacy of and to swap information about vintage trailers. To qualify for the Vintage Airstream Club, one's trailer must be at least twenty-five years old and the owner must be a member of WBCCI. The club, which has its own historian and written archive, prints a newsletter called the *Vintage Advantage,* offering troubleshooting advice on plumbing or electrical problems, and handy tips on restoration techniques. You can't miss the Vintage Airstream Club at a rally since its members park in a tight-knit group and the trailers are often towed by classic cars. A fifteen-foot Cruisette or a sixteen-foot Bubble with blue canvas canopies unfurled next to a rock-lined footpath tend to catch your eye next to the newer, and larger Airstreams nearby. The newer Airstream has evolved into a modernized, squared-off version of original Airstream form. Looking at these trailers side by side, you can't help but to find yourself tracing design lineage from one model to the next.

Intent on preserving and sharing its knowledge of customization within a tight-knit community, the Vintage Airstream Club is always actively pursuing new members, or "first timers." The members feel that they comprise a unique link in Airstream history and would rather take a gutted and abandoned trailer found in a remote lot and bring it back to life from the inside-out, than purchase a new trailer with all the options and modern conveniences, factory built and ready for action with the touch of a button. Today, when Vintage Airstream Club members are not busy revamping and polishing their trailers in preparation for the Concourse d'Elegance, a contest for the spiffiest vehicle, they communicate with each other through the Airstream Central website, answering each other's questions and helping members track down elusive parts. The digital revolution has lent an international flavor to the club, as curious web surfers in England or France check out Airstream Central's links, getting the dates on an upcoming Wagon Wheels Rally or downloading images from a recent caravan.

In reflecting back on all the caravans he had led, Wally Byam remarked, "We feel that we have spread more honest to goodness, down to earth goodwill in the countries we've visited than all the striped-pants diplomats put together." Thirty years later, no one would argue with this assessment. Airstream trailers began as an icon, and they remain one to this day because they are more than the pinnacle of fashionable design wedded to an affordable alternative to comfortable travel. The silver silhouette at rest, blue canopy casting a comfortable slice of shade, and a driftwood nameplate bearing the crest of "The Garrisons" or "The Coopers" exert a magnetic pull on optimistic individuals who believe that community begins with shared values, rather than a piece of real estate drawn up on a map. Thankfully, you don't have to spend lavishly to take part in the pleasure of caravanning—the main ingredients on any caravan are simply enthusiasm and a love of adventure. And, of course, an Airstream.

The dream of adventure, of escape, referred to countless times throughout this book, is, like all dreams, a way of setting aside momentary distractions, or at least distracting ourselves for a moment in the hopes of setting our ambitions in motion, our desires for a better lifestyle. Dreaming, like travel, is as instinctive and ingrained as breathing and the two go back as far as the first hominids foraging for food and fire. In this sense, we are all caravanners, following ideas, aspirations, or simply a comfortable place to live.

From the beginning, the purpose of this book has been to add a broad, wide-ranging written account to an already thriving, intimate oral history in the hopes of stimulating more of the same on both fronts. Call it cultural diplomacy, rather than cultural history. I don't think Wally would object.

endnotes

[1] Seldes, Gilbert, "200,000 Trailers," *Fortune* magazine (March 1937), Vol. XV, #3

[2] Seldes, "200,000 Trailers"

[3] Lewis, Sinclair, *Dodsworth* (New York: Signet, 1995 reissue)

[4] Seldes, "200,000 Trailers"

[5] Burch-Brown, Carol, *Trailers* (University Press of Virginia, 1996)

[6] Byam, Wally, *Trailer Travel Here and Abroad*, David Mckay Company, Inc.
(New York, 1961)

[7] Loewy, Raymond, *Never Leave Well Enough Alone* (New York: Simon and
Schuster, 1951)

[8] Loewy, *Never Leave Well Enough Alone*

[9] Verne, Jules, *20,000 Leagues Under the Sea* (New York: Random House, 1999)

[10] Byam, *Trailer Travel Here and Abroad*

[11] Seldes, "200,000 Trailers"

[12] Douglass, Lillie B., *Cape Town to Cairo*, The Caxton Printers, Ltd. (Caldwell,
Idaho, 1964)

[13] Byam, *Trailer Travel Here and Abroad*

[14] Douglass, *Cape Town to Cairo*

index

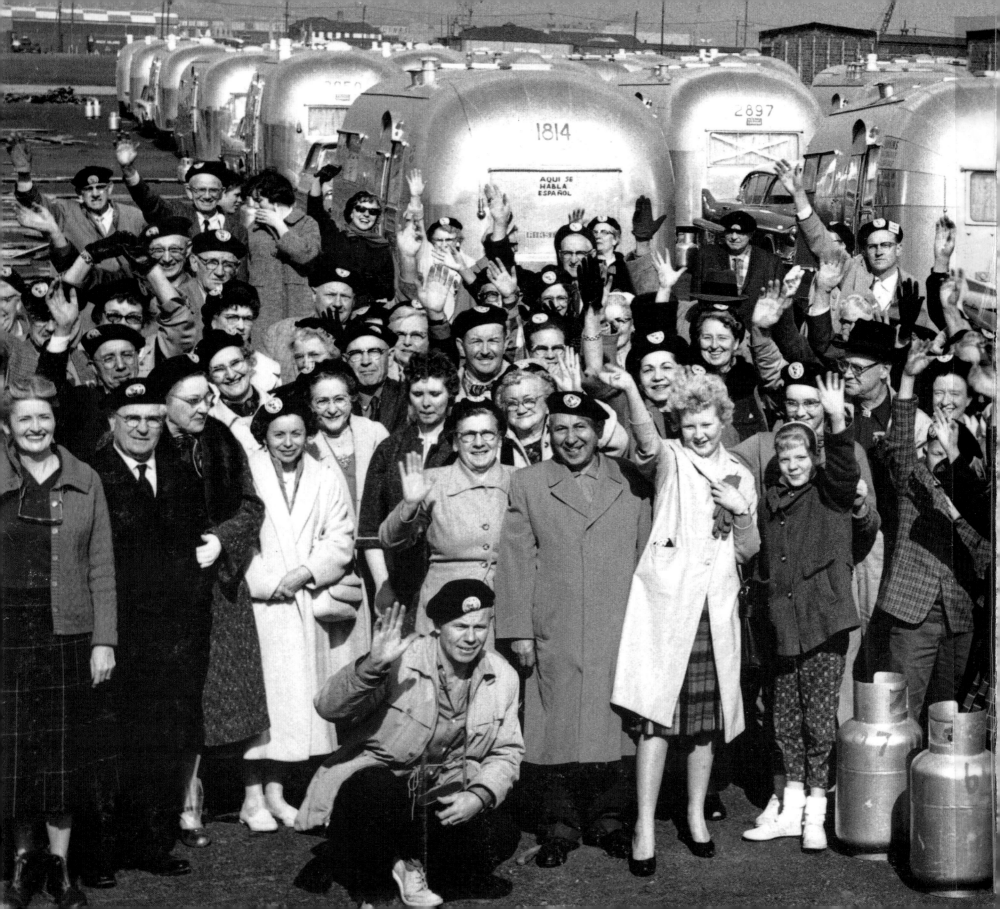